FRAMING THE WEST

CAROL J. WILLIAMS

Framing the West

RACE, GENDER,

AND THE

PHOTOGRAPHIC

FRONTIER

IN THE PACIFIC

NORTHWEST

OXFORD
UNIVERSITY PRESS

2003

OXFORD

UNIVERSITY PRESS

Oxford New York

Auckland Bangkok Buenos Aires Cape Town Chennai

Dar es Salaam Delhi Hong Kong Istanbul Karachi Kolkata

Kuala Lumpur Madrid Melbourne Mexico City Mumbai Nairobi

São Paulo Shanghai Taipei Tokyo Toronto

Copyright © 2003 by Oxford University Press, Inc.

Published by Oxford University Press, Inc.

198 Madison Avenue, New York, New York 10016

www.oup.com

Oxford is a registered trademark of Oxford University Press
All rights reserved. No part of this publication may be reproduced,
stored in a retrieval system, or transmitted, in any form or by any means,
electronic, mechanical, photocopying, recording, or otherwise,
without the prior permission of Oxford University Press.

Library of Congress Cataloging-in-Publication Data
Williams, Carol, 1956–
Framing the west : race, gender, and the photographic frontier in the Pacific northwest /
Carol Williams.
 p. cm.
Includes bibliographical references and index.
ISBN 0-19-514630-1; ISBN 0-19-514652-2 (pbk.)
1. Photography—Northwest, Canadian—History. 2. Indians of North America—
Northwest, Canadian—History. I. Title.
TR27.N7W55 2003
770'.9712'09034—dc21 2002193131

9 8 7 6 5 4 3 2 1

Printed in the United States of America
on acid-free paper

TR
27
B8
W55
2003

TO DON GILL

with appreciation

[ACKNOWLEDGMENTS]

Many talented hands and minds contribute to an individual manuscript, and I'd like to extend special thanks to those who shared their expertise, criticism, wisdom, and wit, including Virginia Yans McLaughlin, Kathleen Brown, James Livingston, Susan Schrepfer, Susanne Klausen, Donna Zapf, Lynne Bell, April Masten, Ruth Sandwell, Geoffrey Batchen, Gloria Larrieu, Catherine Kingfisher, Heidi Macdonald, Aileen Espiritu, Lorna Brown, Allyson Clay, Doreen Piano, Dina Alsoywayel, and Elizabeth Gregory.

Sharing her impressive eye for detail, Susan Ferber at Oxford University Press consistently posed valuable queries at appropriate moments in the draft. I thank her, too, for her commitment to the project. Jurists Robyn Muncy, Nancy Hewitt, and Elsa Barkely Brown of the OAH's Lerner Scott Prize in 2000 offered recognition for my research at a very timely moment, and I'm grateful for their support and that of the OAH.

Regional historians and archivists harbor an astonishing accumulation of knowledge, and my work relies heavily on their familiarity with the sources as well as their individual research, including Kathryn Bridge and David Mattison of the British Columbia Provincial Archives, Bob Griffin of the Royal British Columbia Museum, Bob Raappana of the Victoria Police Museum, Shirley Bateman and Christine Meutzner at the Nanaimo District Archives, Bob Stewart at the British Columbia United Church Conference Archives, and archivists at the American Museum of Natural His-

tory Library. The extraordinary historical photograph collection assembled and maintained by the Anthropological Collections manager and historian Dan Savard at the Royal British Columbia Museum was fundamental to my grasp of the international commodification of photographs of "Indian life." That the collection is frequented by curators, anthropologists, writers, historians, filmmakers, and the various ancestors of individuals portrayed in the images demonstrates the value of this kind of dynamic museum stewardship. Thanks also to Margarita James of the Mowachaht/Muchalaht Band office in Gold River; she provided assistance in identifying a young woman in one of the photographs.

Marcia Crosby's invitation to speak at the First Nations Liberal Arts Program at Malaspina College in Nanaimo, British Columbia, and Michael Yahgulanaas's request for a contribution on using historical photographs for the Haida G'waii watchmen of the Queen Charlotte Islands radically transformed my perceptions about indigenous uses of photography. And pointed queries and criticisms from students and elders at Malaspina College workshops and at other public lectures substantially reconfigured the path of my research. Chief Jill Harris hosted an influential conversation about historical photographs with researchers and historians of the Hul'qumi'num Treaty office in Duncan. This conversation, as well as a brief exchange with photographer Dave Bodaly of the Te'mexw Treaty Association, broadened my understanding of the political import of photographs for treaty activism and the reconstruction of tribal community and family histories. I thank them all for their contributions, and I look forward to on-going conversations.

While the stresses of peripatetic scholarly existence are obvious, this mobility also brings unanticipated gifts: I have acquired an expansive social network of friends and colleagues who have supported my scholarship in meaningful ways. I am particularly grateful to the Women's Archive and Research Center and The Friends of Women's Studies, an innovative experiment in community and academic collaboration within the Women's Studies Program at the University of Houston. This program, headed by literary scholar Elizabeth Gregory, provided generous research support during a postdoctoral fellowship I held from 2001 to 2003 in addition to completion funds for publication. Professor Joseph Pratt, Cullen Chair of History and Business at the University of Houston, too, offered funding to ensure the quality of the photographs and bring the manuscript to fruition. It is more rare than common for itinerant scholars to find such collegiality and support.

In fall 2001, a semester's residency in the Center for Feminist Research at the Women's Studies Program at the University of New Mexico afforded a valuable hiatus from adjunct teaching. A special opportunity study grant

awarded by the Rutgers Graduate School in August 1999 and a travel grant from the Canada Council for the Arts presented the opportunity to participate in a working seminar of international visual anthropologists at the Centre for Cross Cultural Research at Australia's National University in Canberra.

My partner, documentary photographer Don Gill, first inspired my interest in photography at a time when my educational path was embryonic. His intellectual devotion to the practice, history, and theory of photography has shaped my own scholarship incalculably. My fond appreciation also goes to my extended family, including Joan Bartmann, Heinz Bartmann, Suzanne Fryer, Bill Fryer, David Fryer, Sarah Williams, Jackie Gallant, Kathy Swan, and Bud Swan, who, across many miles, have sustained me with daily conversation, laughter, and other substantial offerings of the heart.

Last, I'd like to honor the memory and industry of the people depicted in the photographs and mentioned in written documents. Names and cultural identities of these individuals are too often, and regrettably, lost or forgotten with the passing of time. While the photograph is limited in telling truths about the daily struggles of a single life or community, visual remnants renew a conversation with the present in ways written text fail to do. Employing speculative interpretation and reading a single photograph against a field of thousands, I may have at times overamplified minor detail or abbreviated asides. I apologize if I've generated further misrepresentations; my motives are earnest and fueled by political commitment. With the publication of the photographs, I hope others will recognize someone, pick up the broken or misdirected strand, and resume the reconstruction.

CONTENTS

ILLUSTRATIONS

FRAMING THE WEST

INTRODUCTION

At two o clock I took a photographic view of the Ahouset village—Capcha the Chief—which appeared to contain about 500 inhabitants, it is a long village situated in a beautiful bay, at the foot of a large rounded mountain covered with pine trees, when I put my head under the focusing cloth of the camera to my surprise on withdrawing it, I found myself surrounded by about twenty of the natives squatting on the ground watching my movement, and as I had chose a small hillock jutting out into the bay on the right hand side to get a full view of the village, I could not imagine how they came there without being seen, so I packed up the camera as quickly as possible, and found in my pocket a plug of tobacco which I cut into small pieces and give them to the natives as far as they would hold out, and then raised my hand to them and dattawaed [sic] to the dingy.

—FREDERICK DALLY, *Memoranda of a trip round Vancouver Island and Nootka Island on board HMS* Scout, *Capt. Price, for the purpose of visiting the Indian Tribes by his Excellency Sir A. E. Kennedy the Governor,* August 10, 1866

Mr. R. Maynard of this city accompanied the Superintendent of Indians Affairs in the Boxer *on the recent trip to the north, and has secured several excellent pictures. The first affords a fine view of the Indian village at Knights Inlet, with the powerful tribe grouped in the foreground, and the Supr., Capt. Fitzgerald, Capt. Moffat, and officers of HMS* Boxer *in the rear. No. 2 is a*

group of officers and men of the Boxer *seated on the margin of a dense forest.
No. 3 is a view of a Bella Coola Indian village, with the high snow capped
mountains rising in the rear. [Supr.] Dr. Powell, Capt Moffatt, Mr.
Tompkinson, RN, Mr. Mould, RN and others occupy the foreground.*
—(*Victoria*) *Daily Colonist,* June 21, 1873

*August Sat. 16, 1879. The morning luckily turned out very fine, and some
people went ashore again. Mr. and Mrs. Maynard succeeded in getting two or
three views. At 8:15 we steamed from Friendly Cove and crossed over to
Resolution Cove where Captain Cook refitted his vessels 101 years ago. The
scenery from here to the ocean around Nootka Island is delightful. Snow
capped mountains every now and then come in view: and the water with
scarcely a ripple. Passed an Indian fishing ground and saw a carving,
representing four Indians standing on each others shoulders, the topmost
holding a paddle in his hand.*
—CHARLES KENT, *Notes on an excursion around the [Vancouver] Island
 on board the Princess Louise*

*August Sat. 16, 1879. Fine morning—started to take a view of Nootka Sound.
Left Nootka at twenty minutes after eight and got to Kyaquot at five in the
afternoon—took some views and went on board for tea. Started at daylight
on the 17th and struck on a rock in going out—detained three hours and then
got off and arrived at Quatsino at half past three in the afternoon. Went on
shore and took some portraits of sugar loaf headed Indians also their ranches.
Anchor Forward Harbour.*
—RICHARD MAYNARD, *Princess Louise Excursion*

*August Sat. 16, 1879. Lovely morning so we were called early to get up. We are
now on top of a high rock taking a view of the Indian camp whilst there.
Maynard down to his tent, me on the top with the cameras. Three Indians
camp up with nothing on but a piece of old blanket, however they did not kill
me. We took two negatives when the whistle blew for the starting, so it was
pack up and off for the steamer. Met with an accident. Broke our bath bottle
and spilled part of the bath. Left over half past eight. Took an inside passage.
Scenery lovely. Went on shore and took some photographs. Nice weather. Had
some nice music and singing in the evening.*
—HANNAH MAYNARD, *Princess Louise Excursion*

When diary entries by photographers Frederick Dally, Richard May-
nard, and Hannah Maynard flank accounts by settler Charles Kent
and an unidentified journalist reporting to Victoria's *Daily Colonist*, it be-
comes apparent that from its earliest appearance in northwest coastal North
America (fig. I.1) the camera was not a benign tool of observation. Photog-

raphy's purpose was instrumental: it was evidence in support of imperial science, topographical exploration, and colonial expansion. As practice and artifact, photography fulfilled the curiosity of the colonist and tourist who wanted to comprehend the unfamiliar—in particular, the indigenous inhabitants of the region.

On the two British Pacific coastal colonies of Vancouver Island and British Columbia, photography was first introduced by the 1859 survey crew of the British Engineers Corps, which employed cameras to assess, measure, and survey the land and to record available or exploitable resources.[1] The photographic initiatives of the survey crew were experimental, driven by an imperial need to investigate foreign terrain, and for these men, the photograph convincingly promised a realistic or documentary embodiment of the new land and its attributes.[2] Members of the newly arrived civil and military service documented not only physical topography and geology but also resident populations of Native Americans.[3] For their intents and purposes photography was simultaneously inscriptive and descriptive in that the photographic results mapped the recently acquired territorial possessions of the British as well as describing its topography, vegetation, and original inhabitants with an eye toward settlement.

Photography was a practical extension of the primary political purpose of the British Engineer Corps, whose members were dispatched to the British North American colonies to survey the geopolitical boundary between the northern territories of the British territory and the Washington territory of the United States, thus concluding the agreements made in the Oregon Treaty, signed on June 15, 1846. After the highly publicized gold discoveries of 1858, they were used to maintain law and order among miners, settlers, and Native Americans in advance of a regional police force.

Although cumbersome, photography, by the mid–nineteenth century, had largely displaced hand-produced drawings as the preferred medium for recording exploration in colonial or foreign lands. Seemingly unimpeded by the human hand or emotion, it was well suited to the science of boundary marking. The photographs gathered along the boundary were one type of evidence by which two expansionist nations—the United States and Great Britain—clarified their respective territorial boundaries in what was formerly indigenous ancestral land.

The landscape and portrait photographs produced first by surveyors and, after 1860, by commercial photographers visually manifest the northwest coastal frontier simultaneously as a place and an encounter. Reconstituting the routes and places colonial investigators, travelers, and residents frequented and settled, landscapes depicted both unusual land formations and the growth of a colonial infrastructure in the new territory. Studio and in situ portraiture illuminated the celebrated government officials, civil servants, and resident families, while providing some indication of the devel-

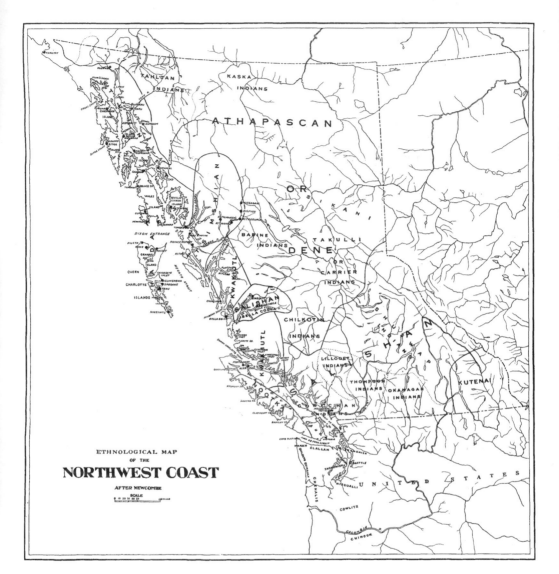

I.I

ROTA

Late-nineteenth-century map
of the Northwest Coast (after
Newcombe)
Courtesy American Museum of
Natural History Library
#320573

oping encounter with individual members of regional Native American tribes. Collectively, these images visualize the intrusive process of Euro-American settlement. By conveying two compatible impressions of the colonies—on one hand, the orderly march of Euro-American settlements and, on the other, the acculturation of indigenous inhabitants in the face of inevitable modernization imported by the settlers—photography propagandistically served a utilitarian and fundamental purpose: to lure Euro-American immigrants into a region where the potential for indigenous resistance had supposedly been put to rest.

Not coincidentally, this era of colonial growth was a time when the visual exploration of northwest coastal Native Americans proliferated. Between 1859, when British surveyors took the earliest incidental portraits of coastal peoples, and 1886, when professional anthropologists, among them German American Franz Boas, began to use photography to record cultural change, a stream of inquisitors including commercial photographers, government agents, missionaries, and tourists used cameras to scrutinize Indian life and bodies. Their individual motives for taking photographs varied but all were, in some sense, invested in the acculturation of the Native American. Moreover, as colonial interest in Indian territory grew, the bureaucratization of Indian affairs correspondingly developed. The political and social intrusion into Native American life expanded especially after 1869 with the introduction of regional acts to administer the Indian. In both the United States and Canada, Euro-American settlers and North American Indians were increasingly segregated by race-based legislation.[4] In the Dominion of Canada, the federal containment of the Indian—a program combining the regulation or suppression of customary cultural practices and re-education—was widely embraced across the growing nation. By 1876, the federal government consolidated all previous, local piecemeal legislation within the nationwide Indian Act, which endeavored to uniformly manage indigenous affairs within each province of the Dominion.

The photographs of colonial and Indian life collectively form a visual impression, a photographic frontier, if you will, often used in contemporary histories of the Northwest Coast. Yet rather than representing an accurate or democratic recollection of a place, or conveying the tumultuousness of the encounters between diverse communities of people in the region, these photographs offer tame impressions of settlement. One must approach the photographic artifact from an oblique angle to gain a more nuanced understanding of the contest of power that was at the heart of colonial encounters between Euro-American settlers and indigenous populations.

For the most part, contemporary historians have confined themselves to an illustrative use of photographs.[5] Employed to embellish an unfurling historical narrative, this limits our understanding of how photography constructed cultural and racial difference between settlers and Native Ameri-

cans, largely emptying the photographic artifact of the imperial, commercial, government, or anthropological motivations behind its creation. Between parties of unequal status, looking was not an innocent act. Photographs, as a consequence, are primary historical sources useful in unveiling the fluctuating state of agency and disempowerment. To understand the social value of photography in the colonial environment, the original, often elusive, purpose or function of the photograph must be part of the overall equation.

The taking of photographs on Vancouver Island and British Columbia began in the British colonial era between 1858 and 1871 and increased during the postconfederation period after the two colonies joined Canada as a unified province in 1871. The resulting mass of visual records now available in public archives throughout Canada and the United States falls into three genres: topographical/landscape, studio portraiture, and ethnographic portraiture. A fourth genre, art photography, is less common, although the work produced by two popular and prolific northwest coastal photographers, Hannah Maynard and Benjamin Leeson, cultivated the market for manipulated imagery of this sort. For the purpose of clarity, in this study the photographs are arbitrarily divided into three distinct genres: survey, promotion, and ethnography. These genres occurred chronologically: the surveyors were the earliest Europeans to carry cameras into the region, followed by settlers and commercial photographers who produced favorable promotional visions of settlement. The ethnographic interest of tourists and anthropologists in "vanishing" Indian culture stimulated a subsequent flurry of photographic activity at late century. Regardless of genre, these photographs collectively expressed a fascination with Indian life and understood a Euro-American settlement as progress.

Promotional Photographs and Settler Portraiture

After 1860, professional and amateur photographers generated a vast corpus of images recording civic and rural development that had occurred as a result of the early initiatives of the imperial surveyors. These photographs depicted changes in the land, the erection of roads and wharves, the evidence of mining exploration and its mechanical detritus, and the growth of domestic and civic architecture in urbanizing environments such as Victoria, Nanaimo, Yale, and Vancouver. From this phase also emerged a substantial collection of honorific portraiture, taken indoors and out, depicting the earliest arriving Euro-American residents and sojourners. Both kinds of photographs can be considered promotional, as they cast a glorious impression of British territorial expansion and mercantilism. These images worked hand in glove to reinforce the notion that im-

perial interests had a positive effect on the transformation of previously un-developed territory.[6]

Many commercial photographers, fueled by a spirit of adventure and exploration, had ventured to the colonies in search of their own economic prosperity. Taking views along traditional coastal maritime trade routes and on roads recently built into the mining fields of the mainland interior of British Columbia, they rapidly assumed the mantle of colonial boosterism. Local government, in turn, apprehended the ideological utility of freelance photography, as images sent abroad to an international audience of potential immigrants, investors, and merchants increased the colony's prospect for success. In an unofficial, or semiofficial, manner photographs produced by the independent entrepreneur exported a favorable vision of the Northwest to buttress government-sponsored immigration campaigns. By advertising the quality and availability of land and resources, promotional photographs thus harmonized with the imperial agenda to attract new immigrants. As commodities circulating internationally, and often detached from their original purpose or intent, this genre of photograph was an expression of Euro-American entitlement to the frontier, delivering this message to a rela-tively uninformed transatlantic audience.

Photographs especially aided frontier expansion after 1880 when visual records were consistently paired with written or spoken assertions about the colony's progress and residents. The emergent print media, including news-papers, immigration manuals, and traveler guidebooks, were a fortuitous and expedient vehicle to disseminate Euro-American views about colonial-ism.[7] By 1884, the introduction of halftone technology, a process whereby a dot screen was laid over a photograph to enable a full range of gray tones to be mechanically reproduced via the printing process, allowed the image to be set alongside the typeface script of newsprint. This innovation allowed the image to be understood as an extension or illustration of the written de-scription.[8] The text or caption accompanying the photograph embellished the reader's understanding of it and transformed its reception.[9] With the halftone, the mutuality of two forms of human-produced documenta-tion—the visual equivalent of what was seen (the photograph) and the writ-ten impression of what occurred (the text)—were fused into a seemingly natural reciprocity.

Photography was rapidly incorporated into the burgeoning national and intercontinental industries of print culture, the legal system, advertis-ing, and the scholarship of the social sciences, all of which combined image and text for interpretive flourish. Whereas engraving, the labor-intensive mode of visual representation used in illustrated papers before the halftone, exposed the material or gestural qualities of representation, photographs were apprehended as neutral sources untouched by human bias and repre-sentative of real people, things, or events.[10] The photographer, in turn, was

seen as an impartial observer divorced from editorial impulses or cultural bias. In other words, the documentary encounter between the subject and the photographer was mistakenly perceived as antiseptic.

Immigration manuals and guidebooks aimed at audiences across the Atlantic and south in the United States mimicked the format of illustrated newspapers by combining visual imagery with anecdotes reporting quotidian existence on the frontier.[11] Essays featured an eclectic mix of nationalism, boosterism, and practical advice—listing needed supplies, tracing routes on maps, and discussing housing. Emigrant guides celebrated the heroics and successes of early pioneers who risked their fortunes by coming to the Northwest or investing in experimental development schemes. Local, national, and international illustrated travel accounts, guides, and newspapers linked the northwestern colonists with ethnically and culturally similar communities *beyond* the region.

Internal communication was also important to the cultivation of social empathy among settlers. Newspapers, personal letters, and news of Britain were freighted up and down marine routes to settlers isolated from southern port cities. Anglican, Methodist, and Catholic communities similarly contributed to the invention of a collective frontier sensibility by circulating newsletters and missionary reports among local worshippers, as well as to followers in Eastern Canada, in Britain, and other overseas colonies.

These diverse forms of communication established imperial connections between real and imagined communities.[12] Hereafter, daily existence in the colonies was legible and accessible to distant audiences because documentary reports and photographs from the colonies conveyed a clear representation of the place and people who settled there. These forms of transatlantic communication, supplemented by photographs, offered Euro-American inhabitants a means to communicate with relatives overseas in other parts of the empire, generating a sense of shared or common values.[13]

An analysis of the commercial photographers, arriving soon after 1860, who produced the sum of photographs circulated in such publications carries the weight of this book's narrative. Some came as merchants but diversified professionally by learning photography, others opened studios that specialized in private individual and family portraiture, still others were itinerant photographers seeking out subject matter and clientele in mining communities and Indian villages. A relatively small, but productive, circle, they included Hannah Maynard (British Canadian, active 1862–1912), Richard Maynard (British Canadian, active 1862–1894), Stephen Spencer (American, active 1858–1883), Frederick Dally (British, active 1866–1870), Charles Gentile (American, active 1863–1866), Oregon C. Hastings (American, active 1874–1899), Edward Dossetter (American, active 1881–1890), and Benjamin Leeson (British Canadian, active 1887–1900).[14] The process and

ideology of Euro-American settlement is illuminated by the body of work produced by these photographers, and especially by the photographs issued by the Maynards during the fifty-year span of their studio's existence.[15]

Commercial photographers may have been motivated primarily by self-interest, but the choices in subject matter reflected concerns that exceeded individual or personal ambition. The consistency of the subject matter among these photographers is a manifestation of a communal, ethnocentric response to unfamiliar cultural and political circumstances. The subjects selected for a photograph were initially sparked by consumer and government demands for a positive impression of colonial life. The images quickly attracted wider attention. By depicting the building of the colonial infrastructure—transportation, civic governance, maritime and overland routes—such images were used to seed the external perceptions of harmony, civility, and progress. After 1880, a transatlantic ethnographic interest in Indian life began increasingly to dictate what was commercially profitable. In sum, the photographic frontier conformed to a predictable sequence: the first stage illustrated the growth of a Euro-American presence; the second stage documented indigenous inhabitants and then romanticized acculturation as they were declared to be "vanishing" in the face of modernization.

All of the commercial photographers mentioned sought financial success. To attract and retain paying clientele they had to create the types of images most sought after. Earliest portraiture extolled distinguished personages, those who were celebrated, socially prominent, or well connected in the colonial economy. As the professional successes of Hannah Maynard and Stephen Spencer show, settler women of the middling strata became prominent consumers of portraits of themselves and their families, proving that fame or masculinity was not the sole criteria for photographic commemoration. The Maynard Studio, in particular, achieved longevity by cultivating products for this emergent market of female consumers. Settler women's increased consumption of family portraiture converged with the political self-realization that women's reproductive abilities contributed significantly to the building of a nation. Portraits of the healthy, fecund woman and her brood were encoded with ideal traits of respectability, virtue, and maternalism. In order to counter the pervasive negative impressions of Native American women, acculturated women of mixed-race ancestry like Annie Hunt Spencer, the wife of photographer Stephen Spencer, also sought portraits of themselves as respectable and affluent. Nevertheless, studio portraiture was formulaic in that each image was informed by a familiar set of codes and conventions, and the sitters were commonly distinguished by occupation, class, or race by the inclusion, or exclusion, of certain kinds of mass-produced studio props such as velvet-upholstered chairs and hand-painted backdrops.

Ethnographic Photographs of Indian Life

Promotional and market-driven initiatives, not coincidentally, gave rise to the third genre of photographic production evident in the oeuvre of commercial photography of this region: ethnographic portraits of Indians and Indian life. These images were widely marketed between 1860 and 1912. Here the historian's attempt to pinpoint the varied motives for the production of an individual photograph becomes progressively clouded. The photograph's ability to be infinitely reproduced and employed within shifting contexts—for example, a travel memoir, a guidebook, and an immigration poster—makes it difficult to trace the origins of any single photograph. Many of the earliest depictions of Indian peoples—images that were, by the 1890s, incorporated into a tourist market—originated at government behest. Photographs taken of various groups of Indians produced by Richard Maynard, Edward Dossetter, and O. C. Hastings were commissioned by Israel Powell, the Northwest Coast's first federal superintendent of the Department of Indian Affairs (DIA), on maritime inspection tours conducted in the 1870s. The photographs of individuals, tribal groups, and village sites resulting from these tours were part of the escalating state intrusion into Indian life. Photographs such as those in the album assembled by photographer Frederick Dally (fig. I.2) were appended to administrative reports filed by regional Indian agents. The tasks carried out on the inspection tours, with commercial photographers in tow, included the collection of demographic data on village populations, the assessment of potential resistance toward industrial or agricultural development, and the determination of reserve allocations necessary for each tribe. Another explicit purpose was diplomacy, as community disputes over the boundaries of reserves and access to resources accelerated with the intrusion of settlers into traditional villages boundaries and ancestral fishing grounds. Regional government Indian agents were appointed to monitor and mediate these conflicts.[16] Photography was vital to the investigations conducted by the DIA, and local commercial photographers profited from the official scrutiny into Indian life.

To further complicate a photograph's provenance, Methodist, Anglican, and Catholic missionaries also took, commissioned, and circulated portraits of Native Americans during these decades, using them to fulfill their promotional and pedagogical mandates. The missionary conversion anecdote, which was commonly accompanied by a single portrait, was thought to convey tangible evidence of acculturation. The photograph that illustrated a conversion anecdote commonly portrayed an upstanding Indian convert in European dress to signify the rejection of physical modifications and garments associated with traditional Native American ways and herald the adoption of Euro-American values. Photographic engravings and missionary testimonials about the conversion process were published in

overseas missionary newsletters and reports such as the *Methodist Mission-*
ary Recorder or the Anglican *Church Missionary Intelligencer.* For missionar-
ies the photograph recorded positive signs of social reform and reinforced
the myth that traditional ways were "vanishing." As historian Carolyn Marr
observes, "Catholic and Protestant missionaries were the first agents of di-
rected cultural change in this region and the photograph documented the
process."[17]

There were obviously different purposes intended for individual pho-
tographs, yet the distinctions between government and church-sponsored
photography of Indians are rarely discernable in the chaotic or subject cate-
gories of the photographic archives. Overall the meanings and function of
documentary photographs were inherently unstable because the context in
which a single photograph was placed consistently shifted—the photo-
graph might have originated with a government-sponsored inspection tour,
yet later have been marketed by the commercial photographer to an inde-
pendent author, or missionary, who placed the photograph in a personal
memoir of colonial life or missionary success. In other words, photogra-
phers often worked on dual fronts, in both official and commercial capaci-
ties, and the meanings assigned to any individual, but infinitely repro-
ducible, photograph fluctuated according to jurisdiction and function. The
growth of the international commerce for images of Native Americans, in
particular, generated a situation in which the Native American subject, cap-
tured by the Euro-American camera in the field or studio, possessed little
control over the final destination of his or her portrait because of the mar-
ket-driven motives of the photographer.

More than other photographs from this era and region, the generalized
images of Northwest Coast Indian life have sustained international cur-
rency as these images were, and remain, widely distributed across national
boundaries into the United States, eastern Canada, Britain, and Ger-
many.[18] The surge in the global commodification of depictions of North-
west Coast Native American life was rooted in two historically significant
circumstances: the introduction of organized tourism and the emergence of
professional anthropology. In 1880, the market for images of Indians diver-
sified with the tourist-driven fascination with the depiction of premodern,
or so-called traditional, Indian lifeways and customs. As commercial coastal
steamship tours between San Francisco and Alaska brought casual visitors
to the Northwest Coast, the appetite for the souvenir memento in the form
of a portable photograph or postcard was whetted. Local photographers un-
derstood the commercial value of these itinerant consumers who carried
mementos back home to a new audience, as Benjamin Leeson's Native
theme album demonstrates (fig. I.3).

In addition, the commodification of Indian life and bodies was also ig-
nited by the research activity of anthropologists who, like tourists, began to

I.2

FREDERICK DALLY ALBUM
"Photographic Views of BC 1867–1870"
British Columbia Archives
#G-03768

I.3
BENJAMIN LEESON
Illustration of the Leeson
Album, n.d.
Vancouver Public Library
#14024

arrive in the 1880s. The emergence of professional fieldwork in anthropology and the adoption of the camera as a tool for the visual preservation of vanishing customs intensified the incentives for the production of photographs of Indian life. By the 1890s anthropological interests widened the circle of consumption for ethnographic photographs, which were collected by educational facilities, museums, and private collectors. Commercial photographers like Hannah Maynard, Benjamin Leeson, and O. C. Hastings scrambled to fulfill this rising demand. Despite the official imperatives to assimilate, the images of "primitive" or unassimilated Indian life became the most enduring of all the documentary genres produced on the Northwest Coast during this time.

The interests of DIA Superintendent Powell, Leeson, and others before and after them were closely informed by a British, and Victorian, discourse on ethnographic and anthropological methods evidenced in the series of nineteenth-century guides written by prominent British ethnographers and anthropologists and published by the British Association for the Advancement of Science (BAAS). The BAAS guides, early on, systematized the methods and themes for the collection of data about Indians for colonial travelers, colonial officials, missionaries, and, by century's end, for professional anthropologists. The influence of the BAAS series in shaping popular and official perceptions in writing and photographs about Native Americans should not be underestimated. The first volume in the BAAS series, *Queries respecting the Human Race addressed to Travellers and Others* (1841), established the guidelines for scientific methods of enquiry for those who explored "exotic" lands. The subsequent edition, *Manual of Ethnological Enquiry Being a Series of Questions Concerning the Human Race* (1851), instructed those "seeking of facts, and not inferences; what is observed and not what is thought" and proved especially popular among British missionaries who ventured to foreign locations. By 1874, a more general guide was issued, entitled *Notes and Queries on Anthropology, or a Guide to Anthropological Research for the Use of Travellers and Others* (subsequent editions 1892, 1899), which was adopted as the standard handbook for British travelers.

These volumes inscribed standards for observation of indigenous subjects before the arrival of professional anthropologists late in the century. Ultimately, BAAS's goal was to "promote accurate anthropological observation on the part of travelers, and to enable those who are not anthropologists themselves to supply the information which is wanted for the scientific study of anthropology at home."[19] With instruction, travelers and colonial officials were cast as ethnographers in training, seeking and tallying data on traditional customs in the face of "the rapid extermination of savages." The rapidity of cultural change, as well as a shortage of trained professional anthropologists among the North American Indians, fueled the BAAS call for the documentation of disappearing indigenous customs and practices by in-

formed amateurs. Thus the series was premised on the notion that assimilation of indigenous peoples was inevitable. The plight of the Indians, it was believed, was dire given the "rapidity with which they are being reduced to the standard of European manners."[20] Recommending a combination of pictorial illustration and written observation, the guides included step-by-step instructions for taking photographs and collecting anthropometric measurements, a systematic gathering of the physical dimensions of human subjects. Divided thematically by topics including music, etymology, agriculture, slavery, relationships, burials, property, trade, money, marital relations, contact with civilized races, and so forth, the guides dictated the areas of investigation.[21]

By calling for a detailed recording of physical and natural "deformities" of indigenous peoples, such as "cranial alterations" or "incisions and other mutilations," BAAS initiated the study of the Indian body. Physical modifications such as the use of the labret by Haida women or head binding among the Quatsino Kwakwaka'wakw stimulated considerable investigative interest. In a section entitled "Anatomical Observations," the guidebook explained "the object of observations on the external formation of the body is to determine the differences which exist between human beings according to age, sex, race and the locality in which they reside." Travelers who collected photographs and observations on unique regional examples of physical modification were reminded to dispatch any "specimens, or papers, or records of observations included in the scope" of the guide to the Anthropological Institute in London.[22]

In the interests of consistency and scientific objectivity, BAAS provided travelers with explicit instructions on how to standardize the photographic depictions of "exotic" peoples, places, and flora. Consequently, the visual conventions employed to portray non-Euro-American individuals, most notably Indians and Asians, diverged from those applied to the portraits of settlers. Thus certain racially or culturally distinct residents were isolated by a collective, and unquestioned, adherence to these pictorial and descriptive conventions. The perception of a common identity among Euro-American settlers, despite ethnic and national distinctions, was strengthened by these uniform codes of race-segregated portraiture designated by the BAAS guides.

While directed by the strictly defined schemes of record keeping espoused by BAAS, the lack of experience and method of the amateur in the field ultimately led to questions concerning scientific detachment. Few visitors actually understood, much less spoke, the dialects used by the numerous diverse tribes along the Northwest Coast, and most travelers, like traders, relied on the jargon of Chinook, which moderately helped to overcome the variances in dialects and language groups. Without linguistic ex-

pertise amateur observers misunderstood culturally distinct practices and thus distorted the objectivity seen as desirable by BAAS. BAAS expressed a growing concern over the faults of the amateur observer when they declared, "the imperfection of our accounts of morals among savage and barbarous peoples is in great measure due to travellers supposing the particular system of morals in which they themselves were educated to be the absolute system."[23] Eventually the BAAS complained that very few colonial observers "place[d] themselves at the point of view of the particular tribe to understand its moral scheme."[24]

By 1913, the professional authors of *Notes and Queries* realized that much of the data accumulated by untrained amateurs, or by politically motivated civil servants, was ethnocentric, and the credibility of the untrained observer began to wane. Instead, the authors called for university-trained professionals armed with alternative methods of anthropological research, in which "the worker lives for a year or more among a community . . . and studies every detail of their life and culture; in which he comes to know every member of the community personally."[25] As early as the 1880s professional anthropologists such as George Mercer Dawson and Franz Boas began to conduct their own research, and their investigations, sponsored by private organizations and museums, represented yet another intensification of "exploration" or scrutiny of northwestern Native American culture and life. The changed methods and standards in anthropological observation put into operation in the early decades of the twentieth century were apparent in subsequent editions of *Notes and Queries* in 1912, 1929, and 1951.

The anthropological push to preserve evidence of Indian traditional culture began to generate change in the popular representation of Indians. By the late nineteenth century, an increasingly nostalgic, romantic view of Native American life gained popularity. Less visible in the public realm was a realistic or modern representation of Indian peoples, who, by this date, were in fact fully integrated into the coastal industrial economy as cannery or hopfield workers, fishers, urban dwellers, or political activists. The nostalgic vision fascinated tourists and anthropologists in ways that reality would not. Photographer Benjamin Leeson reflected on the consumer appetite for images of Indians unadulterated by modern life:

> When I came here, the general opinion . . . was that these Siwash Indians were too dirty and uninteresting to be worth the trouble and expense of photographing them; but a few experiments in that direction showed me that the dirt and odor were eliminated in the process and, for that reason perhaps, people seemed to find the photographs more interesting than the Indians themselves. The pictures have quite a little sale to tourists and others.[26]

A written request from Cambridge's Peabody Museum to Hannah Maynard for photographs of "natives in as primitive state as possible . . . for scientific purposes" confirmed that museum specialists also found value in depictions of Indians untainted by modernity.[27]

In response, Hannah Maynard and Benjamin Leeson used the technique of combining two negatives to create a vision of the Indian untouched by modernity. Hannah Maynard, for instance, combined the figure of a woman identified as Mary, originally taken in the studio between 1865 and 1866 (fig. I.4), with a negative of an exterior landscape and totems taken in the spring of 1884 by her husband, Richard Maynard, at Kayang, a Haida village in the Queen Charlotte Islands (fig. I.5). With this method of merging two, or more, photographs taken at disparate historical moments and distinct places, photographers were able to revitalize older images for the emergent appetite for romantic images. In the final illustration (fig. I.6) the figure of Mary was displaced from the original setting, a southern studio interior, and in the final version stood in front of a totem and big houses in the northern village. To the untrained eye—most commonly a tourist's—the final product seemed authentic, whereas in reality the trick effect of photomontage had been employed. By this act, the social implications of a northern Haida woman earning wages by washing for Euro-American settlers in urban Victoria were erased. The content of the revised portrait was more benign than the former, and it would appeal to the market of international consumers who were indifferent to the harsh impact of global industrialization or colonial expansion on Indian lives.

Benjamin Leeson also experimented with this composite technique, in which any number of negatives was combined. Leeson, who held permanent employment as a civil servant, specialized in depictions of the Kwakwaka'wakw families at the northern Vancouver Island village of Quatsino. As evident in "The Sunset of His Race" (fig. I.7), Leeson favored an intense and dramatic idiom of light contrasted with dark. A male silhouette stands against an ocean vista upon which a sun is setting.

Another pair of photographs reveal the staging Leeson undertook to create such composites. A group in European clothing, with a man sitting cross-legged at the center of the frame and a young boy standing at this man's shoulder, gathers on the wooden porch of a house. Draped cloth hanging from the porch roof re-creates the studio by blocking out exterior views and unwanted sunlight (fig. I.8). The second photograph shows Leeson's final image, with the assembly now clothed in traditional button blankets with small baskets or artifacts placed in front of them (fig. I.9). In the new portrait the group sits within the interior of a traditional cedar longhouse with a house pole looming behind the central male figure.

Leeson compositions such as "The Sunset of the Race" and the "Passing of the Legends" purposefully evoked a sense of longing and loss in

order to symbolize the inevitable cultural disappearance of his Indian sub
jects via assimilation, a topic Leeson had contemplated in published writ-
ings. "These Indians amongst whom I am located," Leeson mused, "are
gradually dying out, and they are, at the same time, giving up practically all
of their old customs and manners. With the passing of the present genera-
tion there will remain but little if any of the original Indian habits of life to
record."[28]

Leeson's belief that Native American cultural traditions were disappear-
ing strongly influenced his aesthetic decisions and figured prominently in
the captions and titles he composed for his photographs destined for a di-
verse market of tourists and anthropological professionals. He was aware
that the fabrications of photographs to show traditional "customs and man-
ners" of Indians benefited his sales. His representations of Indian life, like
Maynard's, targeted consumers who were unaware of the editorial decep-
tions, such as purposely distancing his pictorial subjects from the lived real-
ities of daily industrial or manual labor. While the photographs of "vanish-
ing" Indian customs and costume were most commonly associated with the
work of Edward Curtis, the U.S. photographer who accompanied the
Smithsonian-sponsored E. P. Harriman expedition along the coast to Alaska
in 1899, these themes were evident in the photographs both Maynard and
Leeson produced between 1880 and 1900.

While most frontier photographers on the Northwest Coast, like others
in the British Empire, embraced realism as a standard representational mode
for the depiction of their immediate surroundings, Maynard and Leeson
embraced trick effects, a practice commonly categorized as "art photogra-
phy." Art photography, as exemplified by montage or composite photo-
graphs, enabled the fabrication of meanings beyond the scope of documen-
tary realism. While the two genres of documentary and art photography
coexisted in the region during this era, the existence of art photographs
never seriously challenged the domination of documentary photography ex-
cept in the realm of ethnographic images of Indian life such as those pro-
duced by Maynard and Leeson. Although the photographs discussed above
were manipulated, they were regarded as truthful rather than constructed
romantic perceptions. Portrayals of Native Americans set within a preindus-
trial, premodern setting affirmed the conviction that traditional culture was
destined to disappear. Ultimately, when it comes to the visual archive of the
frontier, realism triumphed and the perception of the documentary photo-
graph as disinterested largely prevailed.

This study analyzes the photograph not only as historical evidence of
the process of colonial expansion but also as evidence of encounters be-
tween two culturally distinct groups. The settler experience of the north-
west coastal frontier represented not simply changes in the settlers' physical
environment but dramatic, as well as mundane, encounters with individu-

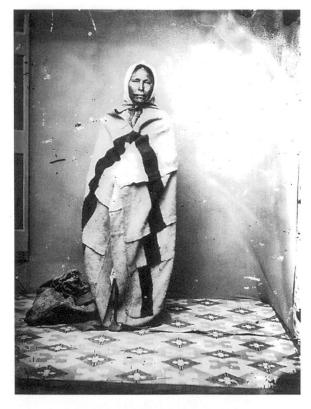

I.4
HANNAH MAYNARD
"Mary, Hannah Maynard's
Washerwoman," Victoria,
circa 1865–66
British Columbia Archives
#F-09011

I.5
RICHARD MAYNARD
Haida Village: Kayang Village,
Queen Charlotte Islands,
circa 1884
Courtesy of the Royal British
Columbia Museum
Anthropological Collections
Section #PN5697

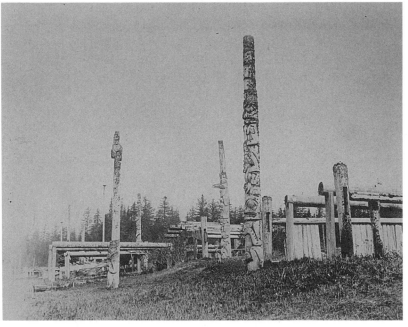

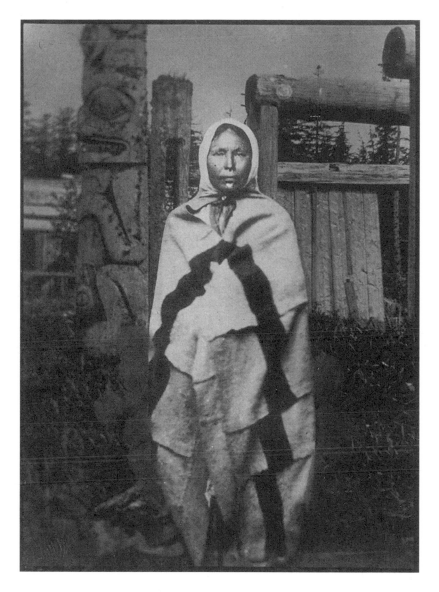

I.6

HANNAH MAYNARD
Haida Mary, composite
photograph with Kayang Village
background, circa 1885
Courtesy of the Royal British
Columbia Museum
Anthropological Collections
Section #PN5311

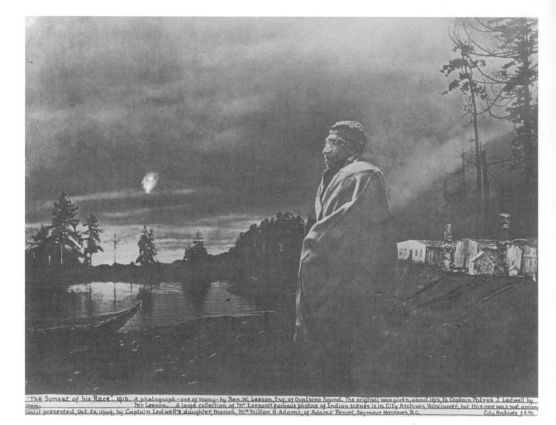

I.7

BENJAMIN LEESON
"The Sunset of His Race," 1913
Caption written by the City of Vancouver
Archivist Major J. Matthews,
Vancouver Public Library #14104

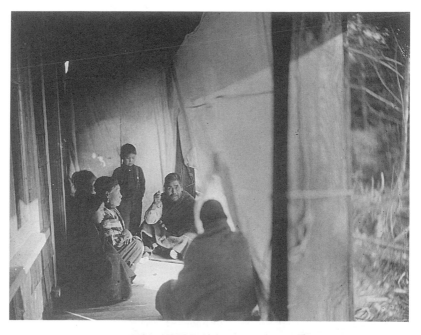

I.8

BENJAMIN LEESON
"Indian Patriarch and
Listeners," Quatsino,
circa 1900.
Vancouver Public Library
#14103

I.9

BENJAMIN LEESON
"Passing of the Legends,"
Quatsino, circa 1900.
Vancouver Public Library
#14062

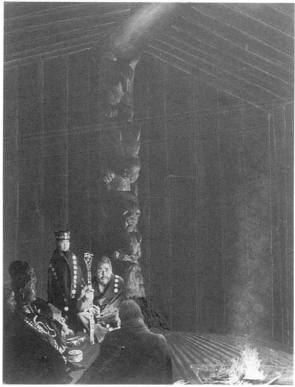

als from divergent cultures and value systems, most notably Native Americans. Literary theorist Mary Louise Pratt has conceptualized the frontier as a "contact zone," a social space where "disparate cultures meet, clash and grapple with each other in highly asymmetrical relations of domination and subordination," and this supposition suits the conception of the frontier as depicted by the camera.[29] Framing the photographic encounter as an asymmetrical relation of power imprinted with questionable ethics, theorist W. J. T. Mitchell wrote, "the 'taking' of human subjects by a photographer (or a writer) is a concrete social encounter, often between a damaged, victimized, and powerless individual and a relatively privileged observer, often acting as the 'eye of power,' the agent of some social, political, or journalistic institution."[30] To a large degree the supposition about the asymmetry of the photographic encounter accurately represents the relations between Euro-American photographers and indigenous peoples prior to 1900. Photographs of Northwest Coast Native Americans were commonly "stolen," or taken without permission, as bluntly admitted in the third (1899) edition of the BAAS guidebook. In *Notes and Queries,* the BAAS authors advised: "A snap-shot camera of some sort is quite indispensable as many incidents must be seized as they occur, and some people will not consent to be photographed so these must be taken instantaneously, and without their knowledge."[31] This asymmetry of power was present in many of the photographic interactions between Euro-Americans and Native Americans during the period when commercial photographers aggressively competed for business and when decisions regarding choices of subject matter were commandeered by official patronage and the speculative concerns of an expanding commercial marketplace.

The ethnographic photographs of Indian life thus promise a tangible glimpse into the asymmetries of power among colonial subjects and, certainly, a great number of photographs from Vancouver Island and the Northwest Coast prior to 1890 reflect the fundamental inequalities of the frontier encounter in which Euro-American values triumphed. Nonetheless, this uneven vision is not the only one represented in historical photographs. Fragmentary evidence of the Native American consumption of photography beginning in 1862 underscores three crucial points: first, that Native Americans as agents in the protoindustrial and industrializing regional economy were, in fact, collectors of photographs; second, that the photographic encounter in which the Euro-American commonly wielded the camera was not wholly one-sided; and finally, and against conventional interpretation, Native Americans were not uniformly in awe or fearful of the camera but rather employed photography for unique cultural purposes. Alternative uses of photographic technology by indigenous people can be glimpsed from diaries, private papers, and official documents, showing that Native American resistance to being photographed was not so much fear as

an assertion of rights over the representation of self and territory. From 1862 on, individual Native Americans collected and commissioned photographs of self and kin, often incorporating the codes of representation and respectability designated for the settler. Clearly, by the 1890s, wealthier individuals and families had embraced photography not only for the purpose of generating positive self-representations but also for culturally unique purposes, including the commemoration of departed ancestors at specific rituals such as naming ceremonies. Prevailing conventions upheld by colonial values were at times challenged, and at other times strategically adopted, by indigenous people themselves who, with wages earned in the economy imported by Euro-American settlers, commissioned alternative, modern representations of the self and family.

This book considers these divergent, often conflicting, applications of photography within the contested milieu of settlement. Although this is a regional study of vested interests in photography, the questions posed about the political significance of photography to the process of colonial settlement may easily extend to other colonial or regional settings.[32] Further, the book exceeds the study of the colonial gaze to consider how those so frequently the subjects of the camera—indigenous North Americans—themselves collected, commissioned, and enlisted photography in opposition to, or conformity with, dominant representation.

By endeavoring to understand how a group or genre of photographs invented truths about Indians or settlers that went unchallenged, this book agrees with other scholars who reject the simplistic equation between truth and the photograph.[33] Instead the goal for historians is to uncover how a set of photographs produced in a confined setting fashions "truths" about places and people. As David Green holds, photographs are manufactured or constructed renderings that repeat certain pictorial and technical conventions to generate a self-referential domain.[34] In the isolation of a colonial setting, this loop of self-referentiality proves more difficult to disable, as viewers beyond the colony possessed few means to test the accuracy of the depictions or the claims made about the region and its people.

Further, historians who use photographs must confront the implications of the photographic caption and the meanings it imposes. As Roland Barthes reflects, the written caption tended to marshal authority over visual meaning: "It is not the image which comes to elucidate or 'realize' the text, but the latter which comes to sublimate or rationalize the image . . . today, the text loads the image, burdening it with a culture, a moral, an imagination."[35] The political implication of this exchange, whereby allegations made in a caption animated the image, was intensified when the power relationship between the photographer and the subject was unequal. Whereas the dominant culture, which held the means of production and the political privileges to wield authority, continually made assertions about the status

and condition of Indians, indigenous peoples initially lacked equal access to the same means of self-representation.

Logocentrism, the privileging of linguistic over visual content, was apparent within the cultural and social contests on the frontier. Indigenous residents relied on the oral transmission of knowledge, culture, and meaning and therefore found themselves at a distinct disadvantage in light of meanings manufactured about them. The captions assigned to photographs heightened the authority of statements made about colonial existence, and these, like the photographs, were repetitively circulated in government brochures and emigrant guides promoting settlement overseas. Obviously, distant readers had little recourse to confirm or contest these reports. While the adjoining text or caption promised to amplify the meaning of the image, it also possessed the capacity to misrepresent. The complex dynamic struck between the caption and the image seen in the numerous photographs used to promote and represent colonial settlement makes the relationship a necessary component of historical analysis. Historical photographs do not merely illustrate the past; they encode relationships of inequity among and between groups.

This book concentrates on the motivations of government, commercial entrepreneurs, missionaries, and indigenous people toward the manufacture of what I call the photographic frontier. Chapter 1 sketches the preindustrial background of early trade and contact relations between Euro-Americans and the Wakashan-speaking Nuu-chah-nulth, on the northwestern coast of Vancouver Island, with whom earliest contact was made. Chapter 2 analyzes the shared sensibilities, common interests, and dissenting views of the primarily male commercial photographers who produced the photographic illustrations of settlers, civic architecture, and colonial infrastructure that pervade the public archives. Hannah Maynard, the earliest female professional commercial photographer on the Northwest Coast, was exceptional in numerous ways. Yet despite her unconventionality and gender-bending acts, such as her contract as Victoria's first police photographer between 1897 and 1903, Maynard's political views were not dissonant from those of her male contemporaries, with whom she shared similar economic and social status as a business merchant. For the most part continuity existed across the photographs produced by the earliest Euro-American photographers, male and female.

Chapter 3 uses the images of two female Tsimshian Methodist converts—Elizabeth Diex (photographed by Stephen Spencer) and Victoria Young (photographed by Richard Maynard)—to exemplify the pedagogical use of the camera and photography by missionaries who tried to prove the efficacy of their contributions toward Indian conversion and acculturation. The category of the "good," or in the missionary case, "reformed," Indian was consistently invoked as the ideal model (in contrast to the bad or resist-

ant Indian). Honorific portraits like those of Diex and Young propagandized the positive impact of religious re-education schemes. Indigenous women bore the brunt of the pressure to assimilate and the reform of female converts like Diex and Young was fueled by the promise of new forms of social status afforded by conversion and assimilation.[36]

Missionaries, moreover, made innovations in religious pedagogy by using the photographic device of the magic lantern slide show to lure and win over converts in relatively isolated villages, like at Clayoquot Sound, where sectarian competition for converts among Catholics and Protestants was fierce. The missionaries' conscious employment of photography alternatively as magic and as science demonstrates how fluid the meanings and functions of photography were in the colonial setting. Among Native American audiences the magic lantern was biblical entertainment, whereas among urban congregations presentations of convert portraits were used as evidence of evangelical success and to solicit financial and moral support. Although missionaries and government Indian agents frequently came into conflict over such issues as indigenous land rights, the Department of Indian Affairs financially and ideologically supported the goals of missionary education. But to sustain government economic support, missionaries had to prove their presence brought results. The photographs of converts served this purpose.

Chapter 4 reviews the jaundiced perceptions of Native American women expressed by travelers, civil servants, and settlers from exploration onward in order to establish the reason why these women became primary targets for condemnation. Stereotypes established early on set the tone for more formal policies instituted by public officials and social reformers after 1869. As Valerie Moghadam has determined in her analysis of women and colonial politics, "women frequently become the sign or marker of political goals and of cultural identity during processes of revolution and state building, and when power is being contested or reproduced."[37] Clearly the assertions that Native American women were morally inferior relative to Euro-American women was part of the colonial rhetoric arguing that tangible racial difference existed between settlers and Indians. Upholding Western models of femininity as the ideal, missionaries and policy makers extended special attention to domesticating Native American women. The irreconcilability of customary Native American culture and identity with settler society was central to the beliefs and actions of missionaries and of federal Indian agents, both of whom proposed total assimilation as the bridge across incomparable value systems.

The phenomenon of colonial feminism, whereby one group of women distinguished themselves from women of other cultures "in the service of colonialism," was operative here.[38] In diaries and memoirs, settler women envisioned themselves as civilizers and gentle tamers in aid of the new na-

tion. Beginning in the 1880s, studio photographs of babies and family groups espoused the maternal worth of the female settler. Hannah Maynard cornered this market with her specialty studio portraits, called *Gems of British Columbia*, that constructed an ever expanding vista of mostly Caucasian babies and children. The baby's picture—a genre generally dismissed as sentimentality in conventional histories of photography—celebrated the fecundity of Euro-American women alone, foreshadowing the idiom and tactics of feminist maternalism that blossomed at century's end when the struggle for (Caucasian) women's franchise intensified. By situating the reproductive labor of Euro-American women at the center of public vision, the baby photographs helped settler women to manufacture their own, seemingly oblique, route toward social and political influence on a frontier dominated by men.

The final chapter shifts the analysis away from a preoccupation with the Euro-American scrutiny and generalized objectification of the Native American body and life, dealing instead with how the spectator or consumer actively participated in the construction of meaning of the photographic image in a manner beyond the original intentions of the photographer. As Barthes posits, the photograph is "not only perceived, received, it is *read,* connected more or less consciously by the public that consumes it to a traditional stock of signs." In other words, the meanings of photographs were reliant on a specific communal context intelligible to a local audience that consumed them within a particular historical moment. The signs, according to Barthes, were "gestures, attitudes, expressions, colors or effects, endowed with certain meanings by virtue of the practice of a certain society."[39] By reconstructing the situated knowledge of the spectator or consumer—in this case, individual Native Americans who collected or commissioned photographs—it is possible to reconnect the historical photograph to the web of social, cultural, and political relations in which it was produced, interpreted, and subsequently distributed.

The greatest reward for retrieving evidence of indigenous responses to photography is the recognition that culturally divergent uses did occur, and these uses conflicted with the dominant values invested in the photograph by commercial entrepreneurs, government agents, missionaries, and tourists. Photographic theorist John Berger distinguished between private and public uses of photography, suggesting that private photographs were less alienated from their context of production and reception, whereas the photograph destined for public view constituted "a seized set of appearances, which has nothing to do with us, its readers, or with the original meaning of the event. It offers information but information severed from all lived experience."[40] As distinguished by Berger, the photographic archives of the Northwest Coast generated by Euro-American settlers with cameras split into two spheres of public and private use. The majority of photo-

graphs were commercially produced and officially approved; they repro-
duce popular myths about Indians and espouse settlement as progressive. A
smaller number of photographs, only incidentally found in public collec-
tions, were commissioned by individual Indian people and intended for
private consumption. The contradictions seen in the latter serve to illumi-
nate the conformity of the former. Therefore, we should not restrict our
photographic research to public repositories, as we may fail to notice alter-
native, radical views of Indian life and modernization made visible in im-
ages produced for domestic consumption. Chapter 5 considers photographs
privately commissioned by local individuals and families in the nineteenth
century as they retaliated against the prevailing negative public and official
representations of Indians.

 By representing a decipherable pattern of places and populations, pho-
tographs manifest colonial habits, systematically tracing where the new-
comers went and with whom commercial negotiations and social interac-
tions were undertaken. The photographs of Indians and Indian life taken by
outsiders are less dynamic and appear remarkably static. We fail to detect
Native American input into the negotiations of the photographic event, as
the photographic frontier became a totalizing mechanism that ultimately
served the goals, interests, and aspirations of those individuals and bureau-
cracies who held power. With their power and status diminished, indige-
nous residents were unable to effectively challenge the monocultural model
of settlement idealized by colonists. That challenge has since passed into the
worthy hands of contemporary generations of Native American artists,
scholars, and educators.[41]

"The Natural Habitat of the Anglo Saxon upon the Pacific Ocean"

COLONIZING

VANCOUVER

ISLAND

Before the European competition for maritime trade and, later, for territory, the Northwest Coast was inhabited by large populations of linguistically diverse coastal peoples who sustained intertribal trade and thrived on the abundance of the sea, land, and forest. The earliest contact with Europeans occurred at Nootka Sound on the northwestern shore of Vancouver Island in August 1774, with an expedition lead by the Mallorcan captain Juan Pérez, who sailed the *Santiago* along Vancouver Island and to the Queen Charlotte Islands. At Nootka Sound the *Santiago* was approached by 150 men, in twenty-one canoes, who boarded the ship and exchanged gifts with the sailors.[1] Due to a lack of adequate supplies and outbreaks of scurvy, the *Santiago*'s stay was brief.[2] Four years later, in March 1778, the British ships *Resolution* and *Discovery,* under the command of Captain James Cook, arrived at Nootka Sound. Cook anchored at Friendly Cove (also known as Yuquot or as Yuquatl) where he remained for a month-long visit.[3] Cook, according to eighteenth-century Spanish botanist José Moziña, traded sea otter furs in exchange for copper, knives, fishhooks, glass beads, and other "trifles."[4] From this visit it is said that Cook was the first to realize the commercial potential of furs on the Northwest Coast.[5] A decade later, Captain John Meares arrived in Nootka Sound on May 13, 1788, with the British *Nootka* and the *Sea Otter* and a mission to acquire furs for Canton markets. During this initial trip Meares, his men, and local Natives built a structure "sufficiently spacious to contain all the party intended to be left in the Sound." The structure was to provide cover for the building of sloops to be

used for ongoing local trade and had "ample room for the coopers, sail makers and other artisans to work in bad weather."[6] In September 1788, the first U.S.-based trading ship entered the competitive fray as the Boston-registered ship *Lady Washington,* headed by Captain Robert Gray, landed at Nootka Sound. John Kendrick, also a "Boston man," in command of the *Columbia Rediviva,* followed in 1789 gaining his reputation from trading ten muskets and gunshot powder for harbor land in Nootkan Chief Maquinna's territory.[7] By 1789, both Spain and Britain claimed military and economic interest in the territory. This dispute continued unabated for five years until Spain ceded all territorial claims to Britain.[8] With the relinquishment of Spanish claims, finalized by the Nootka Treaty signed in Madrid on January 11, 1794, the sovereign possession of Nootka Sound and the sum of Vancouver Island passed into the hands of British administrators.[9]

The interest in Nootka Sound was not merely political or commercial. With international exploration came scientific investigation.[10] Each European incursion into indigenous territory resulted in written records, many of which combine ethnography with botany, zoology, astronomy, and cartography. All offer our earliest written impressions of the sophisticated, Wakashan-speaking Mowachaht confederacy.[11] One of the most compelling and lush accounts was *Noticias de Nutka,* written by Spanish botanist José Mariaño Moziño Suarez de Figueroa, a member of Juan Francisco de la Bodega y Quadra's Nootka Sound expedition of April 1792 charged with resolving the Spanish/British conflict over Nootka territory.[12] Members of the Spanish expedition, combining military reconciliation with scientific exploration, were instructed to "draw up, in consort with the English, a geographic chart [of the coast] from the Strait of Juan de Fuca to the Port of San Francisco of New California . . . and to observe the various items that nature might present in these new discoveries."[13]

Between April and September, Moziño assessed the verdant density of the forest beyond the craggy beaches, the fertility of the soil, and the diversity and abundance of fresh and saltwater fish, including sole, salmon, cod, sardines, and squid. Artist Don Atanasio Echeverria "sketched general scenes and made numerous botanical and zoological plates to accompany Moziño's descriptions."[14] Having learned regional languages, Moziño compiled a catalog of animals and plants and a brief dictionary of Nootka terms, which he appended to his manuscript.[15] The possibility for economic development and colonial settlement preoccupied Moziño, as he estimated the agricultural potential of the land for the cultivation of wheat and the sustainability of small livestock. After observing mineral veins of copper, iron, lead, and silver, he recommended an expanded, systematic analysis of the rock.[16]

The sophistication of the culture of the Native inhabitants, the coastal Mowachaht, obviously impressed Moziño. He reported that they wore gar-

ments sturdily woven from a combination of cedar fibers and mountain-goat wool, the latter a product of a well-established intertribal trade network with the Nimpkish Kwakiutl who resided at Vancouver Island's northerly Cape Cook at Quatsino Sound. Moreover, Moziño noted, the embellishment of cedar garments signified internal class divisions as the capes of wealthier, highly ranked individuals were trimmed with fur borders of otter skin or, in the case of Chief Maquinna, with mink or marten.[17] The Mowachaht made frequent use not only of cedar stripping for the fashioning of capes, conical hats, and aprons, but also of an extensive range of animal hides such as bear, badger, raccoon, weasel, and deerskin.

As for their housing, Moziño observed substantial, permanent, red and yellow cedar plank and beam dwellings decorated with intricately carved human figures. The interiors of the large plank houses were compartmentalized into communal areas and partitioned sleeping platforms, the latter furnished with woven cedar mats. Precisely formed, interlocking cedar "bent" storage boxes, decorated with paint and inlaid with animal teeth, contained precious belongings, garments, and masks used for ritual occasions. Moziño described a resplendent array of summer, ocean, and freshwater harvests suspended from interior beams including sardines (smelts), shellfish, bladders filled with whale oil, and snails. Much to his distaste, the labor-intensive processing and smoking of these foodstuffs, conducted by women, took place within the interior of the big house. Utensils were minimal but wooden tongs and buckets were employed for the boiling and roasting of fish, and wooden bowls and abalone shells served as eating platters.[18]

While freshwater fish, saltwater fish, and shellfish were the principal foodstuff for coastal dwelling peoples, the diet was further diversified with other provisions gathered during the summer months, including multiple species of blackberries, huckleberries, blueberries, strawberries, currants, madrona berries, crabapples, wild pears, and the tender roots of trailing clover, as well as angelica, silverweed, and the *kamchatka* lily. Certain European items were incorporated into the local diet, such as beer, brandy, and wine, bread, coffee, tea, chocolate, and brown sugar.[19]

The spiritual, governmental, and social structures of the Mowachaht were complex. Moziño, for example, mentioned an annual calendar in which seasonal scarcities or abundances of food determined corresponding monthly tasks. He also reflected on the developed networks of intertribal trade, the existence of polygamy, commercial relations established through marriage, women's conventional occupations and the prostitution of lower-ranked women, the rituals of naming ceremonies, puberty rites, and periods of segregation for girls. An internal hierarchy of class, or social standing, wherein commoners, or slaves, were distinguished from those possessing higher rank, was apparent. He noted the expansive scale of terri-

torial holdings and fishing sites held by those of property and rank. For instance, Chief Maquinna, his brothers, and their wives seasonally traversed a series of villages beginning north at Cape Cook and scattered intermittently every two or three miles.[20] Despite the ranked nature of Mowachaht society, Moziño also remarked on the cooperative distribution of goods and provisions among others less endowed. As he reflected, "One does not see here greed for another man's wealth, because articles of prime necessity are very few and all are common . . . in addition to the fact that they are very abstemious in their meals, everyone can partake indiscriminately of the fish or seafood he needs, and with the greatest liberty, in the house of the tais [highest ranking chief]."[21] Moziño's methodical and nonjudgmental account, perhaps better than others, illustrated a self-sufficient erudite, organized culture that existed prior to European settlement. Yet, surprisingly, settlers would characterize the Nuu-chah-nulth of Nootka Sound as "savage" or "uncivilized."

Governing Vancouver Island, 1846–1871

Although international maritime rivalries had subsided by the end of the eighteenth century, Vancouver Island continued to be an arena of concentrated outsider activity with the founding in 1843 of Fort Victoria at the southern tip of the island. The fort was operated by the Hudson's Bay Company (HBC).[22] Located 750 miles north of San Francisco and 30 miles from Port Townsend in Washington Territory, Fort Victoria replaced Fort Vancouver, on the Columbia River, as the northern locus and the center of British colonial interests, maritime traffic, and HBC commerce.[23] Since 1809, HBC had operated trading forts in the jointly occupied U.S./British Oregon territory and, by 1821, had absorbed its competitor, the Montreal-based North West Company. By 1845, the expansionist ambitions of the presidential administration of James Polk harmonized with those of American settlers south of the Columbia River who, invoking the call of "manifest destiny," threatened to take possession of HBC lands and forts in Oregon territory.[24] The dispute was settled by the Oregon Treaty of 1846, known as the Washington Treaty in the United States, which secured the political boundary at the forty-ninth parallel along a topographical line stretching from the Strait of Juan de Fuca to the eastern limits of the Rocky Mountains.

Although the boundary demarcated the political division between U.S. territories to the south and the British colonies of Vancouver Island and British Columbia south of the Russian Alaska frontier of 54'40", twelve years later the annexation worries of local and London authorities was reawakened by the regional gold discoveries of 1858.[25] Official concern over

the increasing American presence was tangible, for instance, in the following comment made by Charles Wilson, secretary of the British Boundary Commission:

> If the majority of the immigrants [into the interior to the Fraser River] be American, there will always be a hankering in their minds after annexation to the United States, and with the aid of their countrymen in Oregon and California at hand, they will never cordially submit to British rule, nor possesses the loyal feelings of British subjects . . . as to the course of policy that ought in the present circumstances . . . be taken . . . I would simply recommend that a small naval or military force should be placed at the disposal of the Government to enable us to maintain the peace and to enforce obedience to the law.[26]

Regulations initiated during the years of colonial administration prior to 1871 consistently arose from British apprehensions over the potential annexation of territory, a fear that had been corroborated by the U.S. military occupation of the San Juan Islands south of Victoria in 1859.[27] Recognizing a need for security against U.S. encroachment, the colonial authorities introduced a military presence into the region, including the Royal Navy, the Royal Marines, and the Royal Engineers, the latter conducting the British North American boundary survey between 1858 and 1861.[28]

Bringing additional British residents to the colonies was an additional means to protect against annexation. The mandate for settled occupation of the colony was placed in the hands of the Hudson's Bay Company and set by the Charter of Grant of 1849. The grant stipulated that the HBC had to establish a colony of settlers on Vancouver Island and sell land at a reasonable cost; if they failed to do so within five years the British government would resume possession of the island.[29] Unfortunately the company's head office in London, at the recommendation of the colonial office, advocated for the Wakefield system of land dispersal and development, which imposed onerous eligibility criteria, including a charge of a pound per acre and a formidable labor clause.[30] As a result, the scheme impeded rather than encouraged diverse settlement. The obstacles set by the Wakefield system had to be overcome by local company administrators before settlement could flourish. Hoping to encourage the presence of working men, the company's agrarian affiliate, the Puget Sound Agricultural Company, imported laborers, on five-year indentures, to work on the four company farms located near Fort Victoria, with a promise of free land after the term of indenture was fulfilled.[31] In sum, company interests toward the expansion of agrarianism and mercantile commerce awkwardly coexisted with British legal and military directives administered from London. Between 1849 and 1851, re-

sponsibility for a stable administration and oversight of the terms of the charter fell to Fort Victoria's chief factor, James Douglas, who reported to the governor and committee of the HBC in London. Douglas (1803–1866) was of mixed ancestry, with a mother from British Guiana and a Scottish father. He governed Vancouver Island between 1851 and 1863 and the united province of British Columbia (which combined the two colonies of British Columbia and Vancouver Island as a province) between 1858 and 1864.[32] Douglas's mulatto identity, along with his marriage to Amelia Connolly, a woman of Cree/Irish ancestry, has led to retrospective speculation that his administrative treatment of Indians and a group of eight hundred free African Americans who immigrated to Vancouver Island from California in 1858 was conducted with exceptional compassion.[33] The respectful treatment of Indians and African Americans eroded after his retirement.

While the 1858 gold rush stimulated an initial bulge in male population, on the whole agrarian and commercially based settlement progressed slowly. As one local medical practitioner retrospectively remarked, "All . . . agreed that the one thing wanted, was 'settlers' and to this end the removal of all obstructions such as the high price of land, and conditions of settlement . . . but they did not realize the expense and difficulty of travellers getting here."[34] Ultimately the success of the colony was seen as dependent on the construction of an infrastructure of roads, bridges, agricultural farms, schools, and adequate civil defence.[35] Similarly, settlement in the even more remote districts of the Island's west coast, the northern mainland coast, and in villages on the northerly Queen Charlotte Islands depended heavily on government incentives, in the form of the wharves and other infrastructure. Although grazing land suitable for ranching was available in the mainland interior, agrarian activity, particularly along the coast and on the gulf islands, was less tenable largely because the terrain was rough and accessible only by water.[36]

Sustained interest in these less accessible, seemingly uninhabitable locales was stimulated by the discovery and extraction of nonagrarian resources such as salmon, other fresh and saltwater fish, lumber, coal, gold, quartz, and anthracite. Thus, the administrative impetus to open districts beyond the increasingly urban southern settlements of Victoria and Nanaimo on southern Vancouver Island rested on the discovery and commercial potential of extractable resources. In March 1862, the comments of Governor James Douglas clarified the crucial connections between the growth of the settled population, geological discoveries, nonrenewable resources, civic development, and the necessity for government, hence imperial, incentives:

> The geological formations of Vancouver Island, and the recent discoveries of Copper Ore in Barclay Sound, and other places, having

given rise to a high degree of confidence in the mineral resources of
the Colony, I recommend you to consider whether it would be ex-
pedient to investigate the character, and extent of those resources,
in different parts of the colony. As it is evident that persons in-
tending to settle on the Waste lands of the Crown, would derive
mutual Aid, and support, and many other advantages, from acting
in concert, and combining together in the occupation of land, I
propose that suitable Districts should be surveyed in different
parts of the Colony, and Roads therefrom opened to convenient
points upon the coast, from whence produce may be transported
by water: and as an attractive inducement to settlers, that they
should be allowed the option of paying for their lands by their
labour on these roads. Such a measure will, I conceive, have the ef-
fect of advancing the progress of the Colony, and developing its
agricultural, and mineral resources.[37]

With the assumption of the joint governorship of Vancouver Island and
mainland British Columbia, a position he held until his retirement in 1864,
Douglas was no longer accountable to the Hudson's Bay Company, but in-
stead to the British Office of the Secretary of State for the Colonies.[38] Dou-
glas managed a cadre of civil servants, many of whom were former employ-
ees of the hierarchical Company. His measured approach to the tasks crucial
to settlement has allowed Douglas to be idealized as the father hero of the
British Northwest who single-handedly brought law and order to the chaos
of the gold-crazed colonies.[39]

In 1871, the era of British imperial external rule concluded with the uni-
fication of the two colonies of Vancouver Island and British Columbia with
the Dominion of Canada's Terms of Union. British Columbia was lured
into confederation by the promise of a western link to the transnational rail-
way system. Some vociferously argued against unification with the Domin-
ion, favoring continued association with southern neighbors since com-
merce between Victoria and various southern U.S. ports, such as San
Francisco, had been, in the opinion of many of the colony's merchants, in-
dispensable to the economic survival of the British colonies.[40] Overall,
however, the merchants and government on Vancouver Island feared being
overrun by the commercial vigor of the United States. The confedera-
tionists triumphed.

The railway, a significant feature of Canadian Prime Minister John A.
MacDonald's National Plan, was an incentive for increased westward mi-
gration, offering feasible overland transportation between the eastern port
cities and the undersettled western prairies and Pacific province across the
formidable barrier of the western Rocky Mountain range. Immigrants to
the Northwest Coast province of British Columbia would no longer travel

by train across the Isthmus of Panama and north via steamship, or overland via U.S. railroads, as was the standard immigration route prior to 1886.[41] Ultimately the national railway sharpened British Columbia's social and political attachments to the Dominion and greatly facilitated westward continental expansionism.[42]

Gold

Before established settlement, trading relations between Native Americans and Euro-Americans had, to a certain degree, been mutually beneficial, but this changed when the commodity sought after was gold, not furs or salmon.[43] The disputes over the rightful entitlement to gold between 1850 and 1858 anticipated future conflicts over territory and were fraught with violence, as the contest, after all, involved large and precious stakes. The prospect of precious metals, especially the discoveries of 1858, accelerated the in migration of Euro-Americans, many of whom were freewheeling speculators and fortune seekers with little respect for Native American claims to resources or land.

According to British naval officer Richard Mayne, gold formed the basis of discreet mercantile transactions between the HBC traders and regional Indians long before the well-publicized discoveries on the Fraser River in 1858. In fact, the earliest discoveries of gold in the region were attributed to the Haida Indians resident on the Queen Charlotte Islands.[44] As one traveler recalled, "The existence of the precious metal in Queen Charlotte's Island and British Columbia had been known to the company for several years before this period. The Indians had been accustomed to offer quantities of this product at the fur-trading establishments, in exchange for articles of food and clothing."[45]

After 1856, the Indian monopoly over gold, and the territory on which it was discovered, was distinctly threatened. If any prior harmony had existed, by this date it began to evaporate. As news of gold discoveries began to reach beyond the region, Indian resistance to Euro-American miners intensified. As Governor James Douglas recollected, "The few white men who passed the winter at the diggings, chiefly retired servants of the Hudson's Bay Company . . . were obstructed by the natives in all their attempts to search for gold."[46] On the northern islands, the Haida quickly "realized how much the miners were taking, they were afraid they would be left on the losing end . . . after all this was their land."[47] It was not only rights to gold and the gold trade that were threatened. Gold seekers physically trespassed on traditional berry and fishing sites, igniting friction between the miners and the Indians and leading to violent retaliation.[48] Incidents of sabotage were noted by chief trader W. H. McNeill of an HBC expedition:

> We were obliged to leave off blasting, and quit the place for Fort
> Simpson, on account of the annoyance we experienced from the
> natives . . . when they saw us blasting and turning out the gold in
> such large quantities, they became excited and commenced depre-
> dations on us, stealing the tools, and taking at least one-half of the
> gold that was thrown out by the blast. They would lie concealed
> until the report was heard, and then make a rush for the gold; a
> regular scramble between them and our men would then take
> place; they would take our men by the legs, and hold them away
> from the gold. Some blows were struck on these occasions. The In-
> dians drew their knives on our men often.[49]

With the influx of U.S. miners, uniformly perceived as being particularly
disrespectful of Native American rights, competition in the Fraser River
gold fields brought reports "of men being murdered by the Indians and af-
frays among themselves."[50]

It was this atmosphere of escalating agitation Governor Douglas had
to contend with and monitor. Unlike many, he was sympathetic to the
need for the protection of Indian resource and land-based rights. In a letter
to the British Colonial Secretary on July 15, 1857, he commented that the
Indians were driven not only by the desire to monopolize the gold but also
by "a well-founded impression that the shoals of salmon which annually
ascend those rivers and furnish the principal food of the inhabitants . . .
will be driven off and prevented from making their annual migrations
from the sea."[51]

The mixed economy of fur trade and gold mining was followed by the
permanent expropriation of large tracts of land by settlers. Prior to the
marking of formal boundaries of Coast Salish land reserves in the district of
Cowichan on southern Vancouver Island, one hundred settlers were in-
structed to go about the business of claiming land preemptions near Indian
villages "in such a manner as is not likely to lead to any misunderstanding
or difficulty with the Indians."[52] Concepts of property entitlement intro-
duced by settlement were ultimately detrimental to Native American ances-
tral territorial rights and usage. In 1863, botanist Robert Brown acknowl-
edged the elusive standards with respect to indigenous rights:

> There is continually an empty boast that they are British subjects,
> but yet have none of the privileges or the rights of one. Their lands
> have never been paid for in these districts at least. They are not
> taxed nor yet vote. They are confined in their villages to certain
> places. Nor are any means taken to protect their rights of fishing
> and hunting and yet if an Indian kills another in obedience to their
> laws of chivalry and right he is immediately taken up to Victoria.[53]

After 1868, Indian resistance was subdued by the implementation of local government policies and policing. As Brown accurately reflected, the introduction of Euro-American schemes of law, order, and policing displaced the culturally distinct systems of tribal law.[54] With British Columbia's entry into the union with Canada, "the charge of the Indians, and the trusteeship and management of the Lands reserved for their use and benefit" fell to the Dominion government.[55] In 1868, the Dominion's *Act Providing for the Organisation of the Department of the Secretary of State of Canada, and for the Management of Indian and Ordinance Lands* authorized the creation of the Department of Indian Affairs (DIA) with the status and actions of Indians regulated by the ever mutating legislative policies of the Indian Act. This legislation was administered by federal civil servants based in Ottawa, and an administrative hierarchy of individual Indian agents appointed to western districts. Divisions between settlers and Indians progressively widened. In 1869, the publisher of Victoria's popular city directory, Edward Mallandaine, qualified British Columbia's entry into the Dominion by stressing the social and political boundaries between the two constituencies of Indians and Euro-Americans. Mallandaine called for "an intelligible and fixed Indian policy by which the natives would know what would be done with and to them."[56] His comments revealed that the notion of cultural difference between Indians and settlers now saturated public discourse. Settlers, missionaries, and the DIA agreed that Indians required isolation on land reserves—reservations—where they would be protected from urban-based temptations.

Localized resistance to the exploitation of resources and land by miners and settlers constituted an early, albeit unorganized, assertion of Native American rights, and these early disputes show that Indians were acutely aware that the forces of colonial expansionism needed to be stopped. By 1888, a government report observed the uneven acceptance of regional federal Indian agents by Indians in addition to tribal resistance to the Indian Act.[57] And by 1907, full-fledged organized intertribal resistance was decisively initiated by the formation of the Nisga'a Land Committee.[58] Nonetheless, the designation of Indian reserves, government sponsorship of Royal Navy military gunboats to patrol coastal villages, and evangelical efforts to reform the Indians united to diminish instances of pan-Indian activism.

With the federal commitment to increasing permanent settlement, the culture of the northwestern frontier decisively shifted in favor of the immigrant settler. Indians necessarily adapted by incorporating manual and, after 1870, industrial labor into their seasonal regime of fishing, whaling, and hunting. Sadly, the increased presence of bachelor miners also brought a corresponding incidence of northern Haida and Tsimshian women involved in an informal and less morally acceptable sector of the labor market:

sexual commerce. This commerce resulted in the spread of sexually trans-
mitted diseases as well as a broad and lasting public condemnation of inter-
racial relations. The development of relationships with miners, bounded
settlement, mercantilism, and waged labor indelibly reorganized the sea-
sonally based, cyclical habits of territorial land and resource use and gender
complementarities that had characterized quotidian coastal tribal life and
trade prior to 1849.

Chinese Immigration

Euro-American miners who had fought with Native Americans over gold
also faced formidable competition from a third party: the Chinese.
With the arrival of Chinese miners and merchants to the bars of the Fraser
River, or Gold Mountain, as Chinese newcomers called it, in search of im-
proved fortunes, the racial profile of labor relations on the British north-
western coast was transformed. The Northwest's economic link to Asia was
significant but not readily admitted. In the eighteenth century, maritime
trade was fueled by a lucrative Canton market for otter skins. While the
ready supply of Chinese labor for mines and private households profited
wealthy Euro-American industrialists and settlers, Chinese competition for
low waged labor and gold also stimulated organized retaliation from non-
Asian workers.[59] As an early settler and former surveyor general claimed,
"When the Chinese first came to British Columbia their advent was hailed
by all employers of labour. . . . they supplied a want deeply felt by all house-
holders. They were found invaluable in the coalmines, in the fisheries when
established and in the sawmills. . . . the agitation against the Chinese has
been almost coeval with their arrival. It was begun, and has been carried for-
ward, chiefly by politicians who have sought the suffrages of the labouring
man by keeping up the cry of 'the Chinese must go.'"[60]

These conflicts opened a space for the public pronouncement of Euro-
American race superiority and anti-Asian sentiment (see fig. 1.1).[61] The
public debate over northwest coastal Asian immigration raged well into the
twentieth century and culminated in organized and violent anti-Oriental
campaigns sponsored by non-Asian workers. With the formation of an anti-
Chinese society in Victoria in 1873 and the Workingman's Protective Asso-
ciation in 1878, labor organizations built the foundation for racism against
the Chinese. The Royal Commissions in 1884, 1902, and 1907, which fol-
lowed in the wake of political and labor agitation, instituted a head tax for
each incoming Chinese immigrant and legitimated popular hostility
against Chinese immigration. In 1885 the head tax was $50, by 1900 the tax
was increased to $100, and in 1911 it was $500. Between 1923 and 1946, the
Chinese Immigration Act barred all Chinese immigrants, except those asso-

1.1
Canadian Illustrated News,
April 26, 1879. Caption reads,
"The Heathen Chinee in
British Columbia."
British Columbia Archives
#42709

ciated with the Diplomatic Corps, children born in Canada, students, and merchants with at least $2,500 in business investments.

Agitation against the presence of Chinese miners and laborers was evident from the start of the 1858 gold rush and figured prominently in the press by 1865. As one commission witness testified, anti-Chinese agitation broke down along class lines with race antagonism arising "in public print about the year 1865. Some few intelligent men of the middle class began it; but at present all classes are carrying on the agitation, all save a few wealthy employers."[62] In reports from the mines on the Fraser River, in August of 1858, a British surveyor casually reported, "The usual amount of quarrelling and fighting going on all about. A couple of days ago a wretched John Chinaman was discovered with five bullets in his back, of course nobody knows anything about it."[63] Because of their willingness to perform hard manual labor and their prospecting of abandoned ground, Chinese miners were accused of displacing Euro-American prospectors. Industrial employers supported the presence of Chinese labor, whereas individual workers seem to agree with racist declaration circulated in the press.

At large-scale industrial mines at Nanaimo, on Vancouver Island, disputes broke out between Asian laborers and Euro-American laborers who felt that wealthy employers favored Chinese and Indian workers because they accepted reduced wages.[64] Between 1874 and 1877, the *Nanaimo Free Press* further antagonized the situation by proposing that certain races were incompatible with industrial labor underground, while Indian and Chinese workers were uniformly ridiculed and their work habits classified as harmful to so-called community or public standards. The long-standing argument against Asian labor was politically supported to the degree that, by November 1899, reports from a Provincial Arbitration Commission directly solicited testimony as to whether Chinese, and to a lesser extent Japanese, laborers were hazardous to mine health and safety.[65] The Arbitration Commission followed in the wake of a mine explosion in the number ten shaft of the Wellington Colliery Company mine in Nanaimo. Rather than investigate overall mine safety, non-Asian miners claimed that the eighty to ninety Chinese employees were a safety hazard.

In public testimony the Chinese immigrant was burdened with a barrage of stereotypes. Chinese men were consistently dismissed as sojourners and never viewed as settlers, while Chinese women, even in limited numbers, were perceived as morally wanting. Another grievance was that Chinese immigrants were poor consumers. Although many had families at home and necessarily dispatched earnings back to China, the tendencies toward self-sufficiency, or the fact that low wages excluded them from "normative" acquisitive behavior, translated into a spurious argument that Chinese immigrants failed to support local, presumably non-Asian, merchants. Their uncooperative, abnormal habits, it was proclaimed, undermined the

economic progress of the province. Guidebooks reiterated this litany: "They make fair cooks and servants, and where they take to digging are generally content to work claims discarded by regular miners; they do not do much good to the colony however, as they eat little and drink less, and spend little or no money in the country."[66] As a result, many respondents at the Royal Commissions condemned the Chinese as a necessary evil, who performed hard or domestic labor at wages refused by others.

Confined to the lowest rung in the occupational hierarchy, Chinese laborers competed against Indians for labor opportunities but in many respects they constituted less of a threat to Indian territorial and resource sovereignty than Euro-Americans, since their interests were not rooted in territorial claims as much as in competition for waged industrial employment. Although the respective conflicts between Native Americans and miners and between Chinese and Euro-American laborers were distinct, collectively these situations exemplify the ways in which race was elevated to public discourse in the social, political, and economic milieu of the settlement period between 1858 and 1871.[67] Interracial disputes over proprietary rights to gold, land, and wage labor caused a discursive fissure out of which seeped racist pronouncements. Language espoused by Euro-American settlers about both Chinese and Indians bespoke a popular belief that cultural difference was biologically predetermined and fixed.

Land

Settlement imported a population of outsiders unfamiliar with the seasonal hunting and gathering culture, tribal politics, or the economy of the indigenous inhabitants. Initially, incoming miners, like the fur traders before them, were reliant on Native American experts hired to pack and guide them along the various tributaries of the Fraser River. Reflecting on this dependency, one writer admitted, "How in any part of the province what the miner, the trader, the farmer, the manufacturer, the coast navigator, or almost any other vocation would do with out the assistance of the Indian element, it is difficult to imagine."[68] As a bureaucracy of civil servants assumed responsibility for the new settler population, the reliance on Indian expertise, local environmental knowledge, utilitarian trade routes, and food ecology was eclipsed.

After 1858, grand and explicitly nationalistic ambitions for a permanent population of British ancestry were proclaimed, and even as late as 1884 the province was recommended as "the natural habitat of the Anglo-Saxon upon the Pacific Ocean."[69] But these ideals were complicated by the influx of "foreigners," defined by the British authorities and elite as anyone not from the United Kingdom. In addition to miners and manual laborers, the

gold rush had attracted an ethnically, nationally, and religiously diverse group of entrepreneurs who hoped to make their fortune provisioning the miners. Promoter and road contractor Alfred Waddington was distraught at this "indescribable array of Polish Jews, Italian fishermen, French cooks, jobbers, speculators of every kind, land agents, auctioneers, hangers on at auctions, bummers, bankrupts and brokers of every description."[70] In other words, a healthy appetite for commerce and profit was celebrated, except when manifest in non-British subjects.

Despite such sentiments and the accompanying expressions for the anglicization of the region, the colonial settlement was never monotone. As German American anthropologist Franz Boas revealed in 1886, the urban population reflected great diversity: "I have never seen such a mixture of peoples among such a small number of inhabitants. Besides many whites there are a very large number of Chinese, who occupy one section of the city exclusively. There are also many Negroes and Indians. Many Indians must have been accepted into white families because their typical facial form shows itself in many of the inhabitants."[71]

While the earliest traders and Hudson's Bay Company men had cohabited with or married Indian women, the climate of intolerance toward Indian demands held fast.[72] Governor Douglas sought formal measures to protect traditional Indian territories. According to anthropologist Wilson Duff, "Douglas believed that all cause for discontent would be removed if he gave the Indians as much land as they requested . . . his policy was to give the Indians whatever plots of land they chose and as much acreage as they requested."[73] Douglas, apparently, understood that political harmony with the Indians was a prerequisite to expanded settlement. His progressive stance on territorial rights, evidenced by his declaration that "I shall nevertheless continue to conciliate the good will of the native Indian tribes by treating them with justice and forbearance and by rigidly protecting their civil and agrarian rights," was exceptional.[74] By 1850 Douglas had negotiated fourteen land reserves with local Coast and Straits Salish populations on southern Vancouver Island in the belief that Indians had to be segregated and protected from the detrimental impact of urban colonization.[75] By 1863, a number of reserves in the conflict-ridden mainland regions of the gold rush had been surveyed. By 1870, around the new settlements at Musqueam, Katzie, and New Westminster, Douglas advised his surveyor to "mark off Indian reserves around all Indian villages, all land cleared and tilled by Indians, and all land claimed by Indians and their heirs. No reserve was to be less than 10 acres for each grown man . . . give the Indians as much land as they wished, and in no case to lay off a reserve under 100 acres."[76] In addition, the Douglas system, as it was known, also authorized the preemption of land by individual Indians, a proposition that gave them the opportunity to incrementally expand the acreage of reserves "on the same terms as

they are disposed of to any [other] purchasers in the Colony whether British subjects or aliens."[77]

The fundamental concepts of land use held by Indians diverged from those of the miners, settlers, and colonial administrators. Distinctions tempered all negotiations. The policy and procedure for the purchase of land around Fort Victoria for settlers from the local Songhee tribe, recommended in 1849 by the Secretary of the Governor and Committee of the HBC in London, reveals the colonial vision of land use.[78] Douglas was advised to proceed in accordance to the following official guidelines:

> You will have to confer with the chiefs of the tribes on that subject and in your negotiations with them you are to consider the natives as the rightful possessors of such lands only as they are occupied by cultivation, or had houses built on, at the time when the Island came under the undivided sovereignty of Great Britain in 1846. All other land is to be regarded as waste, and applicable to the purposes of colonization . . . the principle here laid down is that which the Governor and Committee authorize you to adopt in treating with the natives of Vancouver's Island, but the extent to which it is to be acted upon must be left to your own discretion and will depend upon the character of the tribe and other circumstances. The natives will be confirmed in the possession of their lands as long as they occupy and cultivate themselves, but will not be allowed to sell or dispose of them to any private person, the right to the entire soil having been granted to the Company by the Crown. The right of fishing and hunting will be continued to them, and when their lands are registered, and they conform to the same conditions with which other settlers are required to comply, they will enjoy the same rights and privilege.[79]

These instructions contained the basic agrarian tenants on which all land use was directed and controlled by the British Colonial Office following from the Royal Proclamation of 1763. Ownership had to be demonstrated by improvement, the sale and purchase of Indian land was to be mediated at the discretion of local representatives who acted on behalf of the Crown, the traditional rights of fishing and hunting were to be maintained, and some system of registration of land was required for the Crown to recognize "ownership." Curiously, the author failed to distinguish how timber, minerals, or water rights were determined, although the exploitation and value of these resources in the colonies was emphasized in every emigration guide published from the 1850s forward.[80]

The migratory and seasonal use of land, common to most coastal tribal groups, was irreconcilable within these terms and rendered Indian habits

incompatible with the prevailing system of preemption. Nevertheless the criterion of land use, combined with the colonial vision of the western coastal settlements as an idyllic agrarian land, was the basis of the discriminatory and unfair treatment of Indians with respect to land. If Indians failed to relinquish traditional seasonal patterns of land use, their rights to land title were forfeited. Furthermore, when in 1867 federal parliament in all provinces within the Dominion of Canada was granted jurisdiction over Indians and lands reserved for Indians, land policies became segregationist, and social and political inequity was sanctioned.

In the nascent restructuring of land ownership and use in the Northwest, individual settlers actively lobbied to prevent Indian access to land. While cooperation with the neighboring Indians underwrote daily survival in remote settings, if harmony with Indians was unachievable the settlers sought other means to disarm them. In an 1865 letter to the colonial secretary, settler Phillip Henry Nind evoked a barrage of essentialist stereotypes to force his government representative to recognize Euro-American entitlement to land as a priority:

> These Indians do nothing more with their land than cultivate a few small patches of potatoes here and there; they are a vagrant people who live by fishing, hunting, and bartering skins; and the cultivation of their ground contributes no more to their livelihood than a few days digging of wild roots; but they are jealous of their possessory rights, and are not likely to permit settlers to challenge them with impunity; nor, such is their spirit and unanimity, would many settlers think it worth while to encounter their undisguised opposition. This then, has the effect of putting stop to settlement in these parts. Already complaints have arisen from persons who have wished to take up land in some of this Indian territory, but who have been deterred by Indian claims. . . . These Indians are now quiet and not ill disposed to the whites; but they are capable of giving a good deal of trouble if they imagine their rights are invaded.[81]

Misguided, racist assumptions about the "nature" of Indians allowed the diminishment of Indian land reserves in the decades following the liberal reign of Governor Douglas. Sustained grievances, like Nind's, found a sympathetic ear in Land and Works Commissioner Joseph Trutch, who, during his tenure between 1864 and 1871, repealed many of the Douglas decisions about Indian land rights. Trutch was intolerant of the Indian and, as is clear by his public statements, also ignorant of Native American seasonal traditions. After Douglas's retirement in 1863, the Indian right to preempt was withdrawn and no further treaties were negotiated in the Pacific colonies.

Trutch revised the boundaries of reserves that had been allocated under the Douglas system, advising his surveyor to "reduce the limits of these reserves, so as to allow part of the lands now uselessly shut up in these reserves to be thrown open to pre-emption."[82]

In response to increasing land cut-offs and reductions permitted by Trutch, in 1875 two interior Salish tribes, the Thompson and the Lillooet, complained to their local federal Indian agent, James Lenihan. In obvious empathy with the Indians, Lenihan assessed the "land problem" as follows:

> The paramount question with them was the settlement of their re-
> serves . . . they are patient and reasonable, at the same time they are
> quite sensitive upon this question, and view with suspicion and
> alarm, the encroachment of the settler, the land speculator or the
> surveyors. They know that they are being rapidly hemmed in upon
> their limited reserves and that their domain is fast diminishing;
> under such circumstances it is not an easy matter to convince that
> full and complete justice will be done them.[83]

No satisfaction was granted the Thompson and Lillooet people, despite Lenihan's advocacy. From 1864 forward, British Columbia's Indians were confined to limited reserves, the size of which were further reduced between 1913 and 1916 via a scheme of cutoffs instigated by the joint federal and provincial McKenna-McBride Land Commission. Although the federal government had negotiated treaties with regional groups east of the Rocky Mountains, federal authorities were unable to overcome the provincial resistance to treaties.[84] Consequently, the fight over land titles between Indians and settlers in British Columbia remains contentious today.

2

"An Outpost of the Empire Welcomes You"

THE MERGING OF GOVERNMENT AND COMMERCIAL INTERESTS IN PHOTOGRAPHY

Beginning with the Spanish explorations of the eighteenth century, incoming visitors exhibited an insatiable, encyclopedic appetite for images of the Northwest Coast. The prime vehicle for the collection of this visual data was geographical and geological surveys, which substantiated the topography, flora, and fauna of the landscape as well as the location and availability of fish, mineral, and timber resources.[1] Prior to the mid–nineteenth century, watercolor artists commonly accompanied exploratory surveys in order to produce detailed topographical sketches of colonial lands.[2] Swiss-born draftsman John Webber, for instance, accompanied British Captain James Cook on his 1776 exploration of Nootka Sound on the HMS *Resolution,* resulting in detailed drawings of the Nuu-chah-nulth tribe of Vancouver Island's west coast. And in 1864, artist Frederick Whymper accompanied botanist Robert Brown and his crew on a geographical survey conducted by the Vancouver Island Exploring Expedition. The contribution of topographical artists like Webber and Whymper significantly broadened the scientific and imaginative knowledge of the North American West.[3] Maps were another fundament of the land survey, ordering the New World and inscribing national interest.[4] But the sinuous and unencumbered lines of maps and figures of the survey data relied on the fullness of the descriptions provided by watercolorists and writers to corroborate official knowledge about unsettled lands and their commercial prospects.

By the 1870s, photography rapidly overtook drawing as the descriptive implement for government-sponsored survey and topographical investiga-

tions. Unlike hand-rendered plein air sketches, which revealed the bias of
the maker and were conducted by artists of varied abilities, photographs
were considered objective, since the camera was accepted as a more exacting
recording device than the human eye. Photographic realism acquired even
greater scientific value when, by the 1880s, topographic landscape artists
and illustrators regularly employed photographs as a standard preparatory
aid.[5] Compared to drawn renderings, the photograph seemed more capable
of conveying superior precision or "truth" about the landscape and its in-
habitants. As such it suited the scientific purpose of the modern surveys.
Photography quickly became a standard component of the imperial map-
ping and measuring of recently acquired territories.

Photographs, like survey drawings before them, were transformed into
engravings and either dispatched from the Northwest to British offices,
where they illustrated official reports, or reproduced in broadsheets like the
Illustrated London News or *Canadian Illustrated News.*[6] The photographic
engraving was often accompanied by anecdotal written accounts or cap-
tions to intensify the sensationalism of the image. With the addition of the
descriptive narrative or caption, the sense of adventure was heightened and
eccentric personalities were brought to life. Visceral qualities and context
absent from an isolated static visual representation were, in this manner,
animated.

As this investigation of documentary photographic production in the
earliest stages of colonization illustrates, government administrators and
commercial entrepreneurs earned mutual benefits from their collaborative
efforts to tame the physical and social terrain through representation. In
1859, trained officers and the laboring crew of the British Engineer Corps
arrived in the Northwest to carry out the North American Boundary Survey
between the Oregon Territory of the United States and the British posses-
sions of Vancouver Island and British Columbia. In the first detachment, at
least one individual was trained to use a camera. Shortly after the surveyors,
commercial merchant photographers arrived. Most were British or Ameri-
can immigrants seeking adventure or gold. All, at some stage in their career,
sought or accepted some form of government contract, as the government
recruited photographers to record physical topography, geological re-
sources, and potential routes for overland wagon and railway travel.[7] Be-
tween 1873 and 1881, a number of photographers were commissioned by the
federal Department of Indian Affairs (DIA) to document cultural change
among residents of Indian villages on the northern coast.[8] Out of these gov-
ernment initiatives emerged a distinct genre of photographs, which endeav-
ored to portray traditional Indian life. It was common practice for photog-
raphers to recirculate these photographs for commercial profit. Whereas in
historical accounts the motives of these commercial photographic entrepre-
neurs have been seen as disinterested, they were, in fact, dually governed, on

the one hand by economic self-interest and, on the other hand, by colonial-related government patronage. Moreover, their marketing of photographs of the local Indians to international consumers subsequently stimulated investigations of northwest coastal indigenous life and culture by anthropologists and other scholars.

The British Engineer Corps

It astonished me how men can ever take it into their heads to live in such places so entirely cut off from communications with their own race: certainly the wandering mania of the Anglo-Saxon race is wonderful, they penetrate everywhere.
—LT. CHARLES WILSON, Royal Engineer,
 British Boundary Commission, 1860

The two British colonies of Vancouver Island and British Columbia became potential subjects for the camera beginning with the Oregon Treaty.[9] Government surveys on both sides of the international boundary employed either draftsmen or photographers, depending on the available budget. Artist and draftsman James M. Alden, for instance, produced hand-rendered illustrations for the final boundary report of the American survey of the Oregon Territory. And Captain John Pratt produced forty glass negatives of northern Chilkat Tlingit peoples for a boundary survey between northern British Columbia and southeastern Alaska in 1894, by then a U.S. possession.[10] Like many others before and after, Pratt exploited his official status and experience on the survey to advance his legitimacy as a scientific lecturer when, in 1895, he presented the lantern slides of the Tlingit to the National Geographic Society and reported on their "progress."

The British North American Boundary Commission, unlike the American Boundary Commission, consisted of separate, rather than joint, land and water survey crews. Seven officers and fifty-five men of the British Royal Engineers Corp land crew arrived in Victoria on July 12, 1858, led by chief commissioner Captain John Summerfield Hawkins.[11] Lt. Richard Mayne, who by 1862 had penned an immigrant guide to the region, conducted "a complete survey of the disputed waters . . . along the coasts of Vancouver Island and the mainland of the British Territory."[12]

The land-based team, armed with standard survey instruments such as telescopes, chronometers, and altazimuth, included a naturalist and an individual "trained in photography with equipment valued at one hundred pounds."[13] Unfortunately, the photographer deserted the team, and so official photographs were not gathered during the initial 1858 season. Two more men, trained in photographic skills at London's Kensington Museum, re-

placed the deserter, and beginning in October 1859 twenty-three views were taken around Victoria. This date, therefore, marks the arrival of photography on the British side of the boundary. Thereafter, these two photographers accompanied the land survey crew, taking "views" along the five hundred miles of the international boundary line cut through the forest. This activity resulted in a total of forty-four "relatively dull" depictions of "camps, terrain, boundary markers and cuttings" that eventually illustrated the official survey report.[14] Although the process of taking photographs in the field was unwieldy at this time—the process of wet collodion demanded the exposure of damp, emulsion-coated glass plates as well as on-the-spot development—the photographic images were appreciated for their detailed realism.[15]

Although the photographic activity on the British survey was subordinate to the principal task of inscribing the territorial division between north and south, the introduction of the camera as an instrument for documentation had political implications.[16] The Royal Engineers Corps undertook the mapping and gathering of data on behalf of Britain, which required a full account of its empire. Serving the dual purpose of obtaining "natural features of the countries" and "portraits of remarkable persons and costumes of foreigners," photography offered a tangible, and ultimately self-effacing, means for the colonial office in London to enhance public and official knowledge of the northwestern colonies.[17] Among their many assignments, the engineers established "a network of photographic stations around the world" from which "to photograph . . . all objects, either valuable in a professional or interesting as illustrative of History, Ethnology, Natural History, antiquities, etc."[18]

Although the rationale of survey activity was the measuring of the physical landscape and marking the territorial boundary, interests were never exclusively topographical, as the above quote indicates. Colonial peoples also were subject to objectification and classification. The Royal Engineers' photographer at Fort Victoria from 1860 to 1861 portrayed several Songhee Coast Salish Indians on whose territory Fort Victoria was built.[19] That same year portraits of interior Coast Salish populations were taken at Colville, in Washington territory, by the Engineer Corps photographers. Their efforts have been characterized as "an early attempt to provide a library of ethnological types," but unfortunately the sitters appear "pedestrian and stiff," suggesting the photographer unimaginatively applied prevailing European studio conventions despite an exceptional setting and extraordinary subject matter.[20]

One of the best known of the incoming civil servants associated with early ethnological accounts, photography, and surveys on Vancouver Island and the Queen Charlotte Islands was George Mercer Dawson. An ambitious geologist and amateur ethnologist, Dawson undertook a federally

sponsored, multidisciplinary investigation of the Queen Charlotte Islands between 1876 and 1878 on behalf of the Geological Survey of Canada. Motives for this survey included "topographical and hydrographic mapping" and assessment of the colony's "agricultural potential . . . the biological nature of the islands and the ethnological character of their Haida inhabitants."[21] After completing this early overview, Dawson was promoted to Director of the Geological Survey of Canada, a position of considerable influence in the civil service, and his collections and ethnological research formed the nucleus of the National Museum's anthropological division.[22] On the 1878 tour, Dawson "drew maps, collected fossil, plant, and insect specimens, and . . . investigated the ethnology of British Columbia's Native people."[23] His exhaustive study was informed by the distinctly Euro-American belief in the inevitability of the extinction of the Native American by a process of absorption into the superior European race, embodied in his observation, "The Indian races seem to diminish and melt away in contact with the civilisation of Europe."[24]

Subsequently influential in the professionalization of Canadian anthropology and in the formation of national ethnographic collections in museums in eastern Canada, Dawson supported the expansion of anthropological research in the region and, in particular, backed the research of German American anthropologist Franz Boas, who had arrived on Vancouver Island in 1886 and whose twenty-nine months of research, between 1888 and 1894, was funded by various sponsors, including BAAS, which commissioned him to conduct a study of the northwestern tribes of Canada.[25] Boas's research and reputation eventually brought international attention to the region.

Significantly, Dawson's journals reveal that the photographic documentation of the Haida in the villages he visited was not always conducted in a forthright or ethical manner but, like other forms of collecting with which he was engaged, the procedure was contoured by official motives. For example, Dawson, in an encounter with Haida Chief Klue of Tanu, quickly understood that financial remuneration was obligatory when taking photographs: "Present Chief Klue with a pound of tobacco, and finding no objection made [—] take a photo of the village."[26] In August 1878, at the village of Ya-tza, located on the north shore of Graham Island, Dawson remarked on the reluctance of many individuals, especially women, to cooperate for his camera: "Took photo of the two chiefs [Albert Edward Edenshaw, chief of the Stastas Eagles, and the younger man, Chief Wiah of Massett; fig. 2.1], and of as many of the rest of the people as would come. Most, however, disliked the idea, and especially the women, not one of whom appeared."[27] Despite this acknowledged, and gender-specific, resistance to the camera, and the protocol of monetary rewards in exchange for a photograph, Dawson's compulsion to document was not dampened. An

2.1

GEORGE MERCER DAWSON
Chief Wiah (Noo-Ya) of Massett (*left*) and Chief Albert
Edward Edenshaw of Ya-tza (Na-iza) Village, Queen
Charlotte Islands, 1878
George M. Dawson/National Archives of Canada/PA
#266

imperious sense of entitlement—his right to record everything—held fast.
In retrospect, the controversies surrounding photographic encounters such
as these described by Dawson seem an obvious sign of retaliation against the
pervasive Euro-American sense of propriety. In 1858 the *Illustrated London
News,* for example, reported that photographer H. L. Hime of the Assini-
boine and Saskatchewan exploration expedition had encountered forceful
objections against photography from members of the plains Ojibwa. They,
too, easily made the conceptual leap between the taking of their portraits
and an accelerating, and intrusive, presence of Euro-Americans in Indian
territory, responding that "the whites wanted to take their pictures and send
them far away to the great chief of the white men . . . they knew this was the
way the white man wanted to get rid of the Indians and take their land."[28]
 The Geological Survey of Canada's commitment to photography ini-
tially wavered, although it was generally understood that photography en-
abled the bureau's exploratory goal to "learn as much as possible about the

general geological features of the province and of the minerals to be found along the proposed routes."[29] To meet this goal, Alfred Selwyn, director of the Geological Survey from 1869 to 1895, hired two commercial photographers, Benjamin Baltzly and John Hammond, for the 1871 expedition to "secure accurate illustrations of the physical features of the country and of other objects of interest which may be met with during the exploration."[30] The commitment was surprising given that the lead officer of the British Surveyors Corps had declared a preference for a conventional sketching artist because of the inconvenience of carrying the cumbersome equipment required for the wet collodion plate process. The apparatus often weighed as much as five hundred pounds.[31] Furthermore, the expense of three thousand dollars for photography per trip amounted to "nearly half of the cost of the entire geological expedition" exclusive of salaries and equipment.[32] The innovation of the dry plate photographic process eventually reduced the overall expenses of carrying developing apparatus into the field and, by 1895, the camera, without question, was a standard tool of the survey.[33]

While the primary motive for taking photographs on the 1871 Geological Survey expedition was to supply geologists with a geological record, Baltzly's and Hammond's results were destined for a broader commercial market.[34] Dominion government organizers of the Geological Survey perhaps overcame any hesitation about the expense of Baltzly and Hammond's presence on the survey because their salaries and equipment had been underwritten by the renowned commercial William Notman Studio of Montreal, which "hoped to capitalize on the public interest in the province and the possibilities offered by the mountainous country for new and exciting scenery."[35] Baltzly's photographs were reissued by the Notman Studio for profit and made available for purchase by other prospective clients long after the survey contract was terminated. Given this explicit commercial intent, doubts can be cast on whether or not scientific detachment existed in the taking of the photographs. Yet, by consenting to the presence of commercial photographers, the government obviously believed official interests would be served. On this occasion, as on others, scientific, political, and commercial aims merged.

Commercial Photography

After the departure of the British Engineer Corps in 1863, responsibility for the visualization of the colonies fell to independent commercial photographers who arrived in the region as early as 1858. At least four photographers established permanent ventures by 1862. "Pioneering photographers" who focused on the "region's great potential" were much in demand.[36] Their pictorial emphasis on civic improvements of settlement and

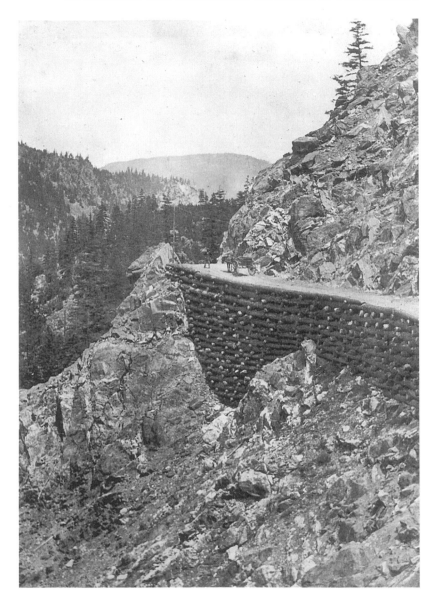

2.2

FREDERICK DALLY

China Bar Bluff on the Cariboo Road, mainland
British Columbia, circa 1866–70
British Columbia Archives #A3867

the "undeveloped" yet picturesque landscape, as well as on the roadways, bridges, and steam wheelers en route to the goldfields, supported colonial ambitions for new immigrants, especially during the earliest stages of settlement between 1858 and 1871, when local bureaucrats were preoccupied with basic organization and administration.[37] Commercial studio advertisements all declared the availability of this genre of promotional "views," many of which were dispatched home in letters—the most effective promotional literature—to enlighten friends and relatives.[38] Photographers gathered an oeuvre of stock images, including popular scenes such as the access routes to the goldfields such as the Cariboo Road (fig. 2.2), in order to build and sustain a market for themselves. These genres of images depicting transportation, mines, mining towns, and wagon roads were incorporated into private, or government-sponsored, immigration literature or into newspaper articles in which authors enumerated the attractions of the colonies.

While some commercial photographers specialized in the evidence of human impact on the landscape, a subject appropriate for promotional literature and topographical surveys, other photographers concentrated on commercial studio portraits. Studio portraiture also delivered a positive impression of frontier life by featuring well-dressed extended family groups and titled or government celebrities. Thus portraiture was a concrete testament that colonial immigration yielded financial profit and social mobility. The commercial market in portraiture rapidly expanded from the late 1870s to 1900. Itinerant portrait photography, moreover, became a specialty, as photographers like Frederick Dally followed the demographic flow of settlers and miners, catering to a clientele in "towns and settlements that could not support a full-time photographer (see fig. 2.3)."[39]

From the start, the aspirations of local documentary photographers were aligned with government. Both benefited from a positive portrayal of the prospects and prosperity of the region; the government needed to enlarge the incoming population for the provision of a larger tax base, whereas the ambitions of the commercial photographer depended on a steady supply of paying clientele. After 1865, the economy took a downward turn and, without migration occurring after the depletion of the Fraser and Cariboo goldfields, photographers necessarily diversified. Those who exhibited the greatest versatility and a commitment to entrepreneurial innovation were the most likely to thrive in this climate.

With the ever pressing need for a steady and guaranteed income, commercial photographers willingly accepted any and all projects. Government work proved the most reliable source of commissions. However, despite the obvious utility of photographs in promoting immigration and creating topographical surveys, the government was initially hesitant to place photographers on the payroll given the problems and expenses inherent in the early

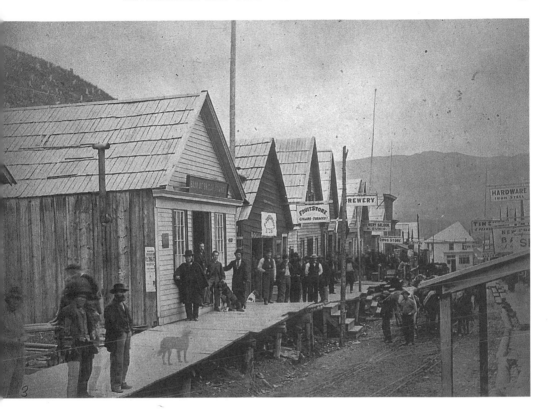

2.3

FREDERICK DALLY

Street scene in Barkerville, mainland
British Columbia, circa 1867
British Columbia Archives #A03786

technology. When, in 1873, photographer Benjamin Baltzly proposed a permanent photographic detachment for the Geological Survey, his suggestion was rejected outright on the grounds of "grave doubts as regards its success in a financial point of view."[40] Lacking insufficient resources to hire permanent staff photographers, regional civil servants instead hired local professionals on a casual, contract-to-contract basis. An added benefit of the government and commercial collaboration was that after the required prints were supplied to the government agency, photographers retained the right to the negatives and were free to use them as they wished. The marketing of the photograph was in no way restricted by the original dictates of the government sponsor.

The Promotion of Immigration

Soon after the completion of initial boundary and geological surveys, efforts to increase a British ethnic presence in the region were undertaken. As early as 1854, administrators in the Province of Canada "took the first steps toward organizing a sustained recruiting campaign" on behalf of immigration, dispatching agents to London with "instructions to distribute a large number of newly printed promotional brochures."[41] Between 1867 and 1892, the promotion of immigration fell under the jurisdiction of the federal Department of Agriculture, although each region also independently endeavored to attract immigrants. Not until 1872, however, did the Department of Agriculture "launch a properly organized, adequately funded recruiting campaign." Working in London and other metropolitan areas in Great Britain, immigration agents stocked their offices "with immigration brochures . . . maps, statistical tables, and other information pertinent to specific areas of the country."[42] Other strategies adopted by agents included the mounting of colorful posters in railway stations, distributing handbills, leaflets, brochures, and emigrant handbooks to the press, who, it was anticipated, would circulate the prospects of the region in local papers. Immigration agents also embarked on lecture tours carrying a bounty of maps and promotional literature for distribution.[43]

In British Columbia, the problems of attracting immigrants diverged from those of eastern Canada. The male population had surged when gold was discovered on the Fraser River in 1858 and in the Cariboo in 1862, but when gold discoveries began to wane a few years later, a more concerted effort was required to draw the most desirable immigrants, especially women, to the region. One major concern was to prevent the migration of men from British Columbia south to the United States, which was a preferred destination before the building of the transcontinental railway in the late 1880s.

Commercial photographers participated in the immigration campaigns by positively emphasizing improvements in British Columbia that had accompanied the arrival of miners, settlers, and merchants after 1860. While the realism of the photograph solicited confidence, immigration agents also felt that "pleasing" representations were critical. This aspiration led to a certain degree of literary and artistic license.[44] For instance, in the early 1870s, Gilbert Malcolm Sproat, Immigration Agent General for British Columbia, produced an illustrated handbook in which a sanitized image of Victoria was conveyed to prospective settlers. Sproat apparently "'doctored' a contemporary lithograph of the city, by removing the Indian village from the picture, by widening the harbour, and by making other little improvements, so as to make 'a lightsome view' of the provincial capital . . . and afterwards reported that he had made these alterations in order to

enliven the handbook."[45] The photograph's capacity to be manipulated was an attractive feature of the medium, as Sproat's adjustments testify.

The consistency with which prosperity was exaggerated for the sake of promotion was evident in the disappointment expressed by photographer Benjamin Baltzly upon his arrival in the region in 1872:

> We were all more or less disappointed in our expectations of Victoria, Vancouver's Island. I expected (judging from reports) to find a thriving and enterprising city, with prosperity written upon it everywhere. But I was grieved to find everything the reverse of prosperity. Some streets are nearly entirely deserted, and there is not a street but what has many, very many, houses—both dwellings and stores—deserted. Everything looks lifeless and desolate. Its population does not exceed 3,500. During the gold excitement of 1864 and 1865 in Cariboo and other places it had a population of 10,000 . . . but in a few years the gold excitement died away, and with it went the sudden increase of population.[46]

It was for good reason, especially during the era of economic downturn after the gold rush, that immigration promoters sought more positive representations and photography aided this endeavor.

Perhaps one of the best examples of how photography assisted with the promotion of immigration was provided by Officer Edmund Hope Verney, who discussed a panorama photograph of colonial Victoria in a letter dispatched to his father in England.[47] By 1860, when the photograph was taken, the city was "already too large for a single exposure illustration of its physical extent, the natural setting or architectural variety," a situation which necessitated that the photographer adopt "the multiple exposure solution from a height of land at the south end of town."[48] Verney's description traces the transition of a colonial settlement from a Hudson's Bay Company trading fort to increased permanence and urbanity:

> On the table before me . . . is a panoramic photograph of Victoria: although barely two years have elapsed since it was taken, I can already see great change . . . taken from the point marked . . . as Songhies [sic] point, on the Indian Reserve: on the extreme left . . . is a bridge which was formerly on the road to Esquimalt . . . near the bridge is a large barque, unloading: below the barque are the huts which for the most part constitute an Indian Village. The spire and tower further to the right belong to a discerning church which is built entirely of wood, and is a great ornament to the town . . . further to the right, we come to the large ugly Hudson's

Store, probably at that time the only brick building in the town . . .
to the right is the stockade of the company's fort, now entirely
pulled down: the blank rock astern of the steamer [the Cariboo] is
now all filled up with wharves . . . to the right . . . is the hideous lit-
tle wooden cathedral, with its short stumpy spire: a couple yards
beyond which now stands the Bishop's palace: there can be no
doubt that the site will be very fine for a stone cathedral some day.
. . . To the right . . . is the wooden bridge across James' Bay; the
white gable end to the right of the bridge, is the end of the gover-
nor's house . . . To the right of the governor's house are the govern-
ment buildings, built in a curious, un-English, fantastical, ginger-
bread style: they are flimsily built of brick and wood: the corner
room upstairs, in the nearest angle of the large centre building is
my office as secretary to the Lighthouse Board . . . the picture gives
a very good general idea of the town, and the ragged look the fir
trees have: but many of the latter have been cut down now, as the
town has extended. The wharves are more numerous: to the right
of the Hudson's Bay store, in lieu of the stockade has risen up a row
of very respectable merchants offices and stores, and brick houses
are every day replacing wooden ones.[49]

In 1862, when Verney's letter was written, Victoria was four years be-
yond the population boom generated by the discovery of gold, an event that
stimulated the expansion of Fort Victoria from "a site of promising settle-
ment into a full-grown town."[50] Verney emphasized the civic architecture
of colonial governance: the governor's house, government buildings, land
office, the treasury, merchant offices, and stores. He referred to population
growth but actual residents were not visible—there are no perambulating
shoppers, ethnically diverse street hawkers, or hardy gold miners, for in-
stance. He approved of the social stability signified by the replacement of
brick domestic architecture for wood construction and noted the recently
built wharves to accommodate the expansion of commercial shipping traf-
fic. Hence, by 1862, Verney's memory of the old fort with its "empty" land-
scape of "ragged" firs, once dominated by a single brick structure of the
Hudson's Bay Company trading store, the wooden stockade of the fur trade
post, and the big houses of the Songhee tribe, was eclipsed in two short
years by more substantial, permanent structures. Verney's concentration on
municipal architecture was derived, in part, from his use of a photograph as
a narrative device. The perspective provided by the photograph enabled a
re-enactment of dramatic change over a relatively fleeting period of time
and guided his concept of the colonial settlement to an overseas observer.
The phenomenon of rapid transformation justified photographic com-
memoration and public awe.

While policy incentives, like the Pre-emption Act of 1861, officially tantalized the landless British immigrant, photographs, especially when united with written anecdote, were an efficient means to deliver the best possible impression of what the colony offered.[51] In this manner, photographs convincingly assured prospective immigrants not only that land had agricultural potential but that services and modern civic facilities, such as schools and churches, were available. The aspirations for a permanent and thriving British settler society relied on a concoction of hyperbole and realism, jointly communicated by graphics and words.

The Economics of Colonial Photography

Photographs like the panorama described above were taken by commercial photographers who established permanent, semipermanent, and itinerant ventures or had a presence during the pre-Confederation era. They included Richard Maynard (active 1862–1893), Hannah Maynard (active 1862–1912), Charles Gentile (active 1863–1866), Frederick Dally (active 1866–1870), George Fardon (active 1860–1872), Stephen Spencer (active 1858–1883), and Oregon C. Hastings (active 1874–1899). Those who arrived prior to 1871 stepped into the professional gap left by the official photographers of the British Engineers Corps and quickly took advantage of government demand for casual photographic expertise. Although compelled by the market rather than explicitly scientific motives, photographers arriving at this time found their professional credibility advanced by participation on government contracts.

Most commonly, however, the photographic entrepreneur "worked on speculation, first making a view and then seeking a buyer for it . . . [she or he] faced a challenge of transforming an essentially private kind of imagery into a more public medium."[52] As competitors in an unfamiliar, still uncertain, economic environment, the earliest photographers were driven by a search for commercially viable products, services, and clientele. On a practical level, the expense of photographic equipment before 1880 meant that economic success required a steady, rather than purely speculative, income. Out of necessity, many professionals combined photography with other business activities. Dally initially operated a dry goods store, Gentile started with a fancy goods store, the Maynards ran a shoe and leather store, and Spencer invested in an industrial fish cannery, in addition to land and property.

Hannah Maynard was one of the most successful commercial photographers in the Northwest. Her extraordinary business acumen and vigilant pursuit of new markets and novelties enhanced the occupational survival of herself and her husband and partner photographer, Richard Maynard, be-

yond many other competitors (see fig 2.4). Hannah Maynard made certain the Maynard Studio kept abreast of global trends and innovations by subscribing to international trade journals and purposefully tailoring certain new and fashionable techniques to the demands of a local clientele. A notable example was Hannah Maynard's innovation of a children's portrait series called the *Gems of British Columbia*. For his part, Richard Maynard accepted many government contracts and maintained the secondary commercial venture of a shoe and leather store on which the Maynards likely relied to subsidize the photographic enterprise. Clearly, the Maynard partnership was split along gender lines; Richard fulfilled the majority of fieldwork and government commissions, while Hannah, in her primary role of household and business manager, mother and grandmother, stayed close to home but specialized in studio portraits, the darkroom labor, and career promotion. While reports of the day distinguished Hannah Maynard as being unconstrained by her sex as she went "out into the field and traveled taking stereoscopic and other views of buildings, ships and groups in any part of the province" and "furnished an example of what women can do when there is necessity or ambition or the incentive," her presence on these back road excursions was more exception than female norm.[53] In the excursions into unsettled land, potential threats to Hannah's safety were eased by the companionship of Richard, and ultimately the documentary results of these trips were largely attributed to him.

Obviously, financial and professional benefits were derived from the Maynards' gendered division of labor, interests, and skills, a collaborative feature other early regional photographers lacked. Family members also contributed to the Maynards' business success. Before her death in 1888, daughter Emma Macdonald, also a photographer, assisted in the darkroom. Eldest son Albert, who assisted Richard on a photographic tour to the mining town of Barkerville in 1868, labored in the boot and shoe business and later assumed responsibility for the management of the photographic supply store and the international distribution of the photographic stock after Richard and Hannah retired.[54]

Other commercial photographers did not possess the advantages of a spousal partnership, family collaborators, or Hannah Maynard's proclivity for innovation and creative experimentation. Some proposed adventurous ideas but lacked the fortitude to follow ambitious projects through to completion. In 1861, J. A. Miller, for example, working under the auspices of the World Panorama Company, announced grandiose intentions to "commence, mature, complete, and publicly exhibit a panorama of the entire route from New York to some point on the Fraser River [goldfields]."[55] The absence of a final result of this project suggests that failure for some may have been more common than success.

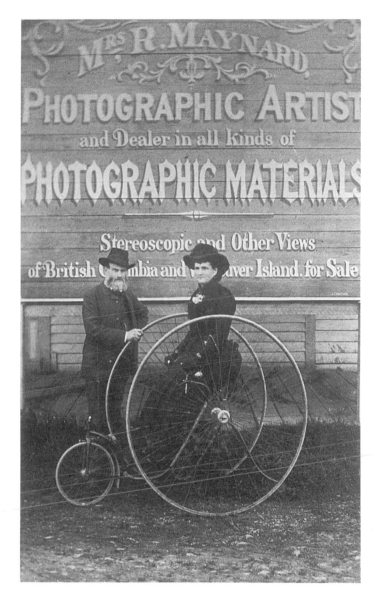

2.4

HANNAH MAYNARD
Richard and Hannah Maynard in front of
the Johnson Street Studio, in Victoria on
Vancouver Island, occupied between 1870
and 1892
British Columbia Archives #C-8673

The brevity of photographer Frederick Dally's stay on Vancouver Island exemplified the tenuous state of existence experienced by the independent merchant entrepreneur. Dally, who arrived in Victoria in September of 1862, abandoned his photographic aspirations by 1870 and instead decided to become a dentist.[56] While the letters of introduction Dally carried with him harbored the promise of social acceptance among Victoria's colonial elite, ultimately they were unable to guarantee sustained occupational success.[57] After an initial struggle, which included a turn at managing a dry goods store in 1863, in March 1864 Dally rented a ground floor of a brick building on the northeast corner of Fort and Government Streets at the seemingly outrageous expenditure of U.S.$50 gold coin per month.[58] Dally stocked his photographic studio with supplies from London and announced it open for business in local papers on June 26, 1866, more than two years after his arrival.[59]

Dally's investment in a permanent, centrally located studio revealed his hopes of attracting an urban clientele for whom he would have produced, one imagines, depictions of houses, local scenery, and family portraiture. However, just two months later he seems to have abandoned this initiative and cast his attentions elsewhere. Between August 8 and August 20, 1866, he took several "excellent views of different points of interest on the east and west coast" of Vancouver Island when he accompanied Governor A. E. Kennedy on the navy gunboat HMS *Scout* on a voyage covering eight hundred miles of the coast.[60] The tour of the HMS *Scout* was a diplomatic excursion to investigate and assess the conditions and attitudes of Indian tribes and settlers who resided in proximity to Indian villages.[61] This opportunity on an official expedition elevated Dally's professional credibility while affording unprecedented photographic prospects that allowed him to subsequently characterize his trade specialties as "Photographic Views of British Columbia, Vancouver Island, Puget Sound, and of Indians."[62] Dally later capitalized on this government-sponsored activity by successfully marketing at least seventy-seven different *cartes-de-visites* of Indians. Many other views taken on this tour were unparalleled "for their variety and quality."[63]

By July 1867, Dally was on the road again, this time accompanying Governor Seymour, Kennedy's successor, into the Cariboo on the British Columbia mainland.[64] Two months later, Dally took an excursion to the gold mining town of Barkerville where he advertised his professional services over a period of one month, availing "views of mining claims, houses, groups, scenery and all kinds of outdoor photography," in addition to the sale of photographs of "Mining towns, and of Williams and other creeks."[65] Significantly, on a trip to Williams Creek in June of 1868, he hired a guide belonging to the Thompson Indian tribe, whom Dally pronounced "very able and willing," in the main because this assistant lured prospective Indian sitters by informing them "that I [Dally] was a great chief and could

work wonders with a small piece of glass, face work especially, and that I wanted pictures to show to the great white chief living a long distance off to show him that the Indians had good hearts toward the white man."[66] Although Dally's motives for taking the photographs did not, perhaps, align with those of the sitter, from his solicitation of Indians as clientele one can infer that individual Indians were consumers of photography. Alternatively, we could interpret an encounter like this as a commercial exchange, with the sitter selling his services to Dally, who profited from the sale of the portraits.

In an attempt to accommodate the itinerancy of prospective clients in the mining town of Barkerville, Dally invited interested parties to deposit orders in writing at the bar of the local Hotel de France.[67] Profit earned on these ventures must have warranted his return to Barkerville twice in 1868. Propitiously, he arrived in time to capture—in writing and photographs—the complete destruction of the mining town by fire that September.[68]

Curiously, by October 1870 Dally left British Columbia for Philadelphia and enrolled in the College of Dental Surgeons.[69] Was his departure caused by an unfortunate combination of restlessness, bad timing, and imprudent economic speculation? Why did Dally fail to establish a stable business presence in the region? Hoping to reap some final profit from his investment before his departure, Dally advertised the liquidation of his entire stock of one thousand negatives of Indian *cartes-de-visites* and an 8 × 10 camera for the asking price of $1,130.[70] The Maynard Studio acquired "at least eighteen glass negatives" of Dally's Indian *cartes-de-visites*, which Hannah Maynard reproduced under her imprint well beyond 1890.[71] A decade after he left Vancouver Island, Dally tried again to capitalize on his Northwest images. In March 1880, he invited the Anthropological Institute of Great Britain and Ireland in London to contribute toward the publication of "his research in connection with British Columbia."[72] Heightened anthropological interest in the region obviously convinced Dally that his photographic activity among Indian tribes conducted between 1866 and 1870 might be converted into marketable currency. His letter suggests that his personal aspiration for professional and financial recognition for his photographic initiatives identified by him as "research" had lingered beyond his departure from the region and his retreat from the profession.[73]

In contrast with Dally's failed business history, Stephen Spencer earned early financial success as a photographer, but like Dally he, too, eventually pursued an alternative profession. According to an obituary notice, Spencer had arrived in the British Northwest from the United States circa 1858, lured, like so many others, by the glittering prospects of the Cariboo goldfields.[74] However, rather than take up the physically demanding manual labor of placer mining with pickax and gold pan, Spencer pursued the more socially prestigious occupation of merchant photographer.

Spencer's portrait studio, established in 1859, constituted one of only two, possibly three, commercial photographic studios in Victoria prior to 1862, and he probably benefited from the minimal competition of those early years.[75] The earliest announcements of his business were listed in 1859, and subsequent notices, posted regularly in local newspapers between 1872 and 1882, are evidence of his financial stability.[76] An advertisement of 1859 announced Spencer's expertise as a "daguerreian artist" possessing qualifications earned on a "professional trip around the Sound."[77] The peripatetic nature of his frontier clientele, like Dally's, was apparent in the wording of his advertising. "Likenesses" were for those "who may desire to leave with or send to their friends a remembrance." That Spencer proclaimed the cost of a photograph as "trivial" may have been an advertising ploy, but this claim significantly revealed that economic success in frontier studio work was hard won. To earn a living wage must have required a massive daily output by the operator, especially given the exorbitant overhead for studio real estate as exemplified by the rent paid by Dally. Apparently Spencer charged one dollar for photographs on patent leather, paper, or glass and three dollars for photographs of children. In 1865, one of Spencer's closest competitors, George Fardon, dramatically reduced his prices to "a dozen cartes-de-visites at five dollars per dozen, three dollars per half dozen."[78] Intensified competition of this nature undoubtedly impeded an individual photographer's chances of success.

In order to survive, photographers continually innovated their practices by offering new products and services, in part because much of the clientele for portraiture was familiar with sophisticated photographic trends in England. By 1862, Spencer had added the popular, and more accessibly priced, ambrotype and melainotype and the novelty of photographs printed on leather to his repertoire.[79] The ambrotype was a wet collodion negative process, popular from 1851 to 1880, in which the final image was backed with a dark piece of material to create a positive. Because of its reasonable price, the melainotype, better known as a tintype, or ferrotype, popular between 1856 and 1930, was made by exposing the image on to a collodion emulsion on a black or brown lacquered iron plate.

Spencer also announced his particular interest in "obtaining pictures of children."[80] At the 1880s price of three dollars per item they were a lucrative, "bread and butter" component of the studio trade for those photographers willing to risk the difficulties of getting the cooperation of caregivers, children, and babies. Hoping the scale and luxury of his studio would put him ahead of competitors, Spencer relocated to increasingly larger premises between 1872 and 1880. From 1872 to 1875, his Victoria Theatre Photographers Gallery was located in Victoria on Government Street.[81] After 1875, he moved into more capacious accommodations on Fort Street, where visitors entered "by a spacious staircase" and then proceeded to "a finely fin-

ished reception-room and thence conducted to a gallery, where improved appliances are in use." With his occupancy at the Fort Street studio, Spencer distinguished himself as an innovative, modern portrait artist "prepared to take pictures in the highest style of the art."[82]

Spencer's occupation as photographer was registered in British Columbia business and city directories and in census records until 1885. In 1881 he had entered into a partnership with Oregon Columbus Hastings, who co-managed the portrait studio and maintained a "very prosperous trade having virtually all the patronage of the city."[83] By 1881, however, Spencer permanently left Victoria to pursue another business affiliation in a fish saltery at the northern Nimpkish Indian village at Alert Bay, a business venture that originated in 1870. Alert Bay was a settlement located on a small island on Broughton Strait just south of the former HBC trading post of Fort Rupert, and it was here Spencer would make his lasting fortune. Spencer transformed the saltery into a cannery (figs. 2.5 and 2.6) at the precise moment when the commercial viability of the fisheries on the Northwest Coast became promising.[84] Once his new enterprise was secure, he retreated from his occupation as a photographer. His marriage in October 1883 to Annie Hunt, one of the daughters of Fort Rupert traders Robert Hunt and Mary Eberts, Hunt's Tlingit wife, was another key to Spencer's transformation. Annie and Stephen Spencer established a permanent residence alongside the cannery at Alert Bay and started a family. Aided by these investments, and local networks through his marriage, Spencer became a proprietor of the Alert Bay Canning Company and postmaster of Alert Bay. The family associations with the Hunts awarded him a distinct advantage among the local Nimpkish Kwakwaka'wakw who, as fishers and plant workers, supplied the fish and manual labor crucial for successful operation of the cannery.[85] His timely pursuit of business investments in an emerging extractable resource industry, in addition to the favorable social ties with the Hunt family, consolidated the future prosperity of Spencer and his family. His earlier success as an urban merchant photographer may have prepared the ground for these grander ambitions. Undoubtedly, his previous associations with many well-known families and individuals in Victoria provided a network of business contacts that was useful in the north. And finally, his industrial success among Kwakwaka'wakw fishers and laborers, alongside his occupational familiarity with photography, made the "Bay," its families, and workers one of the most frequently photographed maritime communities on the heavily frequented route to Alaska.

Oregon Columbus Hastings, or O. C. Hastings, earned his professional reputation as a photographer through his studio apprenticeship with Spencer. Hastings had arrived in Victoria from Port Townsend in 1852 and worked as manager of Spencer's studio on Fort Street for six years. After the death of his first wife, Matilda, in 1880, he temporarily left the business, but

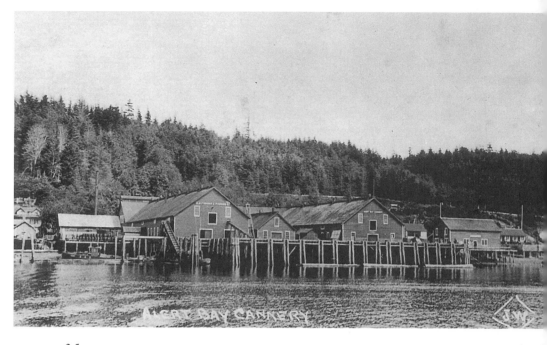

2.5

UNKNOWN PHOTOGRAPHER
Cannery at Alert Bay, n.d.
British Columbia Archives #A-04489

returned as a full partner when Spencer departed for Alert Bay in 1881. In 1883, Hastings bought out Spencer's interest, but both names were listed in studio advertisements in the local business directories of 1885 and 1887. Spencer and Hastings specialized in photographic supplies and in furnishing "views of Victoria and Vicinity" until January 1889, when Hastings sold the urban establishment.[86] A well-respected member of the Natural History Society of British Columbia and the British Astronomical Society, Hastings was identified as "an ardent naturalist and astronomer," and these qualifications bolstered his distinction as a photographer with scientific intent.[87]

During the summer of 1879, shortly after he joined Spencer's studio, Hastings accompanied Superintendent of Indian Affairs Israel W. Powell on a tour of inspection on the HMS *Rocket,* which included a trip to the model Anglican Tsimshian village established in 1857 at Metlakatla, twenty miles south of Fort Simpson. While the official purpose of the tour was "the settlement of a labour dispute involving cannery operators on the Skeena River and the missionaries at Metlakatla," for Hastings, like Dally, it offered the opportunity for the observation of various tribal groups along the

coast.[88] This experience, combined with his professional associations with Victoria's scientific community and with Stephen Spencer, won him a commission with the renowned anthropologist Franz Boas at Fort Rupert in 1894.[89] Between 1888 and 1902 Boas undertook a large-scale anthropometrical project to measure skulls and photograph individual Kwakwaka'wakw and Coast Salish people.[90] Between November 25 and December 3, 1894, under the direction of Boas, Hastings produced 180 photographic plates and an assortment of plaster casts of the heads of individual subjects residing in the Kwakwaka'wakw village at Fort Rupert.[91] Photographic activity of this type arose from the belief that cultural distinctions were discernable upon the body. Boas affirmed that he, as a scientist, was convinced that racial ancestry was inherited and indelibly etched on the corporeal body.

2.6

STEPHEN SPENCER

Village boardwalk at Alert Bay looking
toward the Spencer cannery, n.d.
British Columbia Archives #E-04633

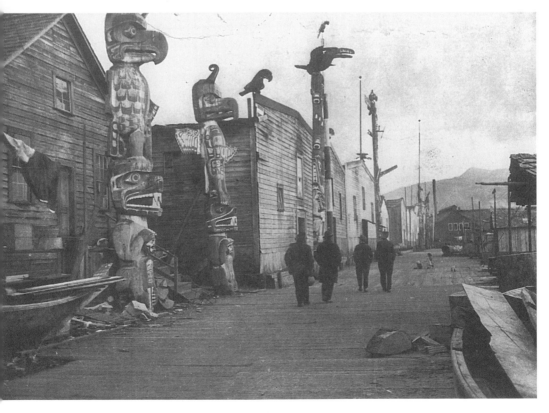

"Many Indians," Boas declared, "must have been accepted into white families because their typical facial form shows itself in many of the inhabitants [in Victoria]."[92] Museums, too, invested in these ideas: Boas's expedition and Hastings's photographs were funded by the American Museum of Natural History (AMNH), the U.S. National Museum (Smithsonian), and the British Association for the Advancement of Science (BAAS).[93] The resulting negatives, and two identical sets of photographic prints, were divided between the collections of the AMNH and the Smithsonian, with Hastings receiving financial compensation amounting to sixty-eight cents per negative from each institution.[94] Hastings's photographs also achieved historical notoriety as a result of Boas's published research on Kwakwaka'wakw culture.

The Documentation of Indian Life

Significantly, the original itinerary of the HMS *Scout* taken by Frederick Dally and Governor Kennedy in 1866 became the standard template adopted by nearly all the official tours of inspection for which local photographers were commissioned. Richard Maynard on the HMS *Boxer* in 1873 and 1874, Oregon C. Hastings on the HMS *Rocket* in 1879, and Edward Dossetter on the HMS *Rocket* in 1883 followed nearly identical itineraries and stopovers. These opportunities, in association with the DIA, raised the public and professional stature of these photographers and expanded their commercial oeuvres of views of Indians and Indian villages available to urban clientele.

The locales represented within the vast selection of commercial photographs now found in the archives inscribe a well-traveled maritime route that stretched from the San Juan Islands in the south to the Bering Sea off Alaska. During this era, certain forts, towns, and villages surfaced repetitively, reflecting the reoccurring patterns of mobility of individual Euro-American photographers and of the colonists more generally. The incoming population streamed through the landscape via rudimentary roadways and maritime routes funded by the government and entrepreneurs. Newcomers, including photographers who arrived after 1859, depended on these maritime cargo and passenger routes for sea and overland travel. Kwakwaka' wakw villages on the west coast of Vancouver Island such as Clayoquot and Quatsino; agricultural settlements and Salish reserves in Duncans, Cowichan, and Quamichan; maritime stopovers such as Fort Rupert and Alert Bay; and the mining town of Nanaimo furnish a sense of the colony precisely because these were the villages, towns, and sites that the photographers, local and outside government officials, missionaries, commercial entrepreneurs, and settlers frequented. Certain places that attracted economic

interest and investment dominate the visual and written records, and it is these that came to signify the new frontier. Quatsino, for instance, a village of the Kwakwaka'wakw people in a harbor on the northwest coast of Vancouver Island, was "opened" to pioneer settlement through private investment of a "highly respectable English Association which proposed to open mines of coal, to establish fisheries, to embark largely in the export of deas, and ship spars and in other branches of trade that promise remunerative employment for capital."[95] Clayoquot, also on the northwestern coast of Vancouver Island, was a village of the Nuu-chah-nulth with an early, prominent, and outspoken Roman Catholic presence. Fort Rupert, established in 1849 as a HBC outpost for the purpose of mining coal, trading furs, and maritime defense, was abandoned once industrial coal operations were established in Nanaimo. Another, more prosaic, reason that certain places were documented above others was that newcomers, unfamiliar to the place, rarely ventured beyond well-appointed routes. Clearly, the reasons a photograph was taken along these routes were neither solely arbitrary nor aesthetic but motivated by economics of colonial development and dependent on the mobility of the individual camera carrier and his, or her, access to routes and a mode of travel. By 1880 Quatsino and members of the local Kwakwaka'wakw had been exposed to outside viewers by photographs produced and marketed by the village's resident photographer, Benjamin Leeson.

Certain locations and themes, therefore, were standardized in all of the writing and pictures produced on the coastal tours depicting new, or emergent, industrial resource ventures. These included the Alberni Lumber Mill at Stamp Harbour; Spencer's cannery at Alert Bay; mining experiments at Fort Rupert, in the Queen Charlottes, and at Nanaimo; Christian success with Indian uplift at Metlakatla; the Mowachaht at Friendly Cove in Nootka Sound; and successful "pioneering" agricultural settlements near Indian reserves at Quatsino, Comox, Cowichan Bay, and Saltspring Island. Not coincidentally, these places were part of the visiting repertoire dictated by the DIA tours of inspection. Thus a continuity of themes and subject matter emerges across all documentary photographs produced on trips between 1866 and 1881, irrespective of the different eye behind the lens.

Hence the appointment of regional DIA Superintendent Israel W. Powell on October 6, 1872, proved to be a boon to regional photographers, as the commercial opportunities his tours of inspection offered were considerable.[96] Powell hired photographers on his various tours of inspection of 1873, 1879, 1881, and 1883, for "taking views of Indian Camps and photographs of different tribes."[97] Following the expedition, each photographer assembled a set of landscape views and ethnographic portrait "types" which were issued as commercial *cartes-des-visites* and stereo cards, or as scientific illustrations available for anthropological and museum clientele. A stereo-

scopic photograph presented two near-identical images taken at a certain distance apart by a special dual-lens camera. The final images were mounted side by side on a single rectangular piece of card. They were often captioned. The cards were viewed through a stereoscopic viewer, a contraption refined by 1863. The stereoscopic viewer fitted snugly over one's eyes, blocking out daylight and heightening the illusion of a three-dimensional effect. The parlor viewing of stereoscopic photographs was popular between 1862 and 1914, and views produced in this format were inevitably destined for a commercial market. After the 1890s, many views circulated as postcards when this format became popular among tourists and at curio shops (fig 2.7).

Charles Gentile, George Dawson, Benjamin Baltzly, Hannah and Richard Maynard, O. C. Hastings, and Edward Dossetter all benefited professionally from the DIA's bureaucratic management of Indians. While a small number of Asian photographers and a modest number of women photographers worked in the region as amateurs or professionals by 1900,

2.7
RICHARD MAYNARD
Nuu-chah-nulth at Cape Caution,
circa 1873, stereo card
British Columbia Archives #F08901

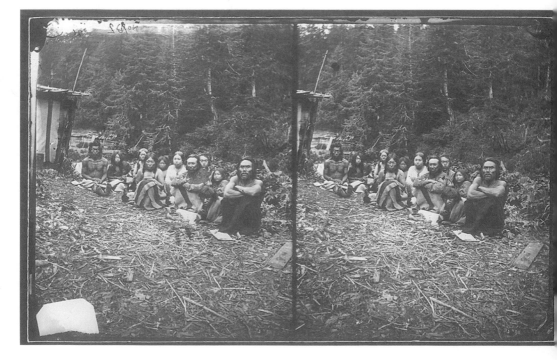

the photographers commissioned by the DIA were consistently Euro-American men who shared a vision that was prosettlement and prodevelopment.[98] Very little empathy or insight into the political demands of Native Americans was apparent. The fact that Dally claimed Indians were "still in a primitive state only one stage removed from barbarism," while earning his professional credibility and livelihood off representations of them, exposes the extent to which photographers of this era were socially segregated from their subjects.[99]

Exclusive of the photographers, each tour included specialized authorities who conducted other, seemingly pragmatic, regulatory bureaucratic tasks, such as census taking and the tabulation of depopulation caused by smallpox and other introduced diseases, such as malaria, measles, influenza, dysentery, whooping cough, typhus, and typhoid fever.[100] By shaping an account and census of scattered populations, these activities were politically motivated by the westward expansion of non-Native subjects of the developing nation-state. In 1873, 1879, and 1881, for example, Powell was accompanied by Alexander Caulfield Anderson, the inspector of fisheries and representative for the Dominion of Canada on the Joint Land Commission. The commission was responsible for negotiations concerning Indian land reserves of 1876. Other tasks assumed by the superintendent of Indian affairs included the appointment of cooperative Native American middlemen as special constables to monitor the traffic of liquor on reserves, and the mediation of disputes between fishers and Indians regarding reported abuses of traditional fisheries. Designed to quickly acquaint Powell with "the conditions and prospects of the most populous and important tribes inhabiting the Province," the inspections far exceeded that benign claim.[101] The use of gunboats, apparently employed to quell Indian unrest, was a testament to the government's readiness to intervene on behalf of Euro-American settlement.[102] On Powell's 1879 visit to Port Simpson, he demonstrated the military might of the HMS *Rocket* in response to a volunteer company of rifles formed by the local Tsimshian.[103]

Nine years following Powell's appointment, the bureaucratic structure of Indian administration expanded, with regional field agents appointed to act on various counts "in improving their [Indians'] moral and social condition . . . [and] securing the development and utilization of the reserves allotted to them."[104] Agents annually assessed the progress of federal policies of assimilation exercised through industrial and educational projects undertaken in their respective agencies. Indian policy of this era was a paternalistic combination of "insulation and amalgamation," whereby reserves were seen to protect Indians from white settlers, but eventually lands would be made available for purchase to British emigrants and Indians would be encouraged to assimilate into the non-Native population.[105] As Douglas Leighton has posited, "Though there were occasional expressions

of public concern and sympathy, there was no great public understanding of the Indian situation. The public saw the Indian as a 'brown White man,' assuming the factors which made for white advancement would meet Indian needs too."[106] While the photographic depictions or views of pre-contact traditions of "Indian life" had value for tourism and anthropology, the ongoing practice of traditional life ways was, in policy, forcefully dissuaded.

Commercial photographers, in general, upheld these core attitudes. Benjamin Baltzly, for instance, voiced the common refrain regarding the state of the Indian when he stated, "The Indians at Victoria appear more civilized, but no more than those at Kamloops. Taking them upon an average they are a poor, miserable class of human beings, very immoral and depraved."[107] If the earliest photographs of Coast Salish taken by the British Engineers Corps were motivated by an unfettered fascination, or earnest curiosity, commercial photographers, who followed in the wake of the engineers, could not claim such naïveté. They were informed not only by the mandate of expansionism but also by a body of evolutionary-based thought about race and inheritance predicated on European racial superiority. By 1873, the political motives for the documentation of Northwest Coast Indians had solidified and were applied through DIA policies that combined scrutiny, paternalism, and isolation as evident in the recollections of prominent departmental bureaucrat Duncan Campbell Scott:

> The close supervision which the government officers have given them [Indians] from the earliest times has resulted in conserving their estate and developing their aptitude for civilized life. The policy of the Dominion has always been to protect the Indians, to guard their identity as a race and at the same time to apply methods which will destroy that identity and lead eventually to their disappearance as a separate division of the population.[108]

The DIA's motivation for collecting photographic documentation of the coastal people and villages on these tours was not by any stretch of the imagination an *aesthetic* gesture, although the eventual redirection of these photographs into the commercial marketplace obfuscated the original political utility of the photographs. As Baltzly's comment reveals, the photograph was not a neutral bureaucratic device, but was used by those who subscribed to ideology that viewed Native Americans as inherently less civilized than Euro-Americans. The adoption of photography to systematically record Indians who, at that precise moment, were engaged in daily, sometimes violent, conflicts with settlers and government representatives over their rights to land, resources, and sovereignty was not coincidental. Photography was part and parcel of the colonial conquest in which "subject" peoples of the

state were classified and judged in accordance with theories expressed across the various social sciences including physiognomy, craniotomy, anthropometrics, and eugenics.[109]

The photographic initiatives of the early DIA inspection tours continued to stimulate interest in Indian life in last decades of the nineteenth century. This continuity is exemplified by the work of Richard Maynard, who was employed as photographer by the DIA on the HMS *Boxer* tours of 1873 and 1874.[110] Superintendent Powell expected Richard Maynard to document the conditions and survival of "Indian" life in Nuu-chah-nulth and Kwakwaka'wakw villages on northwestern and northeastern Vancouver Island, to record the region and people where in 1778 British Captain James Cook had "put Nootka Sound on the charts for all to see."[111] The photographs (including fig. 2.8), among the earliest surviving images of these coastal tribes, subsequently substantiated claims made in written reports submitted by Powell to the DIA in Ottawa.

Throughout their professional lives, both Hannah and Richard Maynard accepted commissions to produce documentary photographs for a diverse assortment of clients including provincial and federal Indian agents, U.S. explorers, museum collectors, civil servants, and, in Hannah's specific instance, the Victoria Police Department. Richard's early involvement with the DIA led to other significant government contracts. In 1881, he documented the construction of the Canadian Pacific Railway through the Fraser Canyon and the Cascade mountains "across deep lateral gorges, canyons and plunging cataracts" performed by a crew of 7,000 indentured Chinese workers at the estimated cost of $300,000 per mile.[112] Indisputably, the tendency of Maynard's documentary work over the course of his career "to advertise the natural glories of his adopted province" made his photographs attractive to provincial boosterism and was fundamental to his commercial longevity.[113] As Hannah Maynard determined, Richard was consistently commissioned to document all government functions occurring in or around Victoria.[114] In 1884 Maynard took advantage of the increasing commercial and ethnological interest in Indian life when he retraced the path of federal geologist-surveyor George Mercer Dawson with a photographic "exploration" of the Queen Charlotte Islands on the *Otter*. Described as "an extensive observer and faithful narrator, the tour's sponsor was U.S. entrepreneur and explorer Captain Newton Chittenden (see fig. 2.9), who produced pamphlets promoting "the interest of British Columbia."[115] The commercial motives of the Chittenden expedition were explicit: to "follow up the water courses to their sources, ascertain the position, extent and character of the arable lands, timber, mineral resources . . . and furnish the government and public with detailed reports thereof."[116] Chittenden also assembled "a number of very valuable ethnological specimens for the Provincial Museum."[117] That explorers like Chittenden ex-

2.8

RICHARD MAYNARD
Nootka Sound, crew of the HMS *Boxer*
with Nuu-chah-nulth villagers, 1873. Sign at
left reads "Indian Ranch at Nootka Sound,
where Capt. Cook was in March 1778."
British Columbia Archives #A-02693

pressed benevolent intention toward the salvaging of "vanishing" Haida traditions was not extraordinary, but an already established practice of removing artifacts that originated with the DIA tours of inspection. In 1873 on his visit to QCI, for instance, Superintendent Powell had recommended "that a collection of Haida art be made to form a nucleus for a provincial ethnological collection."[118] Some 350 artifacts collected by Powell on the 1879 tour aboard the HMS *Rocket* were dispatched to Ottawa and, by 1881, installed at the Geological and Natural History Museum in Montreal, where they illustrated "the history, manners and customs of the aboriginal Indian races of the Dominion."[119] Powell's 1881 trip on the HMS *Rocket,* documented by the AMNH-funded U.S. photographer Edward Dossetter (see fig. 2.10), also collected artifacts that were subsequently sent to that New York museum, including Tsimshian artifacts from the Skeena River area and a sixty-eight-foot Bella Bella canoe.[120] The collecting ardor initiated by Dawson, and sustained by Powell, Chittenden, and many others, lends material credence to the suggestion that government representatives worked in close alliance with museums and anthropologists. And collecting was not restricted to fabricated artifacts, as Boas's statement regarding the unpleasantness "to steal bones from a grave" revealed.[121] These pursuits and subsequent profits were enabled by official policies of potlatch prohibition, assimilation, modernization, and missionization of Indians. During the collecting frenzy, photographs from this period and earlier were used to guarantee authenticity of the displays and dioramas of artifacts, longhouses, and house poles that were reconstructed in museums in major cities in the eastern United States and Canada.

By the early twentieth century, photographs taken by Maynard, Dally, Hastings, and Dossetter influenced academic interpretations of the progress and decline of Native Americans in the remote villages of the Northwest Coast. In 1884, a local museum representative in Victoria publicly commemorated Richard Maynard's photographs for illustrating "the effects of civilisation on the [Haida] inhabitants, chiefly noticeable in the disappearance of the totem poles and old houses."[122] Charles Newcombe, the man responsible for the major museum collection in Victoria, even suggested that "Mr Maynard's name be perpetuated by naming some geographical feature of the Queen Charlotte Islands, to show our appreciation of his valuable ethnological photographic work done in British Columbia and Alaska as well as the large number of historical pictures taken preserved locally and on the Cariboo Road in the 60s and 70s."[123]

Once the Maynard photographs were displayed in a scholarly milieu of museums, the original bureaucratic or commercial motives for the taking of the photographs had been favorably muted. As time passed and Native Americans were assimilated through enforced acculturation and state policies, the historical and anthropological value of photographs taken on

2.9

HANNAH MAYNARD
Studio portrait of Richard Maynard
(standing) and Newton Chittenden (sitting),
Victoria, Vancouver Island, circa 1884
British Columbia Archives #A-1505

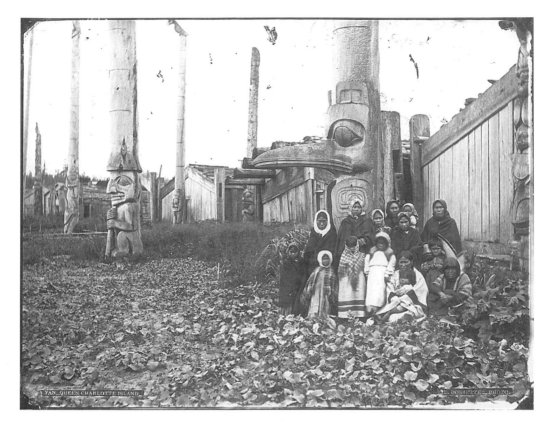

2.10

EDWARD DOSSETTER
Yan village, Queen Charlotte
Islands, 1881
Courtesy American Museum
of Natural History #44310

Northern Vancouver Island and the coastal mainland between 1873 and 1874 increased. Photographs of "Indian life" were sought by an ever widening variety of consumers who sought visual traces of presettlement culture. This market grew in tandem with the phenomenon of international anthropological concern with the preservation of Native Northwest culture, known today as the salvage paradigm. Tourists collected the *cartes-de-visites,* stereo cards, and postcards of Indians, as well as curios and travel memorabilia. Anthropologists used them to illustrate articles. Enterprising photographers thus capitalized on the wistful recognition that settlement was inevitable and had permanently transformed the frontier and its original inhabitants. Tourists, for obvious reasons, wanted romantic, rather than re-

alistic or unappetizing, views of the people, many of whom by century's end experienced a debased existence. The negative afflictions of contact and settlement—prostitution, alcoholism, contact diseases, and poverty—which plagued urban reserves, were expunged from the commercial lexicon, as were the modern successes of Native Americans. The markets—official, commercial, religious, and anthropological—for pictures of "Indian life" overlapped, expanding the lucrative prospects for the commercial entrepreneur. Even Boas spotted the potential for commercial profit when he proposed to write a illustrated "popular or maybe a semi popular book on this part of the country . . . I will try to sell the pictures to Scribner or to another magazine and in this way find a publisher."[124] Museums such as the Cambridge Peabody and the American Museum of Natural History sought commercial photographs to use as scholarly sources for displays and dioramas in which the presettlement existence of northwestern cultural groups was re-enacted.[125] With the merging of consumer markets, boundaries between documentary realism of the official photograph and the romantic fantasies associated with tourism became fuzzy. It became increasingly difficult for outsiders to distinguish fact from fiction, as the realities of quotidian Indian life were displaced from representation.

The official, commercial, amateur, and ethnographic motives for photographic representations of "Indian life" converged in the work of an individual practitioner named Benjamin Leeson. Born in 1866 in Warwickshire, England, Leeson arrived in Vancouver in 1886 with his father Joseph. Benjamin moved with the family to Quatsino between 1894 and 1895, was married in 1912, retired in 1939, and died in Vancouver in 1948. He received his first camera for his twenty-first birthday, and it was with this camera he documented trips to the Cariboo and Barkerville, compiling an archive of glass plates that was destroyed in a fire in 1891. He acquired an 8 × 10 glass plate camera in 1895 when he moved to Quatsino.[126] Unlike other photographers discussed above, Leeson did not sustain a professional studio or a direct relationship with the DIA, but he did generate an extensive archive of photographs of Indian life as a result of his civil service and regional associations with Kwakwaka'wakw families at Quatsino and Winter Harbour on Vancouver Island's northwestern coast. He also established a documentary record of individuals and European "pioneer" families in this same region. Leeson described himself as a man with "a strong interest in anthropology . . . [who] has unearthed many quaint legends, during a long residence in the district."[127] Like other photographers, Leeson complemented his earnings derived from photography with other, more dependable business activities—namely, working alongside his father on a floating flour mill until 1891 and then joining a partnership running a local store and clam-canning venture. By 1897, Leeson took on official roles in Quatsino and served as min-

ing recorder, postmaster, constable, coroner, and customs officer, holding the last position for over thirty-five years.

Known principally for his portraiture of Kwakwaka'wakw mothers, grandmothers, and children, Leeson's work is significant for his pursuit of two distinct strands of photographic production that, seen in a comparative light, constitute the dual poles of popular perceptions of northwestern frontier life. The most popular and commercially viable strand of this photographic activity was the Kwakwaka'wakw portraits. These images mirrored international trends in photography of North American Indians as exemplified in the photographic oeuvre of the better-known U.S. photographer Edward Curtis. Leeson believed that his own photographs of Indians at Quatsino complemented the interests of anthropologists, who were by then actively gathering data on the Kwakwaka'wakw. Distinguishing his initiatives as unique, he claimed, "Our anthropologists have gathered with great care many legends, tools, and utensils to inform us of the native life before the whiteman appeared, but it was the human touch, the variety of personalities what the very daily existence of these fellow human beings would have been in the past ages that the author's camera tried to catch, partly resulting in this collection."[128]

Leeson's romantic records of Indian life were offset by a second genre of photographs depicting the various "pioneering" Scandinavian families who had settled around Winter Harbour.[129] Leeson's own family history fit the category of the hardy pioneer. This second body of work representing frontier life was, however, less celebrated, and less historically influential, than his Indian portraiture. While Indians and settlers both resided in remote rural settings like Quatsino and Winter Harbour, by late century popular interest in Indian life overwhelmed the recognition of settlers and settlement who, as subjects, were largely effaced from the photographs marketed to tourists and anthropologists. By this date, the relation of settlers to modernity had been naturalized and their presence became less pronounced. On the other hand, the myth that Indians were in conflict with modernity, and in need of rehabilitation, was a sustained and consistent pictorial theme. Indians were depicted either as tragic victims, confined to the past and hopelessly facing extinction because of a failure or inability to acculturate, or as modern subjects who, by conforming to Euro-American life and habits, could anticipate a contented future because they had left the "savage" past and Indian traditions behind them. In contrast, the daily travails of settlers were unexceptional.

Between 1858 and 1900, opportunities for commercial photographers were intrinsically connected to a distinct set of economic, social, and political circumstances, contoured by conflicts between settlers and Native Americans. For the most part photographs produced by commercial pho-

tographers championed, rather than challenged, the changes and policies imported by settlement and colonial government. In the hands of surveyors the photographs were scientific documents, whereas for immigration boosters, photography was used to convey practical knowledge of colonial life to prospective immigrants. The DIA, alternatively, conceived of the photograph as a mundane component of modern bureaucratic record keeping, which innovated the procedures of social control. Commercial photographers employed photography more creatively but they, like civil servants, embodied the compulsion for documenting modernity or "progress" in the colonies. Photographs of emergent civil society determined that social progress had, against all odds, taken root in a previously desolate landscape and demonstrated that civility among the Indians, a population "naturally" inclined toward "savagery," was a pressing matter. If Native American subjects were uncooperative or unresponsive to photographic scrutiny, the significance of their resistance was discounted and used as further proof of their inability to appreciate modernity.

As for method, both commercial and government photographers relied heavily on narrative form, combining writing with images to "give structure to their beliefs and experiences . . . with themes made familiar in contemporary literary texts: the taming of the wilderness, the subjugation of its native peoples, and the westward expansion of American culture."[130] Thus the photographic "frontier" unquestioningly depended on a certain consensus in the conventions of display, such as a chronological arrangement of photographs to imply evolution over time as in the "before and after" presentation, which was most commonly employed to illuminate the positive effects of modernity on Indians. Written anecdotes, or captions, further directed the meaning of the photograph for the spectator. While documentary photographers freely ranged across a spectrum of photographic activity, a combination of political and commercial motives ultimately fueled the selection of subject matter, and the economic circumstances of this early stage in regional mercantile development lead to cooperation between photographers, government agents, and, later in the century, with anthropologists and museums. As a consequence, historical photographs generate a decidedly biased vision of frontier existence.

3

"She Was the Means of Leading into the Light"

PHOTOGRAPHIC

PORTRAITS

OF TSIMSHIAN

METHODIST

CONVERTS

While our knowledge of Native American women's response to contact is fragmentary, women were represented in written and photographic documents generated by explorers, traders, colonial travelers, government officials, and missionaries between 1830 and 1880.[1] The editorial concerns expressed by eighteenth-century explorers and early-nineteenth-century traders and travelers about women's dress, behavior, mobility, labor, and morality established a distinct pattern and a judgmental tone that gave way to a uniform call for the reform of Native American women by the mid–nineteenth century.[2]

During the trading era, Native American women performed valuable labor and assumed new roles, working as guides, packers, and interpreters, and these working relations led to increased intimacy with Euro-American men.[3] Nisga'a and Tsimshian women became wives of convenience for traders, as these women and their mixed-race offspring were vital to the maintenance and survival of northern maritime forts.[4] Some highly ranked Haida, Coast Tsimshian, and Nisga'a women willingly provisioned the demand for sexual services, as these women understood there was profit to be made from the gender imbalance among the Euro-American traders and, after 1858, miners.[5] As early as 1850 male kin, too, profited by "selling women, their daughters, and other women of low rank into white operated prostitution."[6] But Euro-American observers interpreted the act of selling or trading sexual services as morally depraved and were unable to fathom

how economics and social ambition might have compelled women, and their kin, into such transactions. With the arrival of missionaries and later with the appointment of government agents charged as overseers of Indian behavior, interracial relations were unfavorably viewed, and this change in opinion led to disparaging views toward any relations with Native American women. When Methodist missionary Jonathan Green visited QCI and southeastern Alaska in 1829, he claimed "that all the young women of the [Haida Kaigani] tribe visit ships for the purpose of gain by prostitution, and in most cases destroy their children, the fruit of this infamous intercourse."[7] In bemoaning the fact that the offspring produced by mixed-race intimacy were subject to self-induced abortion, infanticide, or abandonment Green did so less to mourn the loss of a child's life than to demonize women who performed such acts. With the midcentury arrival of Euro-American women settlers and the idealization of bourgeois femininity, the behavior and roles of Native American women were subjected to extraordinary scrutiny. Thereafter, intimate relations between Euro-American men and Native American women were heartily disapproved because white women were now available for procreative purposes.

After 1870, missionization was generally embraced as a viable, and expedient, vehicle for the reform and assimilation of coastal Native Americans of British North America. The social evangelical movement, conducted by Catholic, Anglican, and Methodist missionaries, reinforced the policies applied by the regional Indian agents. Self-sufficient model Christian communities such as Metlakatla, founded in 1862 among the Tsimshian by William Duncan and the Anglican Christian Missionary Society, worked toward protecting Indians from the negative moral climate stimulated by the presence of miners during the gold rush.[8]

Yet in some circumstances, conversion was a means by which individual Native American women improved personal status during turbulent times of change. Anecdotal accounts of two Tsimshian converts, Victoria Young and Elizabeth Diex, exemplified the success of Methodist evangelicalism among northwestern tribal groups. Yet the story of why Native American women gravitated toward Christian conversion is more complicated than the brief mentions in missionary memoirs allow.

Taking a biographical approach, this chapter investigates two honorific portraits produced between 1863 and 1879 of Young and Diex (figs. 3.1, 3.2) in order to illuminate the complex reasons why women converted. These two very different portraits help to reconstruct the lives of two individual women involved with the spread of Methodism among the Tsimshian at the northern coastal village of Fort Simpson. Notably, honorific portraits celebrate Native American women as respectable and sophisticated.[9] As such they went a long way toward disassociating Native American women with prostitution and the increasing spread of venereal disease.

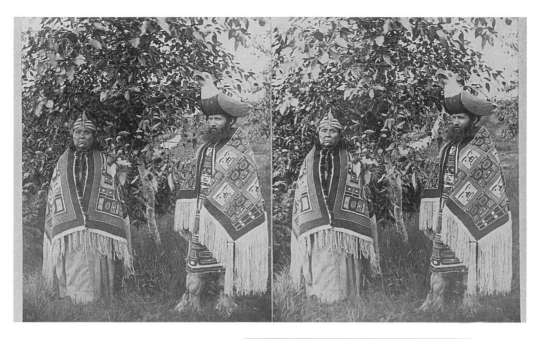

3.1

RICHARD MAYNARD
Shu-dalth/Victoria Young and
Thomas Crosby, taken on July
15, 1879. Stereo card issued by
the Maynard Studio, Victoria,
Vancouver Island.
Courtesy of the Royal British
Columbia Museum
Anthropological Collections
Section #PN4191

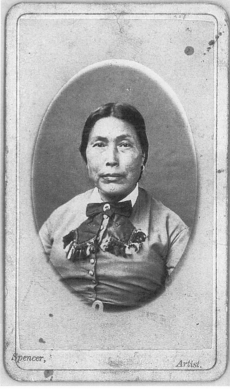

3.2

STEPHEN SPENCER
Elizabeth Diex, circa 1869–70
British Columbia Archives
#BA-95324

In their daily work, missionaries encouraged and stimulated cultural change, which they believed could be represented photographically. To advertise their success missionaries used the formula of the conversion anecdote, frequently illustrated by a pair of photographs, one taken before conversion and another after. For outsiders, the before-and-after conversion story signified the Native American rejection of physical modifications and garments associated with traditional ways, and the incorporation of settler dress signaled the adoption of Euro-American values. Missionary applications of photography contrasted with those of anthropologists who, arriving at late century, considered cultural change as loss. With the intention of documenting vanishing cultural practices and artifacts, anthropologists used photography as a tool of preservation.

Missionaries quickly apprehended the propagandistic power of photographs placed alongside personal testimony, which seemed to tangibly confirm that evangelical activity among the Indians had yielded widespread cultural and spiritual transformation. Anecdotes and photographs placed in field reports, memoirs, public lectures, and newspapers advertised successes to skeptical audiences at home and abroad. Personal letters illustrated by photographs were sent to Britain from the missionary field and were frequently reprinted in newsletters like the *Methodist Missionary Recorder, Missionary Notices of the Methodist Church,* the *Christian Missionary Society Gleaner, Missionary Outlook,* or the *Christian Mission Society Intelligencer.* In 1907 honorific photographs of Sallosalton and three other converts, Amos Cushan, Sarah Shee-at-ston, and Captain John Su-A-Lis, were used by Reverend Thomas Crosby in his memoir, *Among the An-ko-me-num or Flathead Tribes of Indians of the Pacific Coast by Thomas Crosby! Missionary to the Indians of BC,* to reinforce his missionary success in the region.[10] This account, like others of a similar genre, venerated the advancements made by evangelicals in Indian day and residential schools. Well-known Methodist missionary Charles Tate also used photography in public lecture tours not only to aggrandize his personal achievements but also to advocate continuing external financial support of his fieldwork at various stations in Indian villages along coastal British Columbia (see fig. 3.3).[11] Methodists working in the American West uniformly adopted this practice of advertising successes through illustrative campaigns in order to raise funds. Archivist Daile Kaplan has noted, for instance, that the success or failure of campaigns waged by Methodists in territory south of the national border "depended on the ability of photographs to convey a sense of mission to the viewer who responded with increased prayer and increased giving."[12] Using the argument that Indian commitment to the faith was never instantaneous or sudden but demanded a steady application of scrutiny and pressure, the illuminated public lectures given by Charles Tate and others called for sustained funding from potential supporters in order to keep the sinner, or newly

converted, within an ongoing spiritual embrace. It was necessary to convince supporters that true commitment to the faith could not be hurried. Caroline Tate, the missionary wife of Charles Tate, commented on the gradual process of conversion for a Kelsmat couple: "Alex and his wife are both more sensible than the generality of them, and although not Christians are steady attendants at Church, and we hope that the truth is taking root in their hearts."[13] Such evidence made requests for continued financial support of isolated missions and field missionaries in Indian villages more convincing. Missionaries, in general, had to overcome the public belief that Native Americans converted solely for self-interest or under pressure from priests or ministers, as evident in the caption accompanying Frederick Dally's photograph of Indians at prayer (fig. 3.4), a pose struck at the encouragement of a priest.

Unpublished papers and lectures of Charles and Caroline Tate offer insight into the various ways photography proved useful. Though the precise content of Charles Tate's promotional public lectures may never be recovered, the economic, personal, and ideological motives for them was clear. On a yearlong furlough campaign across Canada and the United Kingdom in 1897, Tate used the photographs he had collected during his various northwestern assignments to secure ongoing funding for Methodist evangelicalism among the Tsimshian, Sta:lo, and Coast Salish. And in 1898, Tate assembled thematic slide exhibitions and toured across British Columbia with a magic lantern projector, putting twenty-five years of his experience as a missionary to promotional effect. These public exhibitions, shown to both Euro-American and Indian audiences, were similar to a written memoir, as they were the means by which Tate dignified his personal contributions to Methodism after retirement. The titles of his lectures configured the ideological thrust of his repertoire around a "before-and-after" transformation. In 1899, he projected a "magic lantern exhibition at the Indian Church (in Victoria) . . . showing mission work in different parts of BC, and the difference between Christian and heathen people."[14] Between 1904 and 1915, Tate conducted another exhaustive speaking circuit exploring the topics of "Indians—savage and civilized" and "Manners and Customs of Indians in BC."[15] Tate's intention to illustrate the miracles wrought by evangelicalism most likely showed Indians improved by Western styles of dress, physical decorum, and hygiene, all of which appeared to signify Christian piety and virtue. Through conversion sinners found guidance along the evolutionary path from savagery to civility. Undoubtedly Tate described the experience of conversion for one of his Native followers, Captain John of Kultus Lake, "who there [at the Methodist's annual revival camp meeting], as he expressed it, buried his old heart in the ground, and left there his old ways."[16]

Although much criticized as advancing assimilation, convert photographs and life histories found in missionary memoirs notably distin-

3.3

UNKNOWN PHOTOGRAPHER
(possibly Charles Tate)
Handwritten caption on front
of the photograph reads, "Chief
Jacob-Popcum [*sic*]—BC."
Handwritten caption on back of
photograph reads, "A convert
when stationed at Chilliwack,
grand-daughter and great grand
children," taken between 1874
and 1880 during Tate's
appointment in Chilliwack,
mainland British Columbia.
British Columbia Archives
#BA-95327

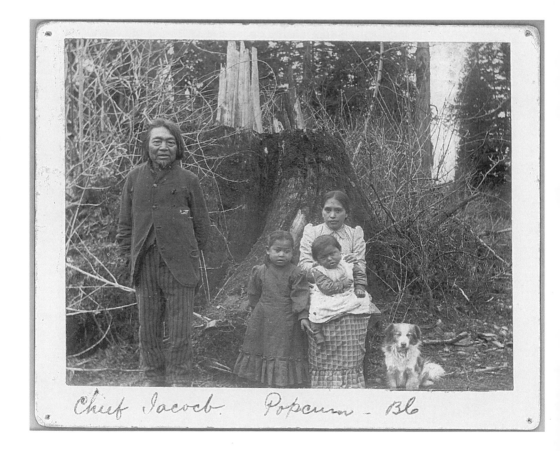

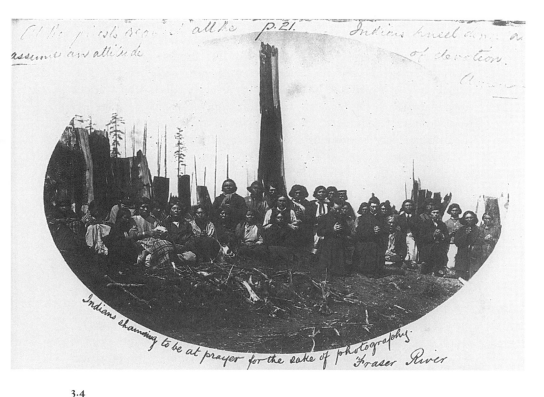

3.4

FREDERICK DALLY
Vignette photograph from
Dally's Album #5, entitled
"Photographic Views of British
Columbia, 1867 70"; caption
above the photograph reads,
"All the priests request all the
Indians kneel down and assume
an attitude of devotion. Amen."
Caption on the photograph
reads, "Indians shamming to
be at prayer for the sake of
photography."
British Columbia Archives
#E-04419

guished Native Americans as accomplished individuals, an approach that contradicted the larger social inclination to homogenize. Photographs, although a fragmentary and incomplete record of an individual's multidimensional existence, confirm the cross-cultural encounters between individual Native Americans influenced by evangelicalism and various missionaries active in the region. For example, photographic portraits and descriptions of teen preacher David Sallosalton, who was stationed among the Nanaimo people beginning in April 1862, animated the public lectures, regional reports, and published memoirs of Thomas Crosby.[17] The photographs of Sallosalton, who died in October 1872 of tuberculosis at age nineteen, captured a brief interval in an eight-year process of acculturation and Christian conversion experienced by one young man (see fig. 3.5). According to Crosby, "Sallosalton was brought up in all the rites and customs of paganism." About his initial encounter with Sallosalton, or Santana, his Indian name prior to conversion, Crosby observed "a bright little fellow . . . with no clothing on except a short print shirt, and painted up in the strangest fashion, with a tuft of his hair tied on the top of his head. Santana was a real flathead Indian, and had endured all the suffering belonging to such a barbarous custom." And further, Crosby implied, Sallosalton's metamorphosis from savage to renowned Christian orator after his conversion at age eleven renovated the material, as well as spiritual, state of his existence. "It was necessary," declared Crosby, as if inscribing the ideological message of the photograph, "to dress Sallosalton up a little more than he had been accustomed to if he was to live with a white man, and so a new suit of clothes was procured. He looked quite bright and neat in his new attire, and soon proved a useful and active assistant to the missionary in working inside and outside of the little home."[18] (See fig. 3.6.) Sallosalton's adoption of Euro-American dress, changed comportment, use of the English language, and dissemination of Christian beliefs among other Indians reflected a process of self-fashioning modeled by the dictates of his Methodist mentor.

Men and women who converted may have profited in several ways. First, conversion offered celebrated recognition and respect from the settler population. Second, as go-betweens on behalf of the Euro-American-headed missionary campaigns, converts commonly performed intermediary roles as educators and interpreters in villages of their kin, and in this way built bridges between the missionaries and the people. Finally, converts often received minor financial remuneration for services performed on behalf of the church. Thus convert photographs, like that of David Sallosalton, Victoria Young, and Elizabeth Diex, speak not merely of the renovation of personal appearance but also to the acquisition of new forms of social status and new relations with Euro-American men and women of the ministry. Similar arguments have been asserted by Michael Aird about the

photographic portraits of Australian Aborigine men and women, which provided insight into their response to overwhelming pressures to assimilate.[19] Photographs of this genre, Aird noted, reveal the ways in which individuals exercised an increment of control over their destinies in the face of oppressive government "protection" policies. The acculturated convert who clearly demonstrated improvement by dressing in European garments was more likely to be accepted by settler society, as the proof of changed appearance seemed to be the expression of a willingness to incorporate the introduced economic, cultural, and spiritual system. Yet the convert photographs symbolized something else entirely for settlers and missionaries: the power of Christianity to move Indians from the degradation of pagan savagery. The photographs of upstanding churchgoing Indians confirmed missionary success.

Both Thomas Crosby and Charles Tate consistently emphasized the contributions of male indigenous converts on the coast and paid much less attention to the influence of women such as Diex and Young, who received abbreviated mentions in missionary memoirs. But a reconstruction of these written and visual fragments, set in profile with the Methodist's advocacy of missionary wives for the education and domestication of indigenous women and girls, enlarges our view of women's roles in assimilation and conversion. Exactly what means and measures were devised to lure and convert Native American women? Determined to be the most effective routes for the reform of women and girls, residential schools, as well as mixed gender houses of worship, were quickly erected in tribal villages. As Thomas Crosby declared at the earliest stages of missionary activity among the Tsimshian at Fort Simpson, "There is no part of our work here that is more trying and yet more important than that connected with the young women of the place; they are exposed to peculiar temptations and up to this time there has been no restraint to their course of sin. . . . they must be cared for , and in some cases the only way to save them is to take them to the mission house."[20] Because of this the pedagogical task of domesticating Native American women and girls in the missionary's home and at gender-segregated schools, with the goal of insulating them from urban-based masculine corruption, fell to the wives and daughters of the clergy. Early on, Methodists and Anglicans adopted the policy of dispatching missionary husband-and-wife teams to the various coastal and interior villages, anticipating that the wives and daughters would assume an aggressive role in female reform work and that wives often replaced husbands when they were absent, as was the case when Caroline Knott Tate, who received her formal license to preach in 1898, frequently stood in for her husband, Charles, during his absences.[21] Thomas Crosby honored the contribution of his wife Emma as follows: "The efficient state of the school is no doubt owing in a great measure, to the energy and wisdom of Mrs. Crosby, who, from the

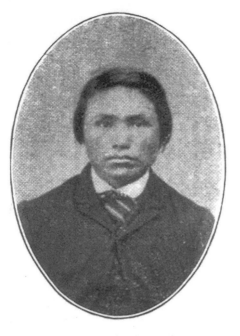

DAVID SALLOSALTON.
An eloquent Indian Preacher of
British Columbia.
(1853-1871.)

3.5
UNKNOWN PHOTOGRAPHER
Caption reads, "David
Sallosalton: An Eloquent Indian
Preacher of British Columbia,
1853–1871."
British Columbia Archives
#1-46955

3.6 *facing*
UNKNOWN PHOTOGRAPHER
David Sallosalton (standing)
and Thomas Crosby (sitting),
circa 1870
British Columbia Archives
#B-05223

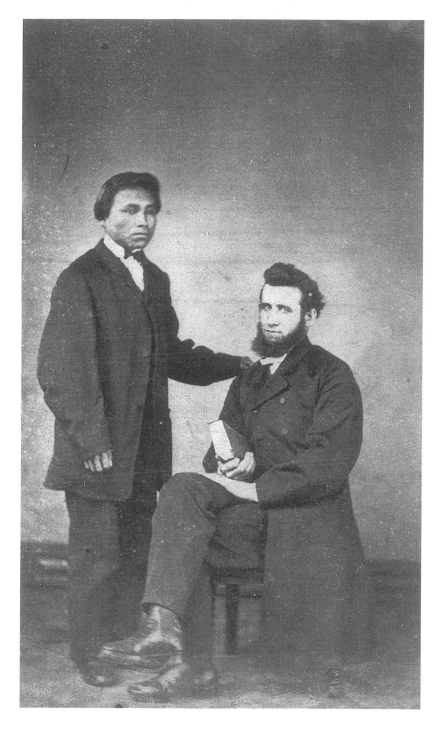

time of her arrival at the Fort [Simpson] has taken a deep interest in train-
ing the native mind, and having had such a through training herself, she was
especially qualified to give it the best possible shape."[22] The DIA also ap-
proved of the involvement of wives. For instance, the Indian agent's wife at
the Cowichan Salish reserve "began at once to help her husband with his
work among the Indians . . . and in his absence . . . had many difficulties to
settle and advice to give."[23]

Caroline Knott Tate exemplifies how missionary wives were expected
to guide Native American women into the faith. After graduating from the
Methodist school in Hamilton, Ontario, and before her marriage, Knott
had accepted a position to teach at Thomas Crosby's day school for girls at
Fort Simpson in October of 1876. In accord with Methodist policy regard-
ing missionary wives, she, like Emma Crosby, claimed duties within the fe-
male domain of the calling, including the "training up" of women and chil-
dren in domestic and household skills within the educational facilities built
by the missionaries.[24] She and her husband later cofounded the Co-
qualeetza Industrial School for Indian students in British Columbia's Fraser
Valley in 1887, and her ten-year reputation as a teacher of Indian women
and girls was integral to the financial pledge granted to the school by the
Toronto-based Methodist Women's Missionary Society.[25] Residential
schools, she would claim, "offered the only feasible plan of dealing with the
children," and, like others, she praised the inculcation of Indian girls with
Christian ideals and European standards of domesticity and femininity.
During special holiday events—which served as the Christian surrogate for
traditional potlatch ceremonies—women and children were recruited by
Knott Tate to collect and prepare the special foods distributed after the serv-
ices, as "the creation of native Christian mothers was a large element in the
evangelistic effort."[26] The annual celebrations, moreover, afforded a public
stage for assessing whether individual women and girls had conformed to
the codes of femininity expected of them.

Anglican reformers Mr. and Mrs. Henry Schutt similarly directed their
attention to domesticating women when they established a women's mis-
sion house at Kincolith at the mouth of the Nass River, where a community
of 150 Christianized and 60 unbaptized Nisga'a adults and children lived.[27]
Their daughter Margaret Schutt, who was fluent in the local dialect and was
often engaged as village interpreter, held her mother up as the feminine
ideal to which the mission schoolgirls were expected to aspire. She recalled
the daily regiment in "home making and subjects of Christianity" whereby
"ten pretty Indian maidens were taken into the mission home, and became,
under my mother's tutelage, efficient cooks and homemakers. . . . can still
see them clad in neat, homemade dresses of brilliant hue, and large woolen
shawls, walking off to church. The girls did the house work, taking turns,
two each week, in the various phases of the home, run very smoothly and

well, under my mother's immaculate housekeeping methods."[28] As is evident, women's conversion under the auspices of the female-run mission house was not exclusively spiritual but required conforming with Euro-American habits of domesticity and housekeeping.

As the reconstruction of the life histories of Victoria Young and Elizabeth Diex demonstrates, it is unrealistic to assume that Native American women and girls complacently submitted to missionary demands to convert and conform. While many coastal Native American women did embrace Protestantism, this did not necessarily imply an absolute subordination to Euro-American ideologies. Rather, conversion was accepted, or resisted, for culturally specific individual motives. Victoria Young and Elizabeth Diex both originated from Tsimshian territory, yet their response to Protestantism and reasons for conversion significantly diverged. The photographs of Young and Diex, interpreted alongside statements by Thomas Crosby, Charles Tate, and others, expose the circumstances as women in search of stability in the face of social and cultural transformations wrought by contact.

Victoria Young, also sometimes identified by her Indian name of Shudalth, was a Gilutsau coastal Tsimshian noblewoman of the Kispaxatot clan.[29] In the sole photograph we have of her, Young stands next to Thomas Crosby, who was stationed in Tsimshian territory at Fort Simpson beginning in 1874. His relationship with Young was first noted in a Methodist newsletter in February of 1876 when he mentions enclosing a "picture of the "chieftess Sudalth [*sic*], Victoria Young, as her name now is."[30]

But why did the Methodists seek out converts in Tsimshian villages? Fort Simpson, built in 1831, and located at the mouth of the Nass River south of the Alaska panhandle, was one of many strategic trading posts founded by the Hudson's Bay Company on the Northwest Coast. Besides the prosperous fur trade conducted with "King George's" men, indigenous residents earned their principal wealth from the seasonal run of small oily fish called *oolachans,* which they employed "in every conceivable form, and for almost all purposes . . . what they do not use they trade with the other tribes and with the white people."[31] In 1856, British Admiral James Prevost offered free passage to any missionary that the Christian Missionary Society could provide, proposing that Fort Simpson be the premier missionary station on the mainland northern coast because of its "many advantages for prosecuting the objects of the mission" and claiming that missionaries working there would be protected by the company.[32] According to Prevost, Fort Simpson might also be advantageous as it gave missionaries access to approximately 15,000 members of coastal and interior tribes who converged there each spring to "receive the commodities of the company in exchange for skins," affording the opportunity for "conversing with the natives, and giving them religious instruction. Here, too, a school might be opened for

the native children, where they would receive an industrial as well as reli-
gious and secular education, and be secluded from the prejudicial influ-
ences of their adult relatives."[33] Prevost's offer was accepted by an Anglican
lay missionary of the Christian Missionary Society. William Duncan estab-
lished the first mission at Fort Simpson but later relocated a number of
Tsimshian coverts to greater isolation by creating a model village of Met-
lakatla in 1862.[34] The Methodists entered the community of Fort Simpson
some ten years after Duncan's departure.

Taken on or around July 15, 1879, at Fort Simpson by Richard May-
nard, the stereoscopic photograph commemorated a portentous political
event in the Indian village attended by both Thomas Crosby and Victoria
Young.[35] It was the occasion of a visit of the HMS *Rocket* carrying Israel
Powell, the federal Superintendent of Indian Affairs. Powell's chief object
was "to visit the scene of the fishery disputes of [the nearby] Skeena
[River]." On Powell's stopover at Fort Simpson, Young was one of six
Tsimshian representatives presenting a series of grievances to the govern-
ment civil bureaucrat. In their formal address, "presented and read by the
Wesleyan missionary, Mr. Crosby," the Fort Simpson Tsimshian demanded
the Crown immediately resolve their conflict with the Hudson's Bay Com-
pany regarding "the land question" and also that fishing grounds on the
Nass and Skeena Rivers be preserved for the people. Powell reproduced a
draft of the address in his report to the DIA the following month. The
Tsimshian's grievances were signed by the six leaders "on behalf of the In-
dian tribes residing at Fort Simpson." One of these was "Shu-dalth, or Vic-
toria Young." That Shu-dalth was the sole female signatory on this disposi-
tion made to the Crown attests to her elevated or noble status among the
local people and in the eyes of Powell. In the address the Fort Simpson
Tsimshian expressed alarm over the Hudson's Bay Company's claims to the
land on which the village stood and questioned whether they might be sub-
ject to eviction. Phrased to appease the government's agenda of assimila-
tion, they spoke of a fear of being displaced by the Hudson's Bay Company,
which, they complained, "kept many of our people from building and im-
proving their houses," and they hoped "before too long to have all the old
houses out of the way, and an entire new village." At the time of Powell's
visit the total village population numbered approximately 900 and the
Methodist Church, headed by Crosby, claimed a membership of 258, with
100 to 150 students attending the school. Undoubtedly scripted to a certain
degree by Crosby, the Tsimshian's address transparently upheld the goals of
the missionaries to eradicate the long houses and support the mission
school, which was determined to be of "of great importance and benefit to
our children and young people," as was the Crosby Girls' Home tended by
Mr. and Mrs. Crosby, described as "a great blessing to our young women
and to the whole community."[36]

In his memoir Crosby had insisted that Shu-dalth was crucial to the advocacy of Christianity among the northern Nishga'a and Tsimshian, and this appraisal matched descriptions of male converts celebrated by the Methodist leadership, such as David Sallosalton, Phillip MacKay, and William Pierce. Another Methodist minister described her as "a woman who has great influence among her own people, and is much respected by the Nass people," and on the occasion of her conversion Crosby noted, "she was generally very calm, dignified and deliberate, and was often a great help to the Missionary in counsel and advice among the people."[37] According to Crosby, Shu-dalth meant "New Woman," and this title announced her status as a recent convert. After three months of spiritual instruction Crosby had baptized the forty-eight-year-old Shu-dalth alongside her consumptive father, Eagle Chief Rapligidahl, in Fort Simpson on January 2, 1875.[38] In written records her Christian forename, Victoria, and the surname of Young (and sometimes Yonge) was placed alongside "Shu-dalth." The consistent application of both names was meaningful as it emphasized her importance as cross-cultural intermediary but also suggested that she was not easily disabused of the Tsimshian convention of multiple names. Interestingly, although Crosby discussed the Indian convention of a double name in relation to David Sallosalton, he rarely employed Sallosalton's Indian name of Santana with the same degree of consistency.

Whatever his opinion on this matter, Crosby acknowledged Shu-dalth's ongoing influence and rank within the governance of the Fort Simpson Tsimshian when he stated, "being a woman she did not always sit in council, although, on account of being a chief, she was often requested to do so. Whenever she knew that there was likely to be a tie vote on any important question, she would be there; and after nearly all the men had spoken, she would speak in her dignified way."[39] Crosby's awe of her prestige and rank is visceral throughout his relatively brief commendations of her leadership. As head of a committee of home visitors, she also fulfilled what Crosby must have considered a more appropriately feminine role by attending to the sick and poor. As a councillor, Shu-dalth stood on the platform with other influential village elders of the village council to address villagers who assembled to discuss vital matters.[40] In their address to Powell, the people expressed an explicit request for self-governance through the village council, but phrased this request cautiously by firmly aligning themselves with the goals of the missionaries: "The council is great benefit to the community, and does much with our missionary to keep peace and order in the village; they have a difficult and responsible duty to perform and we hope they may have a word of encouragement from you."[41]

On another level, the photograph, like the carefully phrased Tsimshian address to Powell, served a self-promotional and propagandistic purpose for Thomas Crosby. Although government and Methodist aims for assimila-

tion frequently coincided, there were occasions when the political aims of
the government conflicted with those of the missionaries, who often lived
closer to the people and exercised informed sympathy in ways government
agents did not. As noted by Thomas Crosby in 1889, relations between the
Indian department in British Columbia and the Methodists had long been
strained, with the government accusing the missionaries of causing trouble
among the Tsimshian at Fort Simpson and the Haida at Skidegate.[42] The
most common form of government control over missionary activity in re-
mote villages was delivered through the granting or withdrawal of funds to
village residential schools. In 1875, Powell established the basic criteria for
support: "Mission societies . . . will take measures to increase the number of
schools, and take advantage of the material assistance afforded by the gov-
ernment in granting a sum of money to every school which can show a cer-
tain average attendance of Indian pupils. On account of the migratory char-
acter of the Indians, great difficulty has been found in retaining an average
attendance of thirty, the number required by a school to entitle it to the an-
nual grant of $250."[43] To prevent the loss of much-needed government fi-
nancial support, the missionaries had to keep enrollment figures high. In
addition, financial support was always tenuous. With Catholics, Anglicans,
and Methodists competing for converts and the education of Indian chil-
dren, the government also took care not to show any sectarian favoritism, as
noted by one observer in 1870: "Government although giving cordially to
these missions every countenance and moral support in its power found it
impractical to grant them any pecuniary aid from the consideration that by
so doing it would be involved in the invidious position of appearing to give
special state aid to particular religious bodies."[44] As a result of this situation,
the presiding missionary necessarily treated federal authorities' visits with
care. It was in the missionary's economic interest to represent themselves as
obedient servants of the state and its policies. The function of the photo-
graph taken on the occasion of Powell's visit in 1879 therefore had much to
do with Crosby's aspiration to prove his qualifications to serve and educate
the Tsimshian, especially following in the wake of the extremely popular
Anglican ministry of William Duncan. With Shu-dalth at his side, Crosby's
credibility was heightened and his acceptance among the Fort Simpson
Tsimshian asserted.

Shu-dalth's participation in the formal process of negotiation with the
federal government on the issue of territorial and fishing rights also moti-
vated the taking of this photograph. That an older woman wielded political
leverage through a position on the village council might have surprised
Euro-American men like Powell. Shu-dalth's community status must have
motivated Richard Maynard to document her for historical posterity. The
photograph encodes a contrary powerful image of womanhood that not
only challenged Euro-American patriarchal norms of femininity but also

undermined the prevailing negative sentiment about Native American women. Crosby's presence in the photograph affirms that he understood that Tsimshian women inherited power and position through age and matrilineality, a form of social organization fundamentally different from his own. That Shu-dalth exacted reverence and respect from Crosby to the extent that he thought it appropriate to be seen as her equal speaks not only of his ambition but also to her political and cultural prominence. Crosby, an intrusive but minority presence in a relatively remote community, could not afford to question Shu-dalth's rank, clan, or family ties. Undoubtedly, his wearing of Tsimshian garments and headdress for the photograph gestured toward reciprocity and respect for Shu-dalth and her kin.

In his written appraisals of Shu-dalth, Crosby avoided passing judgment on her behavior and traditional dress. If it was customary of missionaries to view a Native American woman's attachment to traditional ways and dress as incorrigible, Crosby's silence on this matter, reinforced by his wearing of ceremonial garments in the photograph, affirmed Shu-dalth's noble stature. Shu-dalth, despite Crosby's public declaration of her "conversion," demanded submission, and her role in the negotiations with the Crown protected her from the customary criticisms advanced by missionaries like Crosby. Crosby held precarious footing among Tsimshian constituents, and for this reason he necessarily had to sustain the trust of the people through strategic alliances. The photograph, then, is a visible testament of Crosby's respect for Shu-dalth driven by his aspiration to win approval. Thus the full-frontal defiant gaze of an influential woman named Shu-dalth proudly wearing Tsimshian ceremonial dress challenges the more commonplace impressions of hapless impoverished Indians represented in commercial portraits of indigenous street sellers, who were often shabbily dressed and rarely granted the respect of being identified by name or tribal affiliation. With the inclusion of ceremonially garbed Crosby, a "civilized" Christian man of public repute, any moral shortcomings an uninformed viewer might project onto Shu-dalth were eliminated. For outsiders his civility and stature lent civility to her.

The head-and-shoulders studio *carte-de-visite* portrait of Methodist convert Elizabeth Diex, taken by Stephen Spencer around 1863, was less exceptional than Maynard's stereo card portrait of Shu-dalth and Thomas Crosby in Tsimshian garments. Although the photograph of Diex was taken prior to her conversion and possibly during the years when Diex labored as a domestic in the household of Judge William Pemberton in Victoria, no photograph of Elizabeth Diex wearing traditional Tsimshian garments has been found.

As mother of hereditary Chief Skagwait (also known by the Christian name of Alfred Dudoward) of the Lower Skeena River Gitandau Tsimshian at Fort Simpson, Elizabeth Diex (also sometimes Deaks or Daix) was a

woman of high status.[45] The story of Diex's remarkable transformation as recounted by Thomas Crosby, Caroline Tate, and Charles Tate was, in their view, demonstrated by her adoption of Euro-American dress and Christian habits and, most significantly, by her role in the conversion of her son Alfred in 1872 or 1873. Alfred had been educated at Metlakatla and in service to William Duncan, that mission's lay leader. Both Alfred and his wife, Kate, subsequently aided Thomas Crosby in his pedagogical and religious aspirations for Fort Simpson beginning in 1874. Educated at an Anglican school in Victoria, Kate Dudoward eventually taught at the Crosby Methodist School alongside Caroline Knott Tate and Emma Crosby. As Thomas Crosby asserted in 1875, "Alfred and his wife still assist [in the schools], and I hope they will be favourably remembered by the [Methodist Central] committee. They are a great help to us indeed; we could not proceed without them."[46] Alfred and Kate's daughter Alice would also teach in the Fort Simpson school. Conversion profited the family across three generations.

According to all missionary accounts, the Methodists' success at the formerly "heathen" Fort Simpson originated with Elizabeth Diex, who had experienced a miraculous conversion at a revival meeting held at the Methodist Indian church in Victoria around 1872. This meeting stimulated a mass conversion of between forty and fifty Indians from various villages on the north coast.[47] Apparently Diex had been so enthralled with the words of indigenous convert Amos Shee-at-ston that a week later she sponsored a prayer meeting in her home that resulted in the subsequent conversions.[48] Soon afterward, she was baptized and accepted the Christian name of Elizabeth. Moreover, it was at this time that Diex introduced Alfred, who previously was "a desperate and lawless character, living in riot and debauch," to the "peace and joy which she herself had found."[49] She was, as Crosby recalled, "a woman of commanding appearance and of great force of character, and exerted a powerful influence over her people," so much so that she was "the means of leading into the light quite a number of her own people who were wandering in sin on the streets of Victoria."[50] These circumstances, metaphorically described as a "rich harvest of precious souls," quickly led to an invitation to Crosby to come to Fort Simpson for the purpose of establishing the mission and school. Arriving in February of 1874, "he found hundreds of people hungering for the truth and eagerly waiting for a missionary."[51] Crosby's description of Diex's spiritual transformation and the proof of her evangelical success across multiple generations of her family and tribe reinforced distinctions between those who assimilated and those who did not. And Diex's contributions in preparing Fort Simpson for the spiritual work of the Crosbys and the Tates matched Methodist beliefs that the spread of the faith among the Indians would take steady root only if aided by indigenous insiders. Caroline Tate clarified this policy in her

statement that "a campaign is never won by its officers alone. In the army it-self lie the possibilities of victory or defeat."[52]

These two examples of Shu-dalth and Diex show that Methodists clearly understood that the conversion and reform of women was essential for the transformation of Indian culture and lifeways more generally. In many ways their Methodist beliefs coincided with the policies of the DIA and in particular with the DIA's legislative section 12 (1)(b) of the 1876 Indian Act. By defining who was and who was not an Indian, the federal Indian Act not only increased social stratification among Indian people but also caused women who married "out" to non–Native American men to lose their status. The children of these unions also lost their status. Used for the alleged purpose of stimulating assimilation through behavioral change so that Indians would be "culturally indistinguishable from other Canadians," the act was effectively segregationist.[53] For Indians, the act made matters of privacy—spiritual activities, residential space, physical appearance, tribal and kin relations, child rearing, food gathering activities, the consumption of alcohol, and other basic components of daily life—subject to state surveillance and public regulation. It defined "Indian" by three criteria supporting patrilineality: any male person of Indian blood reputed to belong to a particular Indian band, any child of this male person, and any woman who is or was lawfully married to such a person. Those who were excluded from holding status as Indians were illegitimate children, individuals who had continuously resided in a foreign country for five years, those classified as half-breeds who had benefited from treaties elsewhere, and finally, as specified in section 12 (1)(b) of the act, women who married non–Native American men. These marriages "out" were supported by federal legislation, because women who married Caucasian men were no longer considered Indians. Missionaries stationed in isolated villages were expected to support and enforce such policies.

For Native American women, section 12 (1)(b) of the Indian Act represented a decisive break with the preceding trade era when they had leveraged economic and social opportunities from social affiliations with foreign traders.[54] By 1876, the legislative proviso of section 12 (1)(b) was an instrument by which Native American women were encouraged to conform to Euro-American ideals of reproductive and marital behavior. By declaring "that any Indian woman marrying any other than an Indian shall cease to be an Indian within the meaning of this act, nor shall the children issue of such marriage be considered as Indians," section 12 (1)(b) disenfranchised women who married non-Natives from their cultural ancestry as Indians, divesting them of tribal privileges, property rights, reserve housing, and use of reserve burial grounds. Legally enveloped by the status of their husbands, women were ostracized from their own tribal and clan divisions and dispossessed of their ability, within matrilineal or bilateral structures, to

transmit property and rights to their children. Moreover, the children of these marriages lost their status as Indians. As a result of these marriages the British, patriarchal system of property and marriage law and the biologically related, nuclear, male-headed family gained increased footing.[55] Section 12 (1)(b) acted to gradually reduce the number of Indians through the erosion of female ancestral lineage, a process that legislated assimilation. Given that mothers, grandmothers, and aunts were pivotal to the transmission of culture and language across the generations, the impact of section 12 (1)(b) was grave. Although it is difficult to determine whether or how section 12 (1)(b) was enforced within isolated villages like Fort Simpson, a formal marriage to a Euro-American man had concrete material and political implications for women. On one hand, women were dispossessed of tribal privileges and yet, on the other hand, such marriages might afford an increment of respectability in the eyes of settlers and missionaries. After losing her Indian status by marrying a Caucasian man, conversion might have been an attractive choice for some women. A religious affiliation with the Methodists and their churchgoing membership may have permitted individual women to acquire an alternative form of status to replace that lost through a marriage.

Given the moral sentiment regarding the questionable respectability of Indian women and the changing legislative environment of the 1860s and 1870s, Elizabeth Diex's motivations for her Methodist conversion may have been directly associated with her relationships and, later, marriage to non–Native American men. Other circumstances, which occurred prior to her conversion in 1872, also may have influenced her decision to join the Methodists. Diex had borne her son Alfred with a French-Canadian man named Dudoward, but she subsequently resided "in the habit of the country" with a Fort Simpson customs officer named Lawson. After initially declining his proposal of marriage because she "feared he would desert her as other white men had done to their Indian wives," she legally married Lawson.[56] Before her marriage to Lawson, Elizabeth Diex worked as a household servant to the prominent Judge Pemberton, but was dismissed from this position over an apparently wrongful charge of theft.[57] At this juncture, then, three notable actions were taken: Diex married Lawson, converted to Methodism, and, by 1872 or 1873, returned north to Fort Simpson. The humiliating event at the Pemberton household may have represented a turning point. Any respectability she might have earned among Victoria's urban elite from her formal marriage to Lawson or from her employee association with Judge Pemberton must have been lost. This episode, which occurred prior to her conversion, must have caused Diex considerable anguish and personal embarrassment, perhaps even shame, and may have been influential in her decision to return north and attempt to recapture her reputation with conversion. Therefore, by the time of her public commitment to

Methodism, Diex had experienced intimate, but not wholly positive, encounters with Euro-American society in the southern economy of Victoria.

Diex's exile from Victoria after her experience in the Pemberton household hints at the vulnerability, and in certain cases descent into destitution, experienced by northern women, many of whom necessarily went south in search of labor. Although northern coastal women ably adapted to the regional economic transformations by becoming day laborers, household domestics, door-to-door traders, and casual sex laborers, they placed themselves in settings not always safe or reputable. In contrast, men contracted out their expertise as interpreters, packers, canoeists, and trailblazers but were indisputably less susceptible to the injustices or abuses more likely to occur behind the closed doors of the private household. We may never recover the precise shape of the accusations leading to Diex's dismissal, but police charge books suggest that charges of theft were frequently brought against female domestic workers.[58]

As a woman who left the northern village of Fort Simpson in search of labor among the settler population of southern Vancouver Island, Diex's path to assimilation was more conventional than Shu-dalth's. Diex had possessed recognized status as a chieftainess among the Gitandau Tsimshian, but her intimate affiliations "out," first to Dudoward and later to Lawson, and her experience as a domestic in Victoria afforded her a familiarity with Euro-American culture and economy. These experiences and associations must have tempered her status, or rank, among her own people at Fort Simpson. Her conversion to Methodism may have provided a means to re-enter the community at Fort Simpson, especially after the troubling episode in the Pemberton household. Although the reasons women like Diex aligned themselves with evangelical churches were varied and complex, the circumstances suggest that Diex's relationship to her own people at Fort Simpson may have changed, given her marriage to a white man and the legal scandal in Victoria. The authority she garnered with her new relationship with the Methodists, augmented by the conversions of her son and daughter-in-law, may have eased her return home.

Parallel to legislative reform, the missionization of women was yet another component of assimilation. For Native American women, cooperation with missionaries promised benefits such as respectability, skills, wages, and status beyond the tribal hierarchies, during a complex time contoured by economic transitions and cultural change.[59] From what we know of the life of convert Elizabeth Diex, her renewed status as a public figure associated with Methodist conversion of the Tsimshian allowed her to regain some degree of respect that may have been lost with her southerly migration, her marriage out of the tribe, and the accusations of theft. The existence of individual honorific photographic images of Diex and Shu-dalth, alongside public declarations made by prominent missionaries about these

women, show that both had strategically adapted to a shifting political and social landscape during an era when the social actions of Native American women were generally cast in an unfavorable light. They both made advantageous use of their associations with the missionaries and overcame the economic dependency and the accompanying despair that Native women would inevitably face after the turn of the century.

Between the eighteenth and late nineteenth century, Native American women adapted to the new and ever changing economic and cultural demands of the Euro-American exploration, trade, mining, missionization, and settlement. If, in an earlier economy, women from Haida, Tsimshian, and other northern tribes earned wealth and status through their sale of sexual services to explorers, traders, and miners, by the 1880s a growing dependency on social assistance from the federal DIA was recorded. The DIA attributed the rise of welfare dependency on the loss of nomadic, seasonally based hunting and gathering lifeways, the maladjustment to resource and industrial capitalism, and the decimation caused by imported diseases. As one agent reflected:

> In 1880 the only visible means of livelihood of these people had disappeared. During the next twenty years they subsisted largely on the bounty of the government. Tuberculosis spread among them, and after the manner of most newly introduced diseases, assumed the form of an acute epidemic. . . . Early efforts at education almost failed owing to the high mortality among the children in residential schools. . . . Housing and social conditions were as bad as they could well be among a population which had no experience whatever in living in settled locations.[60]

In retrospect, this agent's interpretation that Native Americans did not fare well with trade and industrialization is not entirely convincing. Women adapted by employing a multifarious range of economic strategies: by providing sexual and household services to bachelor traders and miners, by the sale of goods and domestic services to private households, and by marketing handmade goods to tourists. Some individual women, like Diex and Young, and men, like Sallosalton and others, sought new forms of social respectability and income by establishing what might be identified as professional relationships with missionaries and the agenda of reform.

Less apparent in official documents is the "moral panic" of Euro-Americans in response to Native American women's involvement in sexual commerce, hard labor, and community leadership. Exposing a fundamental fear of women's economic and cultural agency, Euro-American moral panic manifested itself in a widening call to reform, what we now see as the imposition of repressive, culturally biased models of femininity and domesticity.

The misconceptions of Native American women held and promoted by Euro-Americans were tightly bound with the long history of representing them as morally impoverished and fused to traditional ways and practices, but these views had more to do with the construct of the Euro-American as modern savior and the countervailing claim that Indians were incompatible with modernity. The evidence retrieved from an interpretation of contemporary photographs and missionary texts conveys a more progressive vision of the Native American woman's fight for survival.

By century's end the pressure on indigenous men and women to assimilate was intensified. By 1885, on the joint recommendation of missionaries and regional Indian agents, a prohibition was passed forbidding the spiritual and cultural activities practices unique to Indian tribal culture including the potlatch, all winter ceremonies, secret societies, dancing, and the use of tribal languages.[61] While the enforcement of the prohibition remained in the hands of individual government field agents and was often unevenly prosecuted, it nevertheless made all Indians who engaged in rituals or ceremonies potentially criminals. In some agencies field agents, like some missionaries and priests, openly tolerated the potlatch and local potlatch and winter ceremonies persisted. Where they were suppressed, cultural traditions disappeared, were transformed, or went underground.[62] Under the dictates of these prohibitions, the garments proudly worn by Shu-dalth and Crosby in the Maynard photograph of 1879 would be unlawful.

4

"Of
*Moral Qualities
That Would Render
Them an Ornament
to Their Sex"*

EURO-AMERICAN

WOMEN RISE

TO PROMINENCE,

1870–1890

Euro-American women arrived in the Northwest later and in smaller numbers than men, and perhaps for this reason their contributions to settlement have been seriously underestimated. Colonial modernization, conventional history suggests, was fueled by a male elite leadership striving for economic success, with their pursuits occasionally vexed by the more than 20,000 volatile working-class bachelors drawn to the region by the promise of gold. This narrative was firmly embedded in the emigrant guides, which reveal much about masculine needs and expectations but little of settler women or their responses to the indigenous women they encountered daily on the frontier.[1] Unconventional sources provide an alternative to this masculinist narrative. Diaries, letters, published memoirs, and oral histories convey not only the heightened sense of elite settler women's social and cultural importance as mothers in service to the nation but also the perception of threats, real or imagined, from women of other classes and races.[2] Family and baby portraiture, genres largely commissioned by a female clientele, also offer revelations about women's interests. Often marginalized as sentimental, these genres of photographs embodied the growing political and social entitlement among settler women of all classes. Settler women's concerns over interracial intimacy, the dissolution of class and race divisions, household management, childbirth, child mortality, and maternalism emerge from seemingly trivial day-to-day artifacts and observations.

In the late nineteenth century the frontier was theorized as a homoge-
neous process that revolved around Euro-American men and their west-
ward progression into and conquest of "unexplored" territory, and with this
construct, it was proposed that the sequential struggle with frontier circum-
stances produced a composite nationality for the American people.[3] By
using rugged individualism or hardy masculine pioneerism as a pivot
around which environmental, economic, and social transformation re-
volved, regional and amateur historians inevitably reproduced the historical
exclusions of this narrative.[4] Against this monolith, the work of contempo-
rary social, cultural, and environmental historians has addressed the long-
standing oversights on gender, cultural diversity, race privilege, and the in-
equities of power, allowing for the reconceptualization of the frontier as a
conflict-driven space where culturally diverse groups competed for re-
sources and cultural supremacy.[5] This revisionary approach more accurately
reflects the Euro-American competition for indigenous resources and terri-
tory taking place in the earliest stages of maritime trade, governance, and
settlement in coastal British Columbia and Vancouver Island.[6] More re-
cently, the ideological and material contributions of female immigrants and
women of indigenous ancestry also have been subject to investigation.[7]

Unfortunately, historical photographs used a limited choice of subjects
to convey the modern attractions of the northwestern British colonies—
such as transportation, resources, industries, civic, and domestic architec-
ture—reinforcing the vision of settlement as a process wholly dominated by
masculine interests and labor.[8] An 1878 list of available stereoscopic views
from the studio of Hannah and Richard Maynard included "freight wagons
and machinery at Yale, Boston Bar, Indian camps at Hell's Gate, Indian Re-
serve Commission camp at Boston Bar, steamer Reliance, suspension
bridge over the Fraser . . . gold mining near Boston Bar, Chapman Bar bluff,
canyon at Hell's Gate, Tilton Creek, Yale Creek and mountain scenery."[9] In
these images and descriptions, the frontier seems a politically neutral envi-
ronment conquered by the machismo, engineering feats, and mobility of
Euro-American men. Yet the gender and class divisions of social space were
perniciously embedded in pictorial representations, making men and
women's participation in colonial development seem neatly bound. For in-
stance, images of settler women's lives, usually depicting them in leisure or
social activities, seem comparatively passive and pampered compared with
landscape photographs featuring hardy men engaged with the construction
of bridges, wagon roads, civic architecture, mines, dockyards, wharves,
ships, and so forth. Settler women posing in front of cottages or stately
homes surrounded with children, babies, and domestic servants, organizing
games, strolling through domesticated gardens, or serving refreshments at
picnics established women as symbols of affluence and gentility. In these
representations, settler women were construed as gentle tamers who im-

ported the trappings of home and civil society from urban centers of the east or from Britain, bringing with them a penchant for civilized pastimes such as religion, education, the arts, and leisure. These designations of public and private space held that Euro-American men—as administrators or manual laborers—alone built the necessary frontier infrastructure, while women tended the hearth or matters of child rearing.

Photographs portraying the building of the colonial infrastructure were placed in emigrant guides of the era and consistently illustrated contemporary regional histories. Topographical images of natural and manmade phenomena revealed the extensive physical mobility and productivity of the colonists (including the photographers) but shed no light on the imperial contest over territory that granted them and others access to such routes. Studio portraits, in contrast, glorified the existence of individual government officials or elite men and their families but less explicitly illustrated the idea that frontier development was progressing in a timely fashion. Hannah Maynard's composite montage of prominent Euro-American men, entitled "B.C. Pioneers" (fig. 4.1), celebrated a group of male elites, but the historical worth of these men was not evident in the photograph alone. Knowledge of their contributions to settlement depended on local knowledge or companion writings. Daguerreotypist George Fardon, who arrived in Victoria from San Francisco in 1858 and established a photographic gallery on Government Street, photographed Victoria's uppermost tier of the governing elite, including Governor Sir James Douglas and Lady Amelia Douglas; Arthur Kennedy, the third governor of Vancouver Island; Judges Matthew Baillie-Begbie and Peter O'Reilly; and Mayor Thomas Harris.[10] The civic contributions of these individuals were better advertised than Maynard's "B.C. Pioneers" and therefore required less supplementary written records beyond the image. For the most part, however, studio portraiture relied heavily on a caption or companion description to inform the viewer of the sitter's status and historically meaningful accomplishments.

With the invention of cheaper processes like the tintype, or ferrotype, and a competitive commercial environment in the urban centers of the region, studio portraiture became more economically accessible to increasing numbers of individuals and families of a lower and middle social class. These settlers used photographs to chart upward social mobility and commemorate significant stages in the life cycle, including engagements, weddings, and baptisms. Women became significant consumers at this time. Indeed, for female clientele the portrait became a "household necessity."[11] Studio portraits and in-situ depictions of homes and family were dispatched in correspondence to family and friends abroad to advertise the success of their new lives on the frontier. Symbolically, the portraits of babies and children acquired international currency as a testament of women's maternal

4.1
HANNAH MAYNARD
"B.C. Pioneers, Mrs. R.
Maynard, photo," Victoria, n.d.
British Columbia Archives
#1.51985

contributions to the growth of Euro-American populations in the distant colonies of the empire.

A useful starting point to this investigation of women's use of the studio portrait, and the importance of baby and child photography in particular, is to consider how women were conventionally being represented and discussed. Three studio portraits depicted women of Fort Victoria's prominent governing family—Amelia Douglas, the wife of Governor James Douglas, and two of five daughters, Agnes and Jane.[12] In these photographs the sitters are conventionally posed. Hannah Maynard's portrait of Lady Amelia Douglas, by then a widow, shows her seated in an ornate stuffed chair (fig. 4.2). Her entire body is included within the pictorial frame, at the edge of which stands a small studio table top-heavy with a vase of flowers. Her hands are gloved. Her head is bonneted. The portrait of Jane, the Douglas's second eldest daughter and wife of Alexander Grant Dallas, who suc-

ceeded Sir George Simpson as the governor of Rupert's Land, is tightly fo-
cused (fig. 4.3). Her body is depicted from the hips up. In front of Jane rests
a collapsed parasol placed on a low fabricated wall. This wall creates a sense
of a barrier between her and the viewer. Jane Douglas Dallas's hands are
firmly clasped at her waist, and the bow of her bonnet echoes the tension of
her grip. A pose in profile was selected for Agnes Douglas Bushby, the third-
born daughter, who married the register general of the supreme court of
British Columbia (fig. 4.4). The profile of Agnes, with her head slightly
tilted, emphasizes the elaborate shape of the bustle on her scalloped-edged
dress, a complex coiffure, a fan displayed in her hand, and the shape of her
nose and jaw. Ornate tables placed in front of and behind her body seem
like bookends. Like the other two women, Agnes gazes away from the cam-
era's lens as if to reinforce gentility. To stare directly out of the frame at the
camera would be an affront to the spectator and dishonorable of the sitter's
elevated social status.

If these three photographs are unexceptional in pose, framing, dress,
and conventions of studio decor, the commentary about these women and
their appearance is not. The photographs, which highlight social re-
spectability and status, may have been part of an effort to counter the many
derogatory statements made about the Douglas girls. For the most part,
scorn for the women revolved around their mixed-race ancestry. Amelia
Connolly Douglas was the daughter of Irishman William Connolly, the
chief factor at Fort St. James, and a Cree woman named Suzanne with
whom Connolly had a thirty-year relation in the "custom of the country."
As Sylvia Van Kirk and Jennifer Brown have shown, these informal cohabi-
tations "à la façon du pays" between Native American women and the earli-
est of the Hudson's Bay Company factors and traders were common in the
early years of settlement, as the men economically profited from such affili-
ations.[13] As settlement and female immigration increased, some men aban-
doned their informal affiliations with Native women to enter legal mar-
riages with European women. Although social and racial intimacy was
sanctioned well into the mid–nineteenth century, with Governor James
Douglas and his officers setting the example by marrying "half-breed Indian
women" and many of the wealthier colonists visibly displaying "a large ad-
mixture of Indian blood," such alliances were repudiated in the decades
after 1858.[14] Social acceptance of the earlier arrangements waned with the
development of the agrarian frontier and the greater availability of Euro-
pean and lighter-skinned women for wives.

The children of mixed-race liaisons in the urban settlements of the
colonies, like Amelia, Agnes, and Jane Douglas, were a discomforting re-
minder to the first waves of Euro-American travelers and settlers that the
trading and gold rush era had been riven with sexual chaos and class disor-
der. Public and official discourse progressively held that the sexual appetites

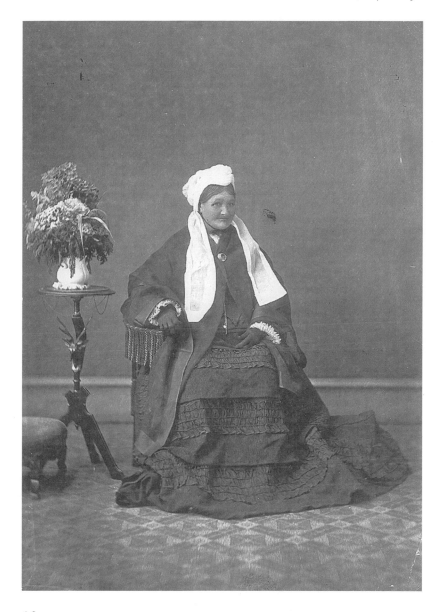

4.2

HANNAH MAYNARD
Amelia Douglas in widowhood,
Victoria, September 22, 1880
British Columbia Archives
#A-01235

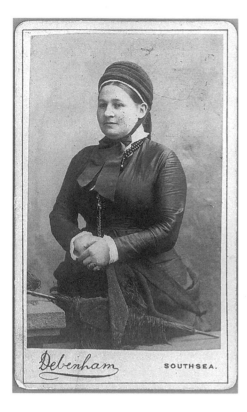

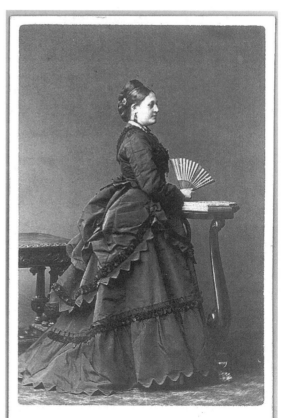

4.3
DEBENHAM STUDIO
Jane Douglas, Southsea, n.d.
British Columbia Archives
#H-3721

4.4.
STUDIO OF ELLIOTT
AND FRY
55 Baker Street, London
Agnes Douglas, n.d.
British Columbia Archives
#BA-A5567

of traders and miners had been corrupted by the availability of Native American women prostitutes and that this unusual situation had encouraged moral depravity.[15] Guidebook authors attempted to reassure prospective immigrants that the times of disreputable mixed-race frontier intimacy was over, that social distinctions of race, class, and gender were stable and that more orderly social divisions were emerging, akin to those found in Britain.[16] To solve the problem of misdirected sexual appetites of unruly miners, the migration of upstanding Euro-American women was advocated. A consensus was emerging: the benefit of female immigration was a more amenable, racially homogenous atmosphere for the raising of children and the cultivation of polite society. This view effectively tainted Native women as disreputable and undesirable.

Euro-American women were equally opinionated on these issues. Sophie Cracroft, the niece and traveling companion of Jane Franklin, wife of missing explorer Sir John Franklin, commented explicitly on interracial mixing while visiting the coastal Northwest fort settlements of Victoria and Sitka in 1861 and in 1870.[17] Her encounter with Lady Amelia Connolly Douglas exposed the escalating public condemnation of all manner of racial intermixing. The Douglas daughters had achieved social mobility and respectability not only because of their relation to the landholding governor but also through marriages to affluent and well-placed Euro-American men.[18] With increased British settlement imminent, Cracroft expressed consternation over the fact that the Douglas women—Amelia and her four daughters—had transcended their origins. Finding the social aspirations of these women suspect, Cracroft wrote:

> Mrs. Dallas [Jane Douglas] is . . . exceedingly agreeable if not quite pretty, but the Indian type is remarkably plain, considering that she is two generations removed from it. She has a very bright complexion, pretty dark eyes and the other features very tolerable—but . . . the great width and flatness of the face are remarkable, and even her intonation and voice are characteristic (as we now perceive) of her descent.[19]

By commenting on Dallas's lingering Native American characteristics, Cracroft conveyed her belief that Dallas's Indian ancestry was incompatible with the elevated social stature she had attained and implied that such women were impostors. Other remarks added force to Cracroft's slight:

> Luncheon with the Governor's wife. . . . Have I explained that her mother was an Indian woman, and that she keeps very much in the background; indeed it is only lately that she has been persuaded to see visitors, partly because she speaks English with some difficulty;

the usual language being either the Indian, or Canadian-French, which is a corrupt dialect. . . . a younger sister Agnes . . . is a very fine girl, with far less of the Indian complexion and features than Mrs Dallas. Considering the little training of any kind that these girls can have had, it is more wonderful they should be what they are, than that they should have defects of manner. They have never left Northern America, nor known any society but such they now have—in fact they are only now, during the last 2 years since the colony began to encrease [*sic*], within reach of any society at all beyond that of the usual few employees of the HBC attached to a fort. Mrs Douglas is not at all bad looking, with hardly as much of the Indian type in her face, as Mrs Dallas . . . She has a gentle, simple and kindly manner which is quite pleasing, but she takes no lead whatever in her family.[20]

Cracroft negatively coupled the social ambitions of the Douglas women with their Native American heritage. By casting a shadow, albeit politely, upon the social and racial "defects" of the Douglas women, Cracroft affirmed the legitimacy of her own social prerogatives of class, race, and national identity.

The secretary of the British Boundary Commission expressed similar opinions about "half-breed" women, writing, "In the evening we all went to a ball . . . where we met all the young ladies of Vancouver. They only number about thirty and are not very great beauties. . . . most of the young ladies are half-breeds and have quite as many of the propensities of the savage as of the civilized being." He, too, scrutinized the social behavior and visages of the Douglas daughters, demonstrating his ignorance of regional tribal distinctions by mistakenly identifying their ancestry as Coast Salish Kwakwaka'wakw, rather than Plains Cree: "Two of the Misses Douglas, the Governor's daughters, had their heads flattened whilst they were young but it is now scarcely visible. They had just had some hoops sent out to them and it was most amusing to see their attempts to appear at ease in their new costume."[21]

Another British civil servant cruelly portrayed Lady Douglas as "a good creature, but utterly ignorant she has no language but jabbers French or English or Indian," while christening another daughter, Cecelia, "a fine squaw" and chiding Agnes Douglas as "a fat squaw, but without any pretence to being anything else." The acerbic daggers of this writer arose, in part, from professional resentment: he perceived Governor James Douglas as governing by a "family clique . . . feathering their nests as fast as they can."[22] While envy and resentment of the Douglas's Hudson's Bay Company fur trade connections sparked his disrespect, his assessment of the Douglas girls echoed the opinion that women of mixed-race ancestry were

unable to transcend the negative taint of heredity. Evidently, only a healthy import of Euro-American women could rectify the problems of colonial civil society.

Cracroft's observations on the idiom of race in the colony were not limited to the Douglas women. Sarah Lester, the daughter of two African American descendants who had immigrated to the colonies in 1858, was happily characterized as "fair as I am, with nice ladylike manners and appearances."[23] Cracroft classified African American immigrants as one "element in the motley population of Vancouver Island. . . . the term coloured is not applied to the Indian, but only the Negro race." Much to her surprise, habits of race segregation practiced south of the border did not extend to the British colony, where "we saw the unmistakeable descendants of Negro, in Mrs. Woods' little school of 30, side by side with the English and American girls."[24] The all too frequent occasions to intermingle with women of other races tested the benevolence of upper- and middle-class British women, like Cracroft and Franklin, as did the dissolution of class distinctions. The negative aspersions cast upon the Douglas women with respect to their social inadequacies and inherited race characteristics reflect the rising level of discomfort experienced by the upper strata of British newcomers faced with a chaotic frontier environment. Social boundaries were in the process of disintegration. Dismayed by the legacy of men's affiliations with Native American women, Cracroft, as did others, called for the reassertion of racial boundaries, but her distress also rested on class angst. Her sympathies, obviously, lay with upper- and middle-class immigrant women of pure blood, not with mixed-race women who had transcended their social place.

Aspirations toward race purity, which surfaced in these earliest decades of settlement, also intensified during the Asian and Caucasian labor conflicts of the 1880s, and these assertions subsequently translated into legislation against Asian immigration.[25] Chinese men who worked as indentured laborers and free miners faced extreme, organized hostility from Euro-American immigrants. At public meetings as early as 1860, local leaders criticized Chinese men for their lack of reproduction, even though earliest Chinese immigration was nearly exclusively restricted to men.[26] Few men brought wives, and many critics felt this a threat to the moral climate of the colony, though they failed to encourage an increase in Chinese female immigration.[27] During the gold rush era, some Chinese women were indentured as prostitutes following, like Native American women, the "movement of miners and labor through Victoria to the sandbars of the Fraser River, [and] brothels . . . in the cities and towns along the mining trails."[28] Incidents of Chinese prostitution as well as minor opium use among Chinese and Caucasians stimulated an exaggerated fear of Asian/European interracial mixing, or miscegenation, as expressed in wit-

ness testimonials published in the *1885 Report of the Royal Commission on Chinese Immigration*.[29] Estimates of how many Chinese women were actually involved in prostitution were imprecise. One witness at the 1885 Royal Commission testified that 150 Chinese prostitutes were practicing provincewide, whereas figures assembled in November 1900 by the Chinese Benevolent Association found only four prostitutes in the entire urban center of Victoria.[30] The 1885 Royal Commission on Chinese Immigration resulted in the first Chinese Head Tax of 1886, which constituted "perhaps the most important constraint on [Chinese] women's entry to Canada."[31] By charging $50 for each new arrival from an individual family, the head tax, in conjunction with anti-Chinese societies organizing as early as 1873, effectively quashed the possibility for the growth of Asian families. By 1900, the head tax had been increased to $100. For their part, Euro-American settlers anxiously vacillated between calling for increased immigration of Chinese women to deflect the potential for Chinese men's associations with Euro-American women and the denunciation of Chinese women's perceived immoral tendencies. A house of rescue established by the Women's Missionary Society in Victoria espoused a mandate to protect and reform Chinese female prostitutes.[32] Mixed-blood, Native, and Chinese women were uniformly equated with immorality and seen as unworthy companions.

The anti-Indian and anti-Chinese sentiment of the colonists was formalized by the federal Indian Act of 1876 and the Chinese head taxes levied between 1885 and 1911. These policies arose from the mistaken equation that physical and cultural difference was incompatible with the expansion of Euro-American settlement. If a degree of ambiguity surrounded the issue of interracial intimacy prior to the 1870s, by 1885 public sentiment championed race purity, as testified by the following statement by a representative of the workers' advocacy group, the Knights of Labor:

> the [Dominion] should endeavor to settle her lands with an intelligent, independent people, imbued with the spirit of patriotism, and bound to their brethren in the other provinces by the sympathetic ties which always exist between those who are akin in blood, who speak a common language, who have the same manners and customs, who have been trained under the same laws, institutions, rules, and usages and who are animated by the same hopes, aims, and aspirations.[33]

In the view of this miner and many others, British-born Caucasian men and women were not only the preferred immigrants but they were also simply the best suited in terms of procreative relations.

The proposed alternative to immoral affiliations with non-Euro-American women had always been an increase in female immigration. By 1862 sponsorship of female immigration was supported by two societies: the Columbia Emigration Society and the London Female Middle-Class Emigration Society.[34] The Church of England, assisted by patroness Angela Burdett-Coutts and in cooperation with Victoria's Anglican Bishop, initiated a Columbia Mission Society campaign for the passage of destitute and working-class British girls between the ages of twelve and fifteen on "brideships" bound for the colony in order to encourage a "family centered existence . . . a nucleus of Anglican and English Society."[35] Edward Mallandaine, the author of Victoria's city directory, married a woman who arrived in the colony by way of the brideship *Tynemouth* and recalled, "Great was the excitement in Victoria when this cargo of femininity arrived."[36] Public sentiment harmonized on this point: that working-class female immigration was a panacea to the bad sexual habits of working men, and at the same time the colony would be racially cleansed, becoming more British. "I have been delighted," Macfie declared, "to see the beneficial change effected by marriage, in arresting the progress of dissipation . . . the paucity of respectable females in Vancouver Island and British Columbia limits so much the opportunities of single men who desire to cultivate domestic virtues, and lead sober lives."[37] The debates over the immigration of women whose presence was "urgently required on social and moral grounds," the complaints about the shortage of domestic servants, and fears surrounding interracial intimacy reflected a social/political/economic nexus concerned with the building of the nation.[38] First, the indiscriminate sexual appetites of miners had to be curtailed. Second, national racial purity had to be secured through the association of these men with modest and respectable Caucasian women to insure the growth of a "healthy," meaning Euro-American, population. Finally, if these conditions were not met, single male immigrants would leave for California in search of "their interesting object and not unfrequently are they tempted to remain on American soil—their industry as producers and expenditure as consumers being lost to the colonies."[39] For all these reasons, female immigration became pivotal to British regional security and steady expansion of the Empire.

Working-class female immigration, moreover, was doubly profitable— marriages converted bachelors into upstanding citizens, and the women's labor also resolved the shortage of domestic workers experienced by upper-class households, a particular concern among elite women. Many bemoaned the seemingly overwhelming struggle of maintaining quotidian comfort in the "wilderness." Although Sophie Cracroft expressed ongoing support for the British colonization of Vancouver Island and British Columbia, her reflections on the pending loss of status threatening upper-class

female émigrés was not a wholly positive advertisement for colonial life. Servants, in her opinion, earned inflated wages, while the women who hired them were victimized by the scarcity of help. "It is the ladies who are most to be pitied," she claimed, "as they must absolutely and unreservedly devote themselves to the smallest cares of every day life—at any rate they must expect to have their hands so filled day by day and be prepared for the worst." Combining an encouragement of immigration with a dose of frontier reality, Cracroft warned of the disintegration of the class-based hierarchy familiar to English ladies. As she noted, "there is not a single lady in the colony who has a nurse, a cook and a housemaid, so she has to be one of these, if not all three." Cracroft's anecdote concerning the household of an Anglican reverend where "the positions of mistress and servant have been for some time nearly reverse" highlighted the rupture of class divisions and more significantly, predicted the use of Native American women to replace Euro-American women who left for improved circumstances or to marry. According to Cracroft, the lady of the house

> is just about to lose her only servant—a woman whom she brought from England, and made the great mistake of believing the right person to engage, because the woman had already been in America! . . . Mrs Pringle finds her lying on the sofa in the little drawing room where she continues to take ease, not withstanding the entrance of her mistress! At another time she prefers the armchair with a newspaper which she continues to read as long as it suits her! The other day she accused her mistress of telling "a lie" which was more than could be endured, so Mrs Pringle gave her notice to leave; and will replace her by a young Indian girl from Mr. Garrett's school if he can select one willing to go to Hope. You can imagine the task of training before her![40]

With the arrival of working-class women colonial society became increasingly stratified, and yet the rhetoric about racial differences was gaining force, especially as Native women stepped into the vacancies left by the departure of Euro-American women. Indeed, from contact onward, individual Northern and Coast Salish women and children had cultivated an informal service economy catering to the consumer needs of Euro-American settlers. These women and children gathered foodstuffs, such as berries, halibut, salmon, and clams, and produced "cottage industry" goods and wares, such as baskets and knitted goods, selling these products door-to-door in exchange for secondhand clothes and other necessities. As Helen Dallain remembered, "My mother was always glad of a chance of getting Indian baskets from them for they, the women, made all kinds and sizes of useful and beautiful baskets and hampers and were very willing to trade

them for a few cast off garments of the white people."[41] Native women had created an independent casual doorstep economy to provision the consumer needs of the Euro-American settlers, as documented in memoirs and photographs. Dallain referred to the value of the goods on offer: "It was quite usual to see the women in shawl, woven peaked hats and a basket on their back with either clams or a salmon or with bundles of finely split gumsticks under their arms, wandering through the city looking for customers. Usually in those early days a qua-ta (25 cents) would buy either and with either you got a very good value for your money."[42] Although most welcomed the products offered by these vendors, others complained of "seeing the old kllotchmen—the squaws, you know, the Indian squaws—walking up and down Government Street with a bag on their backs selling calms and sitting on street corners. . . . there were lots of them around there. . . . They used to make terrible sounds, noise—shouting and screaming and all that sort of thing."[43]

Emily McCorkle Fitzgerald, an army doctor's wife, purchased household goods and services from Native women, as did British émigré Eleanor Caroline Fellows, a resident of Victoria. Fellows hired individual northern Haida and Nuu-chah-nulth women as nurses and domestic servants for her household and interacted with female street peddlers from the Songhees Salish reserve.[44] She described the labor and character of Lucy, a young Nuu-chah-nulth woman who worked in her household, as follows:

> Lucy . . . had come under the influence of Bishop Demers and his Catholic missionaries. . . . she was as good a girl and as sweet-tempered, capable, industrious as any maid could be. She used to paddle her small canoe across from the village, draw it up, and leave it on the pebbly shore, appearing at our door, punctuality personified . . . Lucy was clever at washing the household linen . . . at cleaning rooms, at doing many odd jobs which made her, very literally, a help.[45]

While rural settler Ethel Leather assumed the majority of household tasks associated with the gathering and preservation of food at harvest time, she contracted a local Sooke woman to clean, salt, and smoke sixty salmon for her family, a task that Leather had neither the skills nor patience to perform herself.[46] Native children as well as women possessed marketable skills and knowledge of value to settlers, as apparent in the comment of Susan Moir Allison, wife of a rancher in the Similkameen Valley, who hired or bartered domestic services from local Native women and children. "The children flocked around and I got lots of help with my housework from them," she wrote. "On washing day one or two boys would come . . . to clean knives, polish stoves, and were a great help and

amusement."[47] With a husband rarely at home and the nearest Euro-American neighbors some forty miles down the valley at a Hudson's Bay Company post, isolated rural women like Allison necessarily relied on individuals from the neighboring Similkameen tribe for midwifery. With the approach of childbirth, Allison, who might otherwise have relied on male kin or female settlers for medical advice and birthing assistance, sought the healing expertise of a local Similkameen woman who administered "whiskey" and "smoothed" her bed in her time of "female emergency" when all others were absent. While Allison reluctantly qualified her compliance to this emergency situation by stating, "Suzanne was very good to me in her way—though I thought her rather unfeeling at the time. She thought that I ought to be as strong as an Indian woman but I was not," her mistrust of Suzanne and her extended family eventually softened.[48] Still, in general, Allison's responses to local indigenous women repeated certain basic stereotypes introduced by Cracroft. Editorials on the striking or unseemly attributes, the appropriate or inappropriate garments, and the behavior of individual Native women or children leaven her declarations.[49] Fixated on appearance as the signifier of essential difference, Allison measured the outward fashion and comportment of Native women against her own more sophisticated culture and habits, opining that it was both inappropriate and impossible for them to adopt the fashion or gentility of British women. Reasserting the boundaries of race, she thought Native American women were, at best, poor mimics.

Early studio portraits of lower-ranked Native urban street vendors produced between 1860 and 1870 confirm the existence of this tier of impoverished female labor. Just as Allison's comments reflected an obsession with superficial signs of respectability and femininity, the manner in which these women were portrayed photographically also fixated on visible signs of racial difference as evinced in dress, pose, and props. These photographs are a striking departure from the portraits of the Douglas women and other assimilated or mixed-race women. The portraits of casual vendors of the urban doorstop economy represent the opposite pole of a widening class division among those of Indian ancestry. Individuals were posed against stark walls or the makeshift backdrop of Hudson's Bay Company blankets, wearing rudimentary garments and holding occupational goods to identify their mercantile specialty. Poverty and occupation were signified in numerous portraits, including that of Teanie, a street hawker, seen in a portrait taken by Hannah Maynard and in portraits of anonymous potato, fish, and basket sellers taken by Frederick Dally (figs. 4.5–4.7).

As the distinctions between these images and those of the Douglas women indicate, class as well as racial divisions were encoded by certain conventional uses of props and poses. Ornate hand-painted backdrops, depicting lavish Victorian interiors or English pastoral landscapes, were ex-

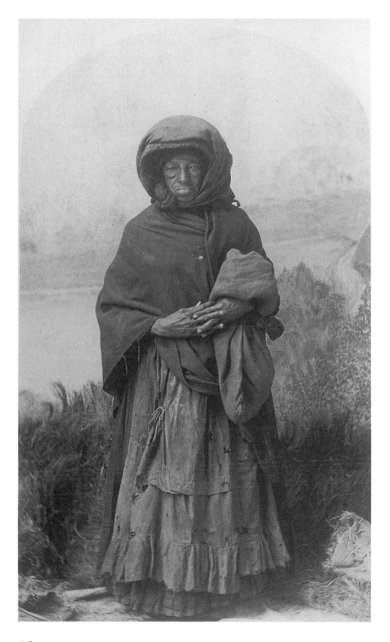

4.5
HANNAH MAYNARD
"Teanie" or "Tini," who lived near Fort
and Cook Street in Victoria, circa 1880s
British Columbia Archives #A-2193

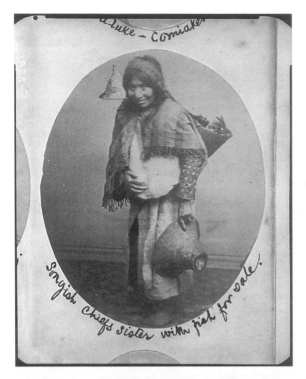

4.6
FREDERICK DALLY
Caption reads, "Songish [*sic*]
Chiefs sister with fish for sale,
Victoria." From Dally Album
#5, circa 1868
British Columbia Archives
#F-08291

4.7
UNKNOWN PHOTOGRAPHER
(from Newcombe Collection,
Charles Tate files)
Clam diggers, Cowichan,
Vancouver Island, circa 1900(?)
British Columbia Archives
#BA95325

clusive to bourgeois clientele or Native women of mixed ancestry. Unassimilated laboring Native women sat cross-legged or on their haunches, staring directly at the camera, while settler or mixed-race women, as in the portraits of the Douglas women, sat or stood upright poised on or near elegant velvet horsehair chairs, their heads slightly tilted, their eyes dreamily cast beyond the frame as if accustomed to, rather than startled by, modern technology. Another common trend for representing the Native worker as if to emphasize her pagan or natural identity was the reconstitution of an organic landscape within the studio interior using an artful arrangement of grasses and artificial rocks, as seen in the portrait of Teanie. The sitter sat alone, or was accompanied by extended tribal kin. The portraits of extended-kin groups confused the Euro-American viewer, who was accustomed to seeing a decipherable hierarchy of the family where gender and age were distinguished: a man, or father, commonly stood above his subordinate wife and children. If photographed without parents, the children were frequently posed in descending height or age and unified by clothing as seen in the portrait of the Dunsmuir daughters of a Nanaimo mining family (fig. 4.8).

Against these distinctions, the portrayal of the Euro-American woman as gentle tamer correspondingly hardened. With their identity synonymous with healthy and happy families, affluence, civility, and comfort, British immigrant women, according to Macfie, espoused all that was good: "We have among us ladies of birth and education, and, what is yet more important, of moral qualities that would render them an ornament to their sex in any part of the world." By Macfie's 1865 account, they were dually crucial to the constitution of civil society: their philanthropy contributed to the building of "public institutions" and their very presence elevated the immoral proclivities of the lower ranks. The philanthropy of respectable women, it was believed, enabled "benevolence, intellectual profit, and amusement on the ground of community of taste, nation or race" to consume the attentions of bachelors who needed to "occupy hours that might otherwise be spent mischievously."[50]

Prior to the widening availability of the Kodak camera after 1888, few women had access to cameras or the technical training required to wield one or develop film. Consequently, as one of only five commercial studio operators on Vancouver Island by 1862, and the sole female professional in the city of Victoria, Hannah Maynard took advantage of this growing clientele of settler women. The call for increased immigration of healthy, fecund women to serve as wives and mothers to miners, ranchers, and settlers took root symbolically in Maynard's unique variation on the baby portrait, entitled *Gems of British Columbia*. The *Gems* deserve special attention as their ideological motives match settler sentiment about racial superiority and nation building.

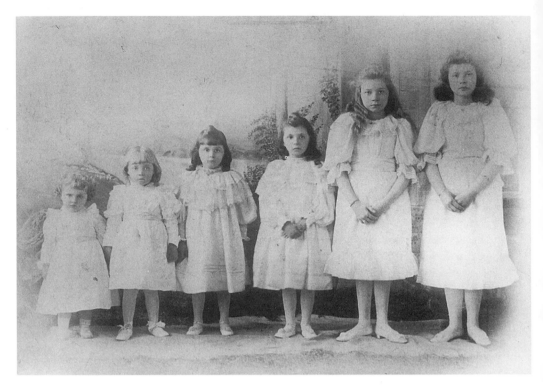

4.8
HANNAH MAYNARD
The Dunsmuir Girls, Nanaimo,
Vancouver Island, n.d.
Nanaimo District Museum,
#I2-I07

Maynard's *Gems* were a creative derivation of the formal, personal por-
trait of couples, children, and families Maynard individually photographed
in her studio. While she had initially conceived the *Gems* as a one-off studio
promotion to entice individual consumers who wished to document the
growth of their offspring, they proved so popular and lucrative that May-
nard continued to produce *Gem* cards annually between 1881 and 1898. An
individual *Gem* card was distributed annually to individual consumers who
had commissioned photographs of their children during the preceding year,
with the hopes of getting their return business.

To create a *Gem,* Maynard cut out faces or bodies from regular format
portraits of children and babies and then mounted them together to form
intricate designs or motifs, the aesthetic equivalent to the crazy quilts

stitched from fabric scraps by settler women. Maynard then rephoto-
graphed this composite of tiny faces and bodies and printed it as a seamless
image. Her gimmick of presenting this annual greeting card to "everyone of
her patrons who had a child in the picture" proved wildly successful and had
the twofold effect of "splendid advertisement and a valuable souvenir for
the parents."[51] Each year the scale of the *Gems* of the previous year was re-
duced and integrated into the design of the current year, so that the visual
complexity intensified each consecutive year. For instance, in the collage of
1889 a diminutive montage of the *Gems* from the six preceding years formed
a decorative border (fig. 4.9).

While viewers marveled at the large number of faces confined to a single
image, Maynard's annual *Gems* transcended sentimentality. In the face of the
endless cycle of smallpox, diphtheria, and tuberculosis devastating Native
and non-Native populations, children were precious commodities, and the
visual celebration of their survival beyond infancy was all the more
poignant.[52] Consider the heart-wrenching grief of Agnes Knight, a
Methodist teacher at Fort Simpson, as she witnessed the death of a child:

> the darling baby . . . only stayed a month with us and then God
> claimed again his precious loan . . . found baby had been very sick
> all night, it seemed to be inflammation of the lungs, we did all in
> our power for the little darling, but by ten that night she was
> taken—taken to be with Jesus I know, but after we had prepared
> her for her last resting place . . . the quiet submission of the dear
> mother is so touching, my heart never ached so for any one as it
> does for her—may our loving, sympathising Jesus comfort her
> thro' all the lonely hours of heart ache that will come to her. They
> buried baby today . . . it seemed so hard to cover up the lovely lit-
> tle face in the cold earth.[53]

The loss of a child, in infancy or adulthood, was a tragedy experienced by
many women, and in 1883 Maynard herself had lost her daughter Lillie to
typhoid fever. Maynard felt compelled to communicate her bereavement to
readers of the *St. Louis Photographer,* whose editor responded "tis hard to
lose our children at any age; still more so where they grow up and become
more our companions than our children."[54] The frequency and shared ex-
perience of maternal loss was answered by a sanctification of children as vi-
sually embodied by the *Gems.*

The *Gems* affirmed a central passion of settler women's lives: child rear-
ing. For Maynard's female clientele the photographic realm of babies and
children was not merely a personal or private expression; the visual repre-
sentation of motherhood was a confirmation of their procreative contribu-
tion to colonial growth in British North America. Though she was beyond

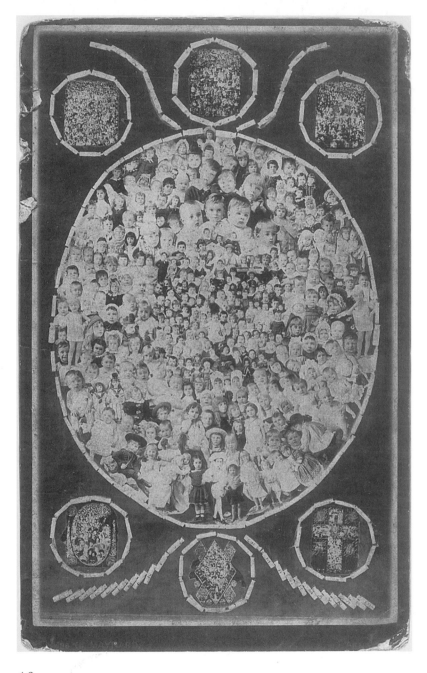

4.9

HANNAH MAYNARD

Gems of British Columbia, Victoria, 1889. Photomontage.
British Columbia Archives #C-7410

childbearing age at this point, Hannah's pursuit of such imagery is proof of her commitment to maternalist values. Her attention to this genre was also a shrewd business strategy on her part, as she fostered and capitalized on the appetite of a burgeoning and socially mobile female clientele who eagerly wished to aggrandize their patriotism, respectability, prosperity, and fecundity. The sustained popularity of the *Gems* over a seventeen-year period demonstrates an awareness of the continuing social and political significance of child rearing not only among a female constituency of settlers but also as an international trend. Always fueled by ambition, Maynard regularly dispatched copies of the *Gems* to the *St. Louis Photographer* in the hope of getting them reproduced so that her skill and expertise might be marketed more widely.

Hannah Maynard's "wide spread fame on account of her child photography" was assisted by the common perception that women were naturally inclined toward children and therefore better suited than a man to take their photographs.[55] In May 1887, readers of the *St. Louis Photographer* were reminded of the lucrative nature of child photography, described as "a very interesting branch of the business. Remember, the road to the mother's heart and the father's pocket-book as well is through the child . . . the photographer who has a love for this branch of the business is pretty apt to be the most successful."[56] In 1886, the journal congratulated Maynard for her enterprise and ingenuity based on the success of the *Gems* and credited her with an inventive strategy toward guaranteed profits for a small-town operator. The *St. Louis Photographer*'s two-year commitment to reproducing the *Gems* and the female editor's reference to the "many compliments on the babies" signaled the national and international popularity and marketability of baby worship across the western United States and Canada. With the publication of her 1,800-face *Gems* in the September 1886 issue, Hannah's Maynard's name and reputation were broadcast across North America on both sides of the international border. The influence of a female editor who was also a photographer may, in fact, be detected in the abundant and regular attention granted baby and child photography as well as to the advocacy of women in the profession. These opinions must have sustained Maynard's association with the journal during this period, which coincided with the era when her baby and child photography trade thrived. The editor reported "a large number of orders from parties from different parts of the US" for the issue of the journal carrying the 1,800-face *Gems* in addition to "an order from a party in Vienna, Austria for 100 proofs, which we have sent to Mrs. Maynard to fill."[57] The opportunities provided by the *St. Louis Photographer* expanded the Maynard Studio's commercial prospects and bought profit, publicity, and fame. During a time of expanding empire, the photograph possessed the capacity of bringing distant, "exotic" places or people into vision for the armchair traveler.

As a photographer, Maynard's location at the periphery of the British Empire was no barrier to international prospects.

The cultivation of a female clientele, the public debates surrounding virtuous motherhood, and the belief that women photographers were vocationally attuned to babies and children as subjects generated a wealth of opportunities for Hannah Maynard. By targeting settler mothers as consumers and catering to their maternal aspirations, she cornered a unique market otherwise neglected by regional male photographers, most of whom captured a more predictable vista of frontier activity. Maynard's imagery of babies, women, and children is no less of an ideological version of frontier, but her representations evoke the deep personal meanings on which women justified their participation in the building of a new nation. The editor of the *St. Louis Photographer* also indulged in these dreams of an expanding infant population by praising the multiplying constituency of children in the caption of the 1886 *Gems:* "Again we present our readers with British Columbia Gems. . . . this is the fifth year of their gathering and they increase in number and variety year by year. . . . Indeed, where can be found *Gems* more precious?"[58] Using the vocabulary of maternalism, a poem written by the editor figuratively celebrated Mrs. Maynard's creative abilities in the generation of such a fine crop of offspring. Maynard's layout of the *Gem* of 1887, fashioned in the shape of an English crown with a flag motif along the border (fig. 4.10), firmly connected the act of female reproductive labor to a patriotic devotion to Empire. Obviously, the Euro-American children of British Columbia were the jewels, or *Gems,* in the British crown.[59]

In reality, the *Gems* misrepresented the regional racial diversity and population density by substituting an imaginary and expansive population of largely Euro-American children (or those of mixed-ancestry who blended in as Euro-American) in numbers that far exceeded the actual census figures at the time. Although the population statistics shown in table 4.1 exclude children, the figures imply that the actual diversity of the child population was

TABLE 4.1

British Columbia's Adult Population by Ethnic Origin, 1870–1981

Date	British	European	Asian	Aboriginal	Total
1871	8,576	—	1,548	25,661	36,247
1881	14,660	2,490	4,350	25,661	49,459
1891	—	—	—	27,305	98,173
1901	106,403	21,784	19,524	28,949	178,657
1911	266,295	69,799	30,864	20,174	392,480

SOURCE: Jean Barman, *The West Beyond the West: A History of British Columbia* (Toronto: University of Toronto Press, 1991), 363

4.10

HANNAH MAYNARD

Gems of British Columbia, Victoria, 1887. Photomontage
reproduced in the *St. Louis and Canadian Photographer*
(February 1889) with the editorial comment, "The reputation
of Mrs. Maynard's *Gems of British Columbia* are [*sic*] becoming
worldwide." British Columbia Archives #F-05089

seriously misrepresented by the *Gems*. In essence Maynard's symbolic representation of a thriving population in British Columbia was not inclusive in any sense. Only those who had the ability to pay to be photographed came to embody the desired growth population of British northwest.

Whereas motherhood for settler women of the middle and upper classes was celebrated by the *Gems,* popular impressions of Native child-rearing practices were tainted by the social sanctions against mixed-race intimacy and beliefs in European cultural superiority. Benjamin Leeson's portraits of contented individual Coast Salish Kwakwaka'wakw children with mothers, or grandmothers, seemed to adhere to the happy maternalism of the conventional baby or family studio portrait until we read the captions. Disparaging captions condemned the Coast Salish practice of physical modification known as head binding, the practice of altering the foreheads of infants to designate high status. Leeson's photographs documented traditions that government policies had actively sought to prohibit. Leeson's caption to the photograph entitled "The New Baby," showing a grandmother embracing a young child (fig. 4.11), stated: "This little native won't have the painful experience of its grandmother, who, at the same age, had her head bound to improve her beauty. Up to date, her head not to be bound up like her grandmother's." The modernization, or European standards, of maternal care, the caption implied, had revolutionized older traditions. Head binding, according to Leeson's judgement, impeded the growth and intellectual potential of children, and by implication he condemned the child-rearing practices of Salish and Kwakwaka'wakw women. His interest in the subject stemmed from his belief that these cultural practices were "passing," in his opinion for the better.

That the cultural practice was of great curiosity to Leeson and others is indisputable. Photographs were often used to discuss racial distinctions. Women with heads elongated by the practice of binding were depicted in profile to emphasize the shape of the modified skull, with one Leeson photograph captioned as the "Longest Head in B.C." (fig. 4.12). Well aware of the anthropological interest in such examples of culturally specific physical modifications, Leeson described the image as "a valuable photograph. The best living elongated head it is claimed. She was a small woman and it was 15 inches from the point of the chin to the crown. The skull will likely out measure any specimen in the Smithsonian Institute."[60]

Leeson's photographs in these decades reflected a continuation of the Euro-American fascination with Quatsino head binding frequently mentioned in earlier documents. In 1866, photographer Frederick Dally had referred to a missed attempt to purchase a Quatsino woman's skull "which is now in the museum of the Royal College of Surgeon at Lincoln's Inn Field [London]."[61] Dally knew that the skeletal remains of coastal peoples had acquired significant monetary value as scientific "specimens," with that par-

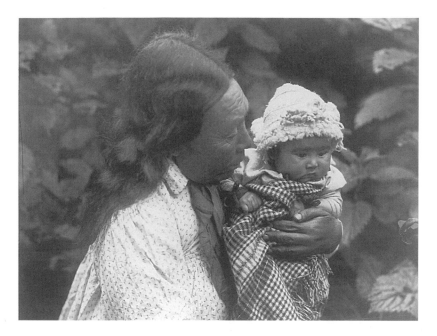

4.11

BENJAMIN LEESON
Grandmother and baby, or "The New Baby,"
Quatsino, circa 1889–1910. Photograph from the
Leeson Album with a caption that reads,
"Grandmother and child—this baby was one of the
first generations not to have her head bound to
improve her beauty."
Vancouver Public Library #14037

ticular skull being placed in the overseas medical collection by his friend Dr.
Richard Brow at the cost of two dollars and a half.

A similar "scientific" approach to the observation, sometimes collec-
tion, of "vanishing" traditions of physical modification practised by women
had been taken much earlier, for instance when John Schouler, a visitor at
Fort Vancouver on the Columbia River in 1825, condemned the wearing of
the labret—a wooden disc inserted in the lower lip to designate status
among Haida women—not as a mark of social status engendering respect
but as "a kind of deformity. . . . An incision is made in the lower lip in a di-
rection parallel to its length, and an oval piece of wood introduced into the
wound, is worn by them on all occasions."[62] In 1879, DIA Superintendent
Powell perceived the apparent rejection of the labret and skin tattooing by a
subsequent generation of women at Skidegate as a positive effect of Euro-

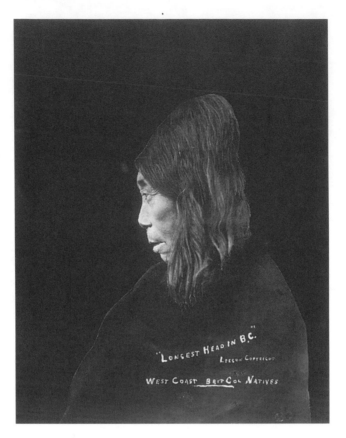

4.12
BENJAMIN LEESON
"Longest Head in B.C.," Quatsino, n.d.
Vancouver Public Library
#14071-D

pean modernization. As Powell noted about the elder generation, they still "perpetuated the custom of tattooing their persons . . . the hideous lip orna-ment" was "a frightful disfiguration," whereas the younger generation, Pow-ell declared, "are not disfigured in any way by these barbarous fashions."[63] Photographers supplied documentary proof of the female body modified by the labret. In 1881 the perspective of a photographic profile of an elderly Haida woman from the Queen Charlotte Islands by Edward Dossetter di-rected the viewer's attention toward the woman's lip labret (fig. 4.13). When settler Eleanor Caroline Fellows praised her servant Lucy for not engaging in any form of body modification—the labret, head binding, or tattoos— she intentionally complemented the reform activity of younger generation

by the local Catholics. Lucy, according to Fellows, was without "walrus tooth in chin, hideous malformation of cranium" or "painted face." Like so many others, Fellows made the association that the practice of head binding meant that indigenous mothers were negligent after observing a "curious looking" neighborhood Salish woman who had been "bound to the board on which of your Indian children passed their earliest infancy, not even legs or arms being at liberty, a large flat stone had been placed upon the upper part of her head, so that it should assume the long tapering shape which then was dear to aboriginal mothers."[64] The repetition of such themes across so many sources indicates that the contest for empire and power uses the bodies and behavior of disenfranchised women, in this case Native women, as the staging ground on which the struggle for cultural superiority is fought. The persistent criticism surrounding physical modification practices, like the labret or head binding, is inextricably linked to the controversy over interracial cohabitation and sexuality, as well as the wider political and social aspirations of Euro-American settler women and their advocates.

The rhetoric of all stages of colonial settlement in early national northwestern Canada was employed to politically distinguish indigenous, Chinese, and Euro-American settler women. Colonial boosters successfully lobbied for female immigration while espousing views that led to the legislation and educational reform of Native and Chinese women. Euro-American settler women of all classes were, by these gestures, politically advantaged, especially in their claim to be ideal reproducers of the race. Writers of emigration guides and pamphlets urgently pleaded for female immigrants to populate the recently confederated province. In light of these social circumstances, motherhood became a politically and socially charged act. Public sentiment on these issues and the condemnation of non-Euro-American women effectively elevated Euro-American women to patriotic heights, and they were seen as the fundament to the building of the nation. Race-based rhetoric, which proposed irreconcilable differences between women, pervasively infiltrated most documents of the time, and these distinctions were etched into law. If only for this reason, it is historically important to address the experiences and contributions of women.

Given this charged environment, the genre of family photographs, including those of babies, explicitly documented the single major political contribution Euro-American settler women made to the larger imperial agenda of colonization: they served the empire by reproducing the race. Assertions of the importance of maternalism, women's superior qualities and "purifying influence," were publicly promoted in the three lectures given at Alhambra Hall in Victoria in 1871 by visiting suffrage activist Susan B. Anthony.[65] With these well-reported declarations and the support of male political opportunists, Euro-American women were invested a moral author-

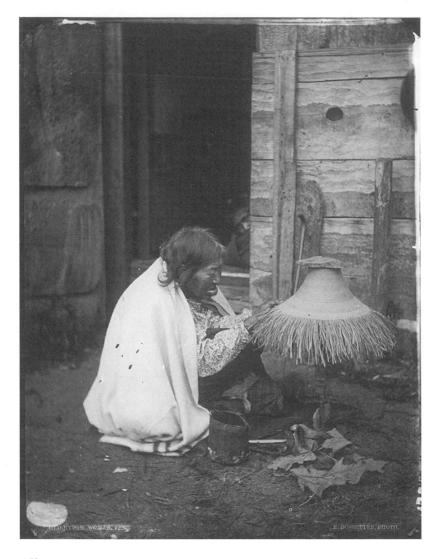

4.13
EDWARD DOSSETTER
"Old Hydah [*sic*] woman, Yan Village,"
Queen Charlotte Islands, 1881
Courtesy American Museum of Natural
History Library #42290

ity that resulted in their provincial enfranchisement by 1917. The Maynard *Gems,* inspired by this blossoming of maternal pride among Euro-American emigrants, presaged the organized, race-inflected, maternalist reform movement that forcefully emerged at the end of the decade, as women of the "better" classes voiced political concern for the health and hygiene of Anglo-Saxon children alone.[66]

5

Indigenous Uses
of Photography

Despite assertions that Native Americans were irrevocably tied to a deep premodern state, evidence shows that they did participate in modernization. In their rapid transformation from hunter-gatherers to maritime traders and, later, to industrial and entrepreneurial laborers in the settlers' resource-based economy, Native Americans progressively adapted to modernity in two characteristic ways: they embraced introduced technologies and they began to strategically acquire manufactured goods. As early as 1862, northwest coastal peoples demonstrated curiosity in the technology of the camera, collecting photographs for private contemplation. Moreover, as coastal people adapted to the Euro-American settlement, their use of photography expanded. By 1890, Native individuals and families began to frequent commercial portrait studios in unprecedented numbers, and individual portraits were increasingly integrated into the ceremonial commemoration of ancestors.

While the use of the camera by the British survey crew in 1859 may initially have been a startling or unfamiliar experience, coastal peoples were not strangers to new technologies—guns, knives, metal products—imported by Europeans. Intertribal trade—with trade goods spreading among the trading networks overland from the east and south—conceivably predated direct contact with Spanish, British, and Russian explorers and traders, so the consumption of goods began well before the Spanish expeditions to the north Pacific coast in 1774.[1] The second officer of the

Santiago was apparently "surprised that the Indians possessed bits of iron, and even more so when they produced half a bayonet that had been shaped into a knife."[2]

Photographs were a European-introduced product of trade. This chapter understands the photographic encounter—with the Euro-American as the photographer and the Native American as the subject—as another variation of the trading encounter. To conceive of photography as an active negotiation rather than a mechanical process resulting in an artifact fundamentally revises conventional assumptions about the European use of photography in colonial lands.[3] Photography, this supposition suggests, was never a purely one-sided event; in addition, photographs were as compelling to Native Americans as they were to Euro-Americans. Written evidence, including photographs, definitively shows that Native Americans developed habits of consuming photographs, and because the process of adaptation to the culture of settlement was creative and contingent, their consumption, acquisition, and commissioning of photography changed over time.[4]

Euro-American perceptions that Native Americans lacked the basic cultural disposition to adapt to European ways and technologies informed all passing references regarding Native American responses to the camera and photography. That Native Americans were naturally resistant to modernity, acquisitive behavior, or imported systems of labor and industrial technology was part of a larger continuum of ideas resulting in calls to "civilize" (reform and re-educate) the Indian. Between 1871 and 1878 Euro-American entrepreneurs who hoped to make their fortunes exploiting the plentiful resources of coastal and interior rivers quickly realized that local Native American women and men would be required as manual laborers if their business efforts were to succeed. As early as 1873 DIA superintendent Powell observed that Indians were essential to the export trade in fur, fish, and fish oil, as these highly valued products were "nearly if not all obtained by Indians."[5] This context of Euro-American dependency on local indigenous cooperation was the root of stereotypes characterizing Indians as reluctant workers. The coastal peoples were, managers and businessmen lamented, inherently estranged from a clock-driven regime. One fish plant overseer, for example, portrayed Kwakwaka'wakw laborers as intractable by declaring "our Indian friends never could see the necessity of working" and "did not take kindly to steady work."[6] Indian agent George Blenkinsop paternalistically found the Kwakwaka'wakw Nimpkish at Alert Bay wanting "a firm, kind, constant, directing hand in their midst to make them the most prosperous . . . the most civilized of the Kwahkewlth [*sic*] tribes."[7] The subscription to stereotypes about Indians was a response taken by educated Euro-American men unaccustomed to having their authority and power questioned. The colonial setting challenged their confidence in their cul-

tural superiority: they were unfamiliar with the language and sophisticated culture of their workers; they found themselves dependent on the expansive territorial knowledge and preexisting mechanical expertise of these laborers for the retrieval of much-desired raw products, be they fish, gold or lumber; and finally, in the face of the shortage of European immigrants, the need to retain subservient plant labor for the industrialized processing of goods for overseas export was essential. In all stages of retrieval, processing, and export a reliable cooperative labor force was crucial. Conscious or not, one means to subordinate the indigenous workforce was the devaluation of the Natives' intelligence. The persistent assertions of the Indian's inability to incorporate anything modern or mechanical imported by Euro-Americans were the result of Euro-American men's anxiety over power and authority.

Between 1859 and 1900 two general categories of photographs were widely distributed among colonists and beyond the region: landscape vistas, which reconstituted the routes and places colonial residents and travelers frequented, and portraiture, which illuminated the emerging network of relations between the colonists but also encoded the new hierarchies developing between colonists and Native Americans. With the labor, land, and culture of Indians progressively acquiring economic and political urgency, photographically illustrated bureaucratic, missionary, and promotional accounts consistently discussed the changing status of the Indian and continually made assertions about Euro-American superiority. Depictions of economically significant northwest coastal peoples—Tsimshian, Coastal and Straits Salish, Nuu-chah-nulth, Kwakwaka'wakw, and Haida—proliferated, and this portraiture supplemented written assertions about the settler conquest of Vancouver Island, the Queen Charlotte Islands, and the northern west coast of the mainland.

Although vigilant of the mediated nature of representation, historian Cornelius Jaenen has convincingly argued that European-produced texts and images potentially harbor valuable insights about the "other side"—the Native American version—of the contact encounter.[8] Reading against convention, Jaenen provides insight into the northeastern woodlands' adaptation to French trade in the seventeenth century by observing, for instance, the cynicism of the Micmac toward traders. While initially curious and greatly appreciative of introduced technology such as knives, hatchets, kettles, beads, firearms, and manufactured cloth, they eventually responded to the growing avarice of French merchants by demanding higher prices or more goods in exchange for furs. Jaenen used familiar sources to trace a shift in the Amerindian consumption of technology and to show increasing sophistication in their strategic manipulation of the French trade.

Contrary methods of interpretation may also be used to investigate the character of Native American engagement with Euro-American photographic technology and its results. At first glance, the bureaucratic patron-

age of photographic activity, which dominated the early stages of British Northwest settlement, seemingly obscures Native American interest in photography. Rather than dismiss the mass of Euro-American produced photographs of Indians and Indian life as inherently biased or one-sided, this chapter utilizes these sources alongside the mentions of Native American interaction with photography found in letters, diaries, and memoirs. Another indispensable source for understanding early Native American responses to photography is interaction with contemporary First Nations treaty researchers, scholars, and students. Photographs have long been valued among Native individuals and families. Furthermore, visual culture as a source is gathering heightened importance as contemporary treaty researchers use nineteenth-century photographs to establish the boundaries of tribal territories, chart traditional land use, and trace family genealogies. The combination of these historical and contemporary sources illuminates the indigenous application and value of photography between 1862 and 1890.

The growth in the Native American consumption of manufactured goods like the photograph was symptomatic of the upward economic mobility of some individuals and families who, as a result of labor in canneries, forestry, and mining enterprises, began to possess a disposable income. By 1890, urban, wage-earning Coast and Straits Salish living in villages in and around Nanaimo on Vancouver Island began to commission family portraits from local studios in unprecedented numbers. But, more significantly, the late-century popularity of private portraiture among Native American families hints at increased personal control over representation of the self. While the commissioning of studio portraits intended for private consumption may have been confined to wealthier, assimilated, or mixed-race families, the increasing occurrence of such portraits is noteworthy. These images convey an impression of affluence and sophistication, thereby posing an effective challenge to prevailing stereotypes of the Indian as homogeneously impoverished. Also significant is the fact that these portraits were motivated by personal choice rather than bureaucratic or political scrutiny. The private use of photography by Native Americans contrasts with the more indexical and oppressive applications of photography so common in these decades. With the pursuit of positive self-representation, Native Americans revealed themselves as purposeful and strategic consumers.

Collection and Consumption: Tu-te-ma as Collector

In her 1916 memoir, settler Eleanor Caroline Fellows briefly mentioned the expressions of pride of a young Nuu-chah-nulth woman about a personal collection of daguerreotype portraits.[9] The daguerreotypist who produced Tut-te-ma's treasures had most likely been a freelancer and must have

taken the images of her kin in anticipation of the growth in a commercial market for Indian portraiture. The first commercially available process, the daguerreotype was produced by exposing a chemically sensitized, polished, mirrorlike silver plate. Some, like Tu-te-ma's, were hand-colored with pigment or gilded with gold leaf; this decorative application was conventionally used to emphasize the status of the sitter as represented by precious items such as jewelry, watches, and buttons. To be viewed properly the daguerreotype plate was titled at a certain angle under adequate illumination to offset the reflective quality. Because of their fragility daguerreotypes were often encased within velvet or leather-covered hinged containers. Admired for "minute detail, sharp definition, delicacy of tone," the daguerreotype process was rarely used after 1860, formally replaced by the wet collodion process, although their popularity as collectibles obviously extended beyond that date.[10]

Although Tu-te-ma's collection of daguerreotypes is no longer available for analysis, Fellows's memoir, and other photographs in general circulation, leads to the speculation that they may have been taken by photographer Charles Gentile. Gentile, a portrait photographer who had emigrated from San Francisco in 1862, was a family acquaintance of Arthur and Caroline Fellows. Like others, Gentile expanded his professional status by accompanying government officials on maritime and interior tours to Indian villages and the goldfields. He toured Tseshaht territory on the northern interior of Vancouver Island in 1864.[11] His attachment to the Fellows household undoubtedly offered him the opportunity to meet, and photograph, their young Tseshaht worker, Tu-te-ma.

A resident of Victoria between 1862 and 1866, Fellows regularly hired Tsimshian, Haida, and Nuu-chah-nulth women and girls as temporary day laborers. They served as nursemaids to her children and some, like Tu-te-ma, performed domestic chores in elite white households. Tu-te-ma and her family sought casual labor, traveling to Victoria from Tseshaht territory in Barkley Sound, an inlet on the west coast of Vancouver Island. Once in Victoria the family may have encamped near or on the Songhees Coast Salish reserve on Victoria's inner harbor across from the Euro-American settlement. While in Fellows's employ, Tu-te-ma canoed daily from the reserve to the Fellows house in the nearby military port of Esquimalt. Although not explicitly mentioned, Tu-te-ma's wages undoubtedly were minimal, and may have taken the form of bartered provisions.

A fleeting exchange between Fellows and Tu-te-ma (identified by Fellows by the Christian name Lucy) supports the contention that photographs were collected and discussed among coastal peoples not long after the camera's regional introduction by the British Engineer Corps in 1859. Fellows recalled her discussion of the daguerreotypes with Tu-te-ma:

Lucy brought her chief household treasures to show me—the portraits of her family! It was still the era of the now forgotten daguerreotypes, hideous things which invariably made one's nearest and dearest folk look like the worst of malefactors: and Lucy's cherished specimens were the most hideous I ever beheld. . . . Half a century ago, the outer garment of every male Indian consisted of a blanket, fastened, in lieu of brooch, with a wooden skewer; and this particular one of Lucy's daguerreotypes showed a chief thus attired. The portraits were many and the artist must have found the transaction profitable . . . he had gilded the skewer! The effect was most funny, but Lucy thought the adornment beautiful, and to please her I feigned an admiration equal to her own.[12]

Interestingly, the two women of this encounter—employee and employer—registered conflicting interpretations about the utility and meaning of the portraits. Tut-te-ma was pleased with seeing her ancestors portrayed in an honored and respectful manner, whereas Fellows, alluding to the profundity of the images for Tu-te-ma as a beholder, was bewildered by Tu-te-ma's reverence for the daguerreotypes, as she personally found the images and the gilded surface embellishment hideous. Expressing a disproportional sense of confidence in her intellectual superiority, Fellows confided her "feigned" admiration to a like-minded community of readers.

Fellows's response to Tu-te-ma's "chief household treasures," and three, possibly four, extant portraits of Tu-te-ma, two of which (including fig. 5.1) were taken in 1862 by Gentile, provide a glimpse into the consumer habits of an individual Nuu-chah-nulth woman who was not fearful of photographic technology or its results. One of these portraits of Tu-te-ma and another woman in a canoe (fig. 5.2) was taken by Gentile at the request of Eleanor Caroline Fellows. In possession of a private collection of daguerreotypes, Tu-te-ma was a bona fide consumer of a product of modern technology. Yet, as the extant portraits indicated, she was also objectified by Gentile's camera. Although no concrete evidence determines how Tu-te-ma acquired her collection of daguerreotype portraits, it is feasible that they were purchased from Gentile in exchange for posing, or another form of labor. The photographs, alongside the statements made in the memoir, ascertain that Tu-te-ma was an economic agent negotiating wages or barter in exchange for labor with Fellows and, possibly, with Gentile. The fact that she modeled for photographs at the request of Fellows also suggests a use of the photographic encounter as a vehicle of trade. Whereas conventional interpretations of photographic activity in colonial settings have tended to reduce the agency of subject peoples by assuming they were passively objectified by the Euro-American camera, the record of Tu-te-ma's daguerreotypes

and her modeling activity imply agency, not passivity. She sought individual photographs as collectibles and believed it appropriate for these precious artifacts to be shared and discussed. For her, the status of the sitters was elevated, not objectified, by the camera's gaze. Her acquisitive activity and her cooperation as a subject of a photograph for her employer confound the stereotype that Native Americans operated outside of modernity or that they lacked the sophistication or intellectual capacity to fully appreciate introduced technologies.

Native Americans not only collected photographs for their own edification but also were aware of the accelerating value of photographs of Indians and Indian life. The photographic encounter, consequently, was understood as an opportunity for economic advancement. Nevertheless, individual Natives often resisted posing for the camera, realizing that the returns from this compliance to the white man's wishes were minimal. The objections of local men, and especially the women, to George Mercer Dawson's requests for photographs and the Haidas' demand for compensation lead us to believe that adult Native Americans comprehended that the photographs of them had wider political implications for their lives and that some formal negotiation regarding consent and compensation was expected in exchange for cooperation.

Misapprehension of the Native expectation for compensation was common. Photographer Benjamin Leeson was perturbed that his requests for photographs of individual Kwakwaka'wakw subjects in Quatsino were met with the insistence of "a money consideration for posing." Leeson was surprisingly oblivious to the contradiction of his own entrepreneurial thinking when he informed his Euro-American readership that his photographic depictions of these sitters "have quite a little sale to tourists."[13]

Euro-Americans characterized Native American reluctance or unwillingness to pose or be photographed as an irrational fear of modern technology and used this stereotype to further degrade them. A tourist account published in 1890 corroborated the attitude that Native Americans were inherently unaccustomed to the camera.[14] Leaping to the conclusion that the Tlingit basket sellers whom she tried to photograph on a wharf at Sitka were technologically naive, Septima Collis wrote:

> It is wonderful what a superstitious aversion they have to the camera. When we tried our Kodaks on them they instantly enveloped themselves in their blankets, and would not uncover until some old crone who had an eye through a hole of her hood gave the signal. . . . we tried to reason with them, showed them pictures of ourselves, offered to send them their likenesses by the next boat, but all to no purpose. . . . we were about to give it up when at the

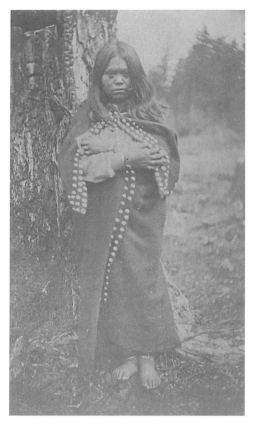

5.1
CHARLES GENTILE
Tu-te-ma, taken in Victoria or
Esquimalt, circa 1862
Courtesy of the Royal British
Columbia Museum
Anthropological Collections
Section #PN 4701-A

5.2
CHARLES GENTILE
Caption reads "Tu-te-ma
(Lucy) in canoe, Barkely
Sound, Tseshaht tribe, taken
for Mrs. Arthur Fellows,"
Victoria or Esquimalt,
circa 1862
Courtesy of the Royal British
Columbia Museum
Anthropological Collections
Section #PN 4732

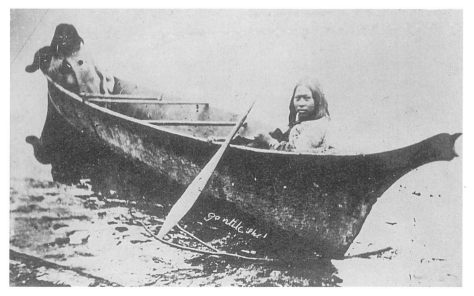

suggestion of one of the "oldest inhabitants" we held aloft a silver dollar. Instantly there was a change.[15]

Unable to pursue her own commercial desires, Collis transposed personal frustration into a characterization of the women as inherently uncooperative. Moreover, they were "superstitious," marking them as pagan, and "irrational," or lacking in reason. Collis, thinking the women were oblivious to marketplace protocol, misapprehended their expectation for remuneration. Evidently the women were prepared to drive a hard bargain and Collis took offense. The women's objection to the camera was interpreted as greed rather than a steadfast refusal to perform on demand. Collis's consternation over the inability to capture the photograph in face of the women's resistance demonstrates the extent to which photography had become a fundamental component of the tourist experience at late century. Although desiring a photographic depiction of Indian women uncorrupted by modern habits and behavior, Collis vilified all Indians as primitive and depraved, declaring, "I cannot work myself up to any sympathy for the Indian . . . with his filth and his vice, his dishonesty, his cunning, and his general unreliability" and believed that her solution for reform was widely shared when she claimed, "I am among those who believe he should be coerced into good behavior and not tolerated as he is."[16] The contradiction between her expectations of the Tlingit women and her blatant racist stereotypes of Indians across the memoir is not, by any means, atypical. Such contradictory responses were common.

The women on the other side of Collis's lens were, in my opinion, conscious of the expanding tourist appetite for pictorial representations of Indians. As a result they understood Collis's demand as an opportunity for entrepreneurial commerce. Objectified in this manner by passing tourists, they would willingly trade on the condition that the interested party meet the asking price.

Objection to photography was not so much about a fear of the camera, or its theft of the soul or spirit of the sitter, as about a growing recognition that photography constituted another intrusion by the Euro-American that had to be effectively controlled by the individual. Tourists or travelers initiated a trading negotiation by pointing their camera lens toward the body, territory, housing, or other proprietary objects. While the Euro-American photographer exuded supreme confidence in his or her sense of entitlement and commonly neglected to ask permission, the recipient expected material recognition in exchange for cooperation. The conception of the photographic encounter as a form of trade was an enterprising and innovative strategy on the part of the Native American subject. Unfortunately, tourists like Collis and civil servants like Leeson were unable to conceive of the Indian expectation of remuneration as entrepreneurial.

The Uses of Photography for Ceremony and Commemoration

Indisputably, early explorers, travelers, and settlers were dependent on Indians for their local knowledge of coastal and interior routes, the provision of food such as fresh fish and the varied assortment of seasonal produce, in addition to much needed freighting services. Although it is difficult to see beyond the cultural biases of Euro-American newcomers, the occasional appreciation of Native American creativity, craft skills, and intellectual abilities punctuates early accounts. Admiral James Prevost reported to the Christian Missionary Society in 1856 that "some naval officers who . . . have lately visited these regions, have been most favorably impressed with the highly intelligent character of the natives . . . they are not idolaters: they believe in the existence of two great spirits—the one benevolent, and the other malignant; and in two separate places of reward and punishment in another world. They are by no means bigoted. They manifest a great desire and aptitude to acquire the knowledge and arts of civilized life."[17] Indian agent Reginald Pidcock, writing of events between 1862 and 1868, heartily approved of the extraordinary handiwork evident in indigenous canoes, which he described as "beautifully made and modeled; all the work of finishing being done by a very small kind of hand adze with which most of the natives are very expert."[18] Unlike many, he saw that canoe construction varied according to the individual waterways used by the northwestern tribes, with oceangoing canoes of the Tsimshian and the Haida distinct from those of the Chinook Interior Salish, who resided on the Columbia River. He also observed that women's paddles were unique in scale and shape. Pidcock purchased a Haida canoe for his personal transportation describing it as "a splendid canoe in every respect." Impressed with the "delicate and fancyfull" sandstone pictographs, or picture writing, located at the Coast Salish village of Cedar near Nanaimo, Pidcock recommended that the place was "well worth a visit as it extends with little interruption for some miles." Comments like these demonstrate that respect for the creativity of indigenous peoples was admitted.

Another exchange conveys the vast potential for creative reciprocity between the newcomers and coastal indigenous inhabitants. On his visit to Vancouver Island and the Queen Charlotte Islands in 1854, R. C. P. Baylee noted,

> One of our lieutenants showed to a native a daguerreotype likeness of his father, which the latter immediately undertook to copy on ivory: for this purpose a whale's tooth was given to him, with which he returned in a few days, having carved out of it a bust, which, from its resemblance to the original, excited general admi-

ration; from the frontispiece-portrait of Shakespeare or any other
author, they will also carve out a bust.[19]

In this instance, the pictorial realism of a daguerreotype provided a source
of inspiration for a skilled carver. This man, likely Haida, used traditional
carving expertise to translate a one-dimensional portrait into a two-dimen-
sional sculpture on ivory. Surely the surface designs of house poles, ceremo-
nial robes, and masks as well as of functional objects such as bowls and stor-
age boxes were, at times, influenced by the photographs regionally
produced and circulated by Euro-Americans. Another incident suggests
that at least one Native American youth in Burrard Inlet (near present-day
Vancouver) was creatively intrigued by the mechanics of photography. After
exposing a photographic plate with his large format camera—covering his
head with a large drape as a barrier for exterior light—Frederick Dally no-
ticed a young boy who "imitated all my movements, with an empty beer
bottle and a coat over his head as if he was doing the same thing."[20] Al-
though the description of early and midcentury encounters is always frus-
tratingly deficient, the potential for cultural exchange seems, momentarily,
possible.

By the late 1800s, Native American life was undeniably defined by ide-
ological and material segregation from dominant settler culture and always
complicated by the external collective pressure from Indian agents and mis-
sionaries. One ethnographer asserted that "the chief cause for the disappear-
ance of the poles was the dropping of the old customs by the Natives upon
accepting Christianity which soon lead to a great many being used as fire-
wood," deflecting responsibility away from the collecting frenzy initiated by
museums and simplistically blaming missionaries for the demise of Native
customs and culture.[21] In reality, a convergence of events, actions, and leg-
islation generated changes in Native American traditions and culture.

Did the mounting pressure for the assimilation of coastal peoples allow
for the development of unique or culturally innovative uses of photography?
Five individual photographs, dated between 1880 and 1890, suggest that
photography was progressively integrated into ceremonial life and com-
memoration among three tribal groups on Vancouver Island: a Central
Coast Salish family at Quamichan and Nanaimo villages used portraits of a
deceased ancestor in a naming ceremony, Nu-chah-nulth in Ditidaht terri-
tory at Nitinat Lake displayed a historical photograph of a powerful and
well-known leader at meetings of the local tribal council, a portrait of Annie
Charles of Beecher Bay included another smaller gem inlaid to commemo-
rate a female relation, and finally, two individual postmorten portraits com-
memorate the tragedy of child mortality for Coast Salish mothers.[22] These
photographic occasions suggest that modern technology was being used to
viscerally remind the living of deceased ancestors.

The first photograph was taken between 1899 and 1913 by Methodist Indian missionary Charles Tate, when he was stationed at a Central Coast Salish reserve set on the north bank of the Cowichan River, midway between Victoria and the more northerly Nanaimo.[23] At this time, the population of the Halkomelem-speaking Cowichans was substantial, with Quamichan being one of eight socially cohesive villages, or house clusters, situated on the mid-island waterways.[24] The cultural traditions of the Winter Dances at Quamichan, too, were vibrant, showing little evidence of decline despite the presence of missionaries and a government Indian agent who were charged with the task of preventing them. Each winter some dances with religious or spiritual content were performed within the context of the potlatch, a seasonal, secular gathering of kin and village. The potlatch gave "formal public notice of a birth, a coming of age, marriage, or a death . . . [dances and ceremonies] provided the opportunity of recounting or dramatizing the supernatural origin of names, crests or other privileges."[25] Disheartened by the extravagant "pagan" behavior and "many other abominations," Charles Tate was frustrated by his own and the Indian agent's ineffectuality.[26] Between 1900 and 1905, he reported, numerous well-attended ceremonial and political gatherings occurred at Quamichan village, and his photographs scrutinized the traditional spirit dances and naming ceremonies performed at these occasions.

Tate undoubtedly knew the photographs he had taken of the spirit dances could potentially serve as concrete evidence of illegal potlatch activity among the Cowichan. Beginning in 1885 and lasting until 1951, a federal prohibition criminalized all traditional ceremonies, rituals, and dances associated with the potlatch.[27] The prohibition was a legislative response to three types of grievances expressed by regional Indian agents and missionaries. The first concern was health and hygiene, as large gatherings such as the potlatch were viewed as an opportunity for the rapid spread of introduced diseases such as smallpox, which had plagued northwest coastal communities from 1808. Second, the potlatch was condemned on moral grounds, as it was seen to promote certain unsavory activities such as prostitution. One component of Kwakwaka'wakw potlatch activity—the *tamanawas* dance— was singled out by Euro-Americans as especially offensive, since the dance symbolically re-enacted cannibalistic practices. This and other dances of secret societies were thought to be irreconcilable with Euro-American Christian values. Finally, the prohibition of the potlatch was justified on the grounds that it caused a lack of industriousness on the part of Indians. That work in the canneries was interrupted by the extended ceremonies of the potlatch angered the industry's overseers. In 1875, Superintendent Powell determined that "frequent assemblages of the different tribes for the purpose of holding donation feasts" whereby "large amounts of property is given away or destroyed, and the continual round of feasting . . . is quite de-

structive to any settled habit of labor and industry."[28] Franz Boas was one of few observers who fully comprehended the economic and social significance of the secular potlatch. Employing an idiom accessible to Euro-Americans, he defined potlatch as a system "largely based on credit, just as much as that of civilized communities." The need for the potlatch, Boas explained, grew out of the northwest coastal Native Americans' oral tradition. "In order to give security to the transaction, it is performed publicly," Boas determined, "the contracting of debts, on the one hand, and the paying of debts, on the other is the potlatch."[29]

In Tate's photograph from Quamichan (fig. 5.3), a middle-aged man wearing a felt bowler hat stands in front of a communal shed house. Surrounded by observers, two beached cedar dugout canoes, one overflowing with goat-hair twill blankets, sit in front of him. As goat hair was scarce on Vancouver Island, the blankets were a mark of social prominence, luxury, and wealth.[30] Towering above the man's head is an elevated platform, or scaffold, weighted heavily with manufactured and woven blankets and cloth ready for the "scramble," a choreographed moment in a potlatch ceremony when blankets, or strips of blankets, were tossed from the platform to assembled guests by the host or someone appointed as his speaker.[31]

The first photograph captures the moment before the scramble. The host displays a framed photographic portrait for the guests and for the camera. Although his eyes are shaded by the hat brim, he and a young man standing beside him look directly out at the photographer. The photograph held aloft portrays a woman wearing a tightly corseted European dress sitting upright on a chair. The style of the painted backdrop and props in the portrait, as well as the pose, were common to one of two commercial studios in Nanaimo circa 1895–1898. The pose is frontal, with the entire body of the woman visible. Two young children, a boy and girl, stand poised beside the host, who holds up the photograph for scrutiny. Tate identified the event as a potlatch at Quamichan with the "four children standing" as "members of a family [parents] who have died" and he believed that the portrait "is a photograph of another."[32] Anthropologists Homer Barnett and Wayne Suttles agree with Tate's captions that the displayed portrait represents a deceased relative of the participants in a naming ceremony, which is in progress. On their heads and limbs the children wear "strands of mountain goat wool" typical of garments worn during a naming ceremony, during which adolescent children were publicly conferred heredity names.[33] Barnett describes how the distribution of property was an important part of the naming ceremony with the amount and value of goods distributed to witnesses establishing the social prominence and prestige of the persons being named. The young boy grasps a horn rattle decorated with goat-hair streamers. Another man, possibly an older sibling, stands between the two canoes and he, like the young children, wears a goat-wool headdress

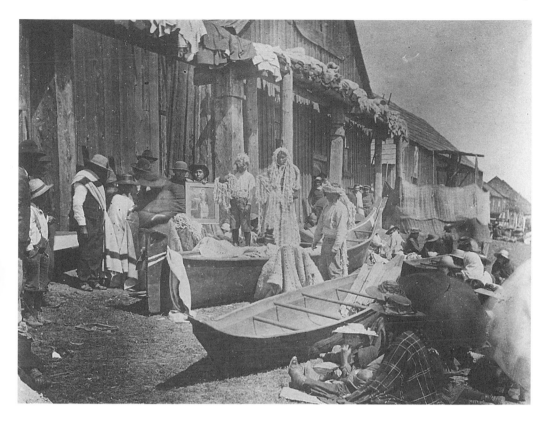

5.3

CHARLES TATE
Potlatch at Quamichan
Vancouver Island, circa 1913 (?).
Courtesy of the Royal British
Columbia Museum
Anthropological Collections
Section #PN 1499

and a waist sash, which were "distinctive parts of a performer's dress." After a declaration of the genealogical history of the ancestral name, no less than four *swaihwe* dancers, wearing distinct masks and elaborate costumes (not depicted in this photograph but apparent in companion photographs) made of swan feathers, swan down, and deer-hoof anklets, would dance in order to symbolically cleanse the children standing in or near the loaded canoe.[34]

The inclusion of the photograph of a deceased relative illustrates a distinct transformation in a ceremonial activity in which ancestry was evoked. Apparently commercial portrait photographs, like the one held aloft, gradually replaced the customary goat-hair effigies (*hwisi*), or rag figures, which symbolically represented a deceased ancestor and which "in late days were made more realistic by the use of the hats, scarves, and jackets of the deceased."[35] As Tate's photograph unintentionally demonstrated, the photographic portrait, and the high realism conveyed by it, had been incorporated into the ceremony by the first decade of the nineteenth century. Here the use of portraiture to evoke the soul or spirit of a departed ancestor at a life cycle event seems compatible with Coast Salish beliefs. In death the corporeal body and soul "perished" but, according to Tsartlip Coast Salish informants, humans and creatures

> possessed a shadow or reflection, *kayahenettan,* visible in sunlight or moonlight, and as some thought also, in clear water. Naturally, this shadow or reflection resembled in form [of] the body. So too, did the soul. . . . human beings must possess two souls . . . [one of which was] a wandering soul. . . . At death the body and the shadow perished. . . . a ghost *spalkweetha,* which fed on the souls of food, traveled in the souls of canoes, and generally passed a ghostly replica of its former existence inside the body . . . a ghost or disembodied soul was reborn in the same family, explaining in these ways the frequent likeness of a child to some ancestor.[36]

A ghostly resemblance of the departed woman was represented in this naming ceremony by the photographic portrait. Her soul, as visually evoked by the realism of the photograph, would linger protectively over her living kin on this important day.

In the foreground rests another, smaller, cedar dugout canoe bearing woven cedar house mats, and beyond the canoe are seated a row of well-dressed guests, young girls and women wearing hats, shawls, and leather boots. The gifts for these assembled guests were readied for individual distribution to the guests by the host or speaker, whose gesture of giving acknowledged the bestowal of the ceremonial names on the recipients. The naming ceremony was both a ceremonial and economic part of the north-

west coastal potlatch, with wealthy or noble hosts giving away goods "in anticipation of the reimbursement of his capital at some future date."[37] The family's use of a modern commissioned portrait may have underscored their prestige.

Given the prohibition of the potlatch at this time, it is not unrealistic to assume that Charles Tate's motives for taking photographs during the naming ceremony and the *swaihwe* dance at this potlatch were suspect, especially since Tate zealously supported the federal legislation. In letters and diaries he criticized the local Indian agent for his neglect in enforcing the prohibition. On the other hand, the subjects of this particular ceremonial occasion appear cooperative and almost eager to be represented by the photographer, suggesting that the photograph was not in fact "stolen" by Tate. Was their apparent cooperation an expression of political defiance against the legislated suppression of ceremonial activity?

A second photograph (fig. 5.4) also documents the manner in which coastal peoples incorporated nineteenth-century portraiture to honor the past accomplishments of a departed ancestor. This photograph depicts a meeting of a Southern Nu-chah-nulth government tribal council taken in a longhouse at Clo-ose, a village of the Ditidaht people at Nitinaht Lake.[38] This photograph was donated to a public collection by Gwendolyn Bennett, daughter of the Anglican Indian missionary Reverend Stone, who was stationed at Clo-ose between 1894 and 1904.[39] The photographer stood at the base of the public platform looking upward toward five unidentified tribal councillors: two men standing and two men and a woman sitting. The lower perspective of the photographer and elevated status of the sitters lends reverence to the councillors. A portrait depicting the head and shoulders of a renowned Nuu-chah-nulth Clayoquot leader named Chief Seta-Kanim (also spelled Seta-Canim) is prominently displayed at the center of the hand-painted screen and mounted on a post in front of the platform and table. The portrait sits in the precise center of the log frame house structure drawn on the painted screen.

A number of other extant photographs of Seta-Kanim may be found in local archives, indicating that he was a man of established reputation with a status and influence worthy of commemoration by itinerant Euro-American photographers. These photographs of Seta-Kanim were taken by commercial photographers active in the region beginning in the 1860s, including Frederick Dally, Charles Gentile, Richard Maynard, and Hannah Maynard. Dally had traveled to the Nuu-chah-nulth villages on the west coast of Vancouver Island with Governor Arthur Edward Kennedy on the HMS *Scout* in 1866, at which time he may have met and photographed Seta-Kanim. Gentile was in Nuu-chah-nulth territory around 1864.[40] Gentile's portrait of Seta-Kanim was inscribed as follows: "Cedar Karnim [*sic*], chief of the Clay-o-quot Sound Indians. A celebrated warrior and orator

5.4

UNKNOWN PHOTOGRAPHER
Clo-ose Tribal Council meeting, Vancouver
Island, circa 1894–1904. Photograph of Chief
Seta Canim mounted on the front of the
council table.
Photograph from the collection of the
Reverend William Stone, United Church
Minister at Clayoquot, courtesy of the Royal
British Columbia Museum Anthropological
Collections Section # PN 5311

who has killed over 200 men."[41] Two other portraits of Seta-Kanim, one with his son "Curley Ishkab" and another with an unidentified man, were taken in the Maynard studio circa 1865–1869.[42] In 1874, Richard Maynard must have encountered Seta-Kanim when he accompanied the tour of inspection conducted by Superintendent Powell on the HMS *Boxer* (fig. 5.5). Another, solo portrait was taken by an unidentified photographer.

Prominent colonist and civil servant Gilbert Malcolm Sproat, a resident and sawmill entrepreneur at Alberni on the inlet of Barkley Sound on the west coast, recalled meeting Seta-Kanim between 1860 and 1865. Having gained his reputation as a leader, warrior, and orator in a confrontation between the Central Nootkan Clayoquot of Clayoquot Sound and the Northern Nootkan Kyuquot in 1855,[43] Seta-Kanim was described as "a tall muscular savage, with a broad face blackened with charred wood, and his hair tied in a knot on the top of his head so that the ends stood straight up . . . such a voice as he had! One could almost hear what he said at the distance of a mile." Oratory, Sproat informed his readers, was a quality and skill "much prized" among the Nootka, so much so that it was "the readiest means of gaining power and station" in which the Clayoquot, and their leader Seta-Kanim in particular, "excelled." Orators of great renown were influential at public political meetings and festivities wielding "great effect upon the hearers" and Sproat urged those who wished to know "what natural earnest manner in public speaking really is" to visit Seta-Kanim at Clayoquot Sound.[44] Keenly aware of Seta Kanin's influence and the violent encounters between the British gunboats and the Clayoquot people under Seta-Kanim's leadership, Superintendent Powell diplomatically described negotiations with him during his 1874 visit to Clayoquot Sound as follows:

> Seta-ka-nim [*sic*] is . . . frank, open, and generous. . . . our interchange of salutations was of the most friendly character and the greatest satisfaction was evinced by his people (by whom he is held in great respect) when I invested him with a military coat and cap, and confided to his care a British Ensign as a distinguishing emblem of law, order and protection. Seta-ka-nim has promised to control his people and preserve peace and good government among them, and reciprocal assurance of assistance, and a preparation of my visit early next year were given by me in return.[45]

The conspicuous display of Seta-Kanim's framed portrait at the center of the Ditidaht council platform at Clo-ose in the early twentieth century was testament to the legacy of a forceful orator and leader with whom the British newcomers had to contend. Although deceased by 1904, his presence, as commemorated by the portrait, secured a continued place of honor and respect in the public history of the Clayoquot people.

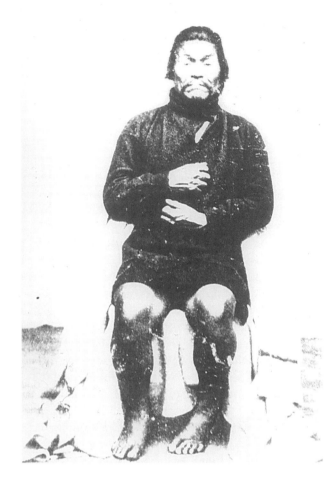

5.5
MAYNARD STUDIO
"Seta Canim of Clayoquot," n.d.
Courtesy of the Royal British Columbia
Museum Anthropological Collections Section
#PN 5036

A third photograph depicts a close-up facial portrait of Mrs. Annie Charles, who was a member of the Clallam (or Klallam) people of Beecher Bay.[46] The Clallam occupied a dozen villages on the northern slope of the Olympic Peninsula in the mid–nineteenth century. Later they expanded northward and eastward to settle in Sooke Territory at Beecher and Parry Bays on the southernmost tip of Vancouver Island. By using the technique of montage to mount a jewel-like circular portrait of an unidentified woman on the throat of the central subject of the portrait—Annie Charles—the photographer experimented with photography's capacity for manipulation (fig. 5.6). This technique is seen in another photograph, depicting photographer Albert Maynard, the son of Richard and Hannah Maynard, with a miniature face of his wife, Adelaide, inlaid over his heart. In both portraits, the miniature replicates the shape and scale of a pendant or a jewel. In the photograph of Annie Charles, both the large and gem-size portraits are closely cropped to isolate the facial features of each woman. Their faces are in such close proximity that the viewer automatically looks for a familial resemblance between them. Overwhelmed by the full and more prominent face of Annie Charles, the smaller gem portrait suggests an absent or diminishing presence.

On the back of Annie Charles's photograph a written caption identifies her as the wife of Henry Charles. The second woman portrayed within the frame is unidentified. A companion vignette portrait of Henry Charles is comparatively conventional, with his formal garments and pose emphasizing respectability (fig. 5.7). Because the portraits of Annie and Henry Charles are aesthetically distinct, the assertion of a marital bond between them might be subject to question. No unifying design or repeated pose visually substantiates the relationship. In contrast, the inclusion of the gem portrait of a woman within Annie's portrait couples the two women for eternity. The montage knits an intimate matrilineal relationship between the women within the single frame.

In the fourth photograph, and one of two postmortem photographs of children of indigenous ancestry found in the public archives, a young Northern Straits Sooke woman and a child have been posed against an obviously makeshift backdrop in an exterior setting (fig. 5.8). Like the Clallam, the Sooke were part of the Central Coast Salish and spoke the Northern Straits dialect. They lived on the southern tip of Vancouver Island around Sooke Harbor facing the Olympic Pennisula, relatively close to Victoria.[47] The frail body of a young male child tenderly rests on the lap of this woman. Because the woman's head is cloaked, her face and body recede unobtrusively into the background, whereas the child is more prominently displayed. A brief caption captures the emotional and social significance of the portrait. The father of the child, it states, was away on a sealing expedition, and in his absence the child died of smallpox. Smallpox, among other

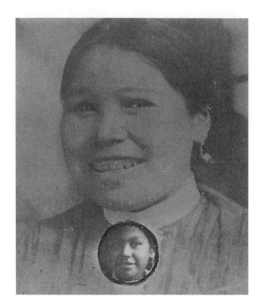

5.6

UNKNOWN
PHOTOGRAPHER
Annie Charles of Beecher Bay,
wife of Henry Charles, n.d.
Courtesy of the Royal British
Columbia Museum
Anthropological Collections
Section #PN 6388

introduced diseases, including malaria, measles, influenza, dysentery, whooping cough, typhus, and typhoid fever, caused unprecedented population decline among coastal peoples beginning with an outbreak from 1775 to 1801, followed by others from 1824 to 1825, 1836 to 1838, in 1852 and 1869, a regional epidemic from 1862 to 1863, and others in 1868 and 1870.[48] An HBC census of 1839 estimated Vancouver Island's Halkomelem-speaking population at 2,649; by 1884 the DIA census enumerated the same population at 1,694.[49] The combined Coast Salish population of Vancouver Island and the mainland in 1835 was collectively tabulated at 12,000, but had been reduced to 5,525 by 1885 and fell to 4,120 by 1915.[50]

Given these striking statistics, postmortem photographs like this symbolize more than a personal tragedy; they remind us of a public health crisis when child mortality among Native families was extreme. As author Michael Lesy observed, postmortem photographs, popular in the 1890s in the U.S. West, linked "photography and the presence of epidemic diseases . . . [which] killed the youngest before the oldest."[51]

The husband's temporary departure from this individual family provided a mother's personal motive for the photographic record of the tragic loss of a child. Given that missionaries and Indian agents insisted on the immediate burial of victims of contagious diseases for preventative measure, it would have been impossible for this woman to delay the burial of the child until her husband's return. The photograph's caption also determined that the mother had commissioned the photograph to "show what a fine burial"

5.7
UNKNOWN PHOTOGRAPHER
Henry Charles of Beecher Bay, n.d.
Courtesy of the Royal British Columbia
Museum Anthropological Collections
Section #PN 6319

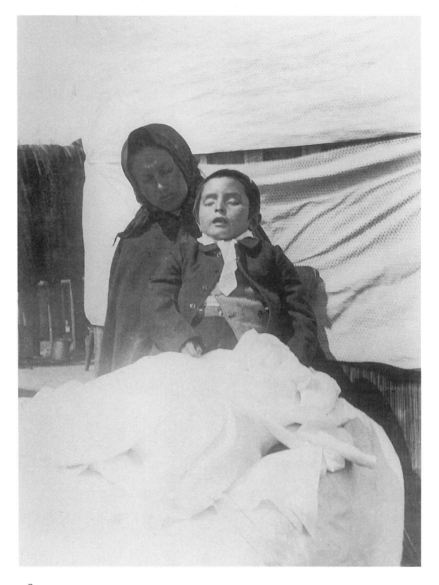

5.8
UNKNOWN PHOTOGRAPHER
Northern Straits Sooke woman with
deceased child, n.d.
Courtesy of the Royal British Columbia
Museum Anthropological Collections
Section #PN 6142

the child had been given, affirming that the photograph was intended for an audience greater than immediate family. It was not merely a display of personal bereavement but a public testament of the status and honor of the kin as reflected in the fine garments worn by the child. Witnesses were anticipated for this significant, increasingly common event in the life cycle of a family.

A fifth photograph (fig. 5.9), depicting a Coast Salish woman with a deceased child, was less spontaneous than this one. The adult woman may have traveled to an urban commercial studio soon after the death of her baby. The face of the young, elegantly dressed woman evokes a troubling combination of despair and fatigue. A floral bouquet sits arranged between the small hands of the child. These two examples of the postmortem photograph to commemorate and mourn the passing of a child seem a notable departure from the popular celebratory portraits of babies and children that prevailed among Euro-American settler mothers. These postmortem images are also distinct from the postmortem card of a young settler named Richard Drew, who is depicted alive although a caption on the card informs the viewer of his passing (fig. 5.10).

The distinctions between the postmortem photographs of the Salish mothers with children versus the plethora of baby photographs of settler children reflect the social asymmetries existing between two increasingly segregated populations. Child mortality caused by introduced diseases devastated Native American families who lacked natural immunity. Although many Euro-American families experienced the loss of children, their relative proximity to urban settlements and the availability of medical treatment and vaccines reduced their risk. The two postmortem photographs also reveal that the demands of seasonal hunting and industrial labor generated circumstances when Native mothers and grandmothers on reserves had to single-handedly cope with the frequent illness and death of children and the elderly, lacking the customary support of fathers, brothers, husbands, and other male kin. As primary caretakers of children, women thus assumed primary care for the deceased, preparing and dressing bodies before burial. Ultimately it must have been the mothers who decided to photograph their children. By scrutinizing these photographs of maternal loss, it is not my intention to insensitively prolong the suffering of these two women or their kin. In this instance, the photograph is a unique, politically charged historical document from which contemporary viewers might grasp the extent of the grief experienced by individual Native women and families in the face of regional wide epidemics causing child mortality.

The photograph, as it functioned in these circumstances, was a metonymic device. The images of the Quamichan naming ceremony, the Ditidaht tribal council meeting's portrait of Seta-Kanim, and the postmortem portraits were, on one level, realistic in aesthetic and content. On the other

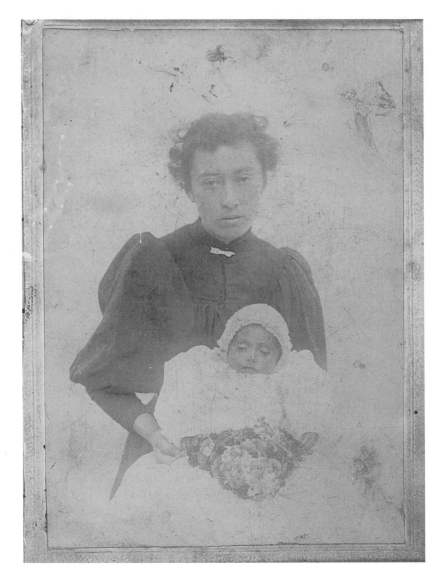

5.9
UNKNOWN STUDIO PHOTOGRAPHER
Coast Salish woman and child, n.d.
Courtesy of the Royal British Columbia
Museum Anthropological Collections
Section #PN 6376

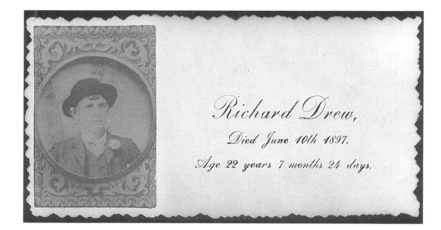

5.10

UNKNOWN PHOTOGRAPHER
Postmortem card. Caption reads,
"Richard Drew, Died June 10th, 1897.
Age 22 years 7 months 24 days."
Nanaimo District Museum #I1-28

hand, the portrait of Annie Charles with the gem portrait situated at the base of her throat utilized an experimental technique to evoke an intimate connection to an absent relative—expanding the social and symbolic role of photography. The function of the public commemoration of the deceased, either in photographic representation or for the purpose of taking a photograph, was binary: the social status of the family and kin was emphasized and the absent individual was honored. As a ghost or reminder of the corporeal body and soul, the photograph was a commemorative device whose purpose of display was to bestow honor on the departed and their kin for the eyes of the living. Because northwest coastal culture revolved around oral and pictorial tradition and placed value on extended kin affiliations, the role of the photograph among these families differed from the settler, who might consider the public display of grief or the departed as culturally inappropriate.

Family Portraiture

Commissioning personal and family portraits from commercial studios had proven all the rage among Euro-American settlers, but was this activity as sought after by Native American individuals and families? Accord-

ing to one contemporary Sekani woman, photographs of kin provided a unique record of those who "weren't born in hospitals . . . didn't register births or have land or houses in their own names . . . didn't go through immigration . . . never dreamed of owning such a thing as a camera . . . [and for whom] only the spoken word records a family's history."[52] Despite an excess of bureaucratic scrutiny, social and economic marginality has relegated Native Americans to a considerable degree of historical anonymity. A personal photograph of an identifiable family member, therefore, was of great value for surviving kin.

Reflecting on these circumstances from another perspective, ethnohistorian Victoria Wyatt observes that photographs of the Native American destined for a commercial market conventionally depicted the lowly or impoverished. "Caucasians," Wyatt states, "rarely saw images of Native Americans who looked prosperous in European terms," as "prosperity was equated with sophistication."[53] In essence, scenes of Native prosperity, respectability, or success, as seen in private portraits such as that of Alice White and three children (fig. 5.11), shook the dominant stereotypes of Indians. These representations of successful or affluent Native Americans contradict the prevailing claims that Native Americans lacked the industry and ambition equal to the settler. The women and children in both of these studio portraits wear leather shoes, jewelry, ready-made dresses and tailored suits and, in the case of Alice White, a well-endowed hat. The Brooks and Sampson studio photographers incorporated props and painted backdrops conventionally reserved for Euro-American clientele. At the turn of the century, between 1892 and 1900, four commercial studios in Nanaimo—the Elite Studio operated by P. E. Larss and W. C. Pierce, William Burton Finley's studio, the E. C. Brooks studio, and John Sampson's studio—apparently catered to local Nanaimo families and individuals.[54] Finley, most notably, specialized in hand-painted portraiture similar to the portrait displayed by the host at the naming ceremony at the Quamichan village. Unlike the photographs of converts or imagery produced for Indian agents, the studio portraits are historically significant because they were secular; their commission, use, and content was exercised exclusively by the Native American clients rather than by external imperatives.

What purpose did these commercial photographic studio portraits hold for indigenous clients? A collection of photographs housed in the Nanaimo District Museum discloses that certain individuals, like William Good, son of Louie Good, the hereditary chief of the Sne-ney-mo, repeatedly returned to a commercial studio over an extended period.[55] Good was a celebrated boxer and runner who set an 1897 world record for running in San Francisco. Regionally, he was active as a tribal law keeper and enforcer on the Nanaimo reserve until 1918. A series of portraits (figs. 5.12–5.14) depict William Good and his immediate family over a considerable stretch of

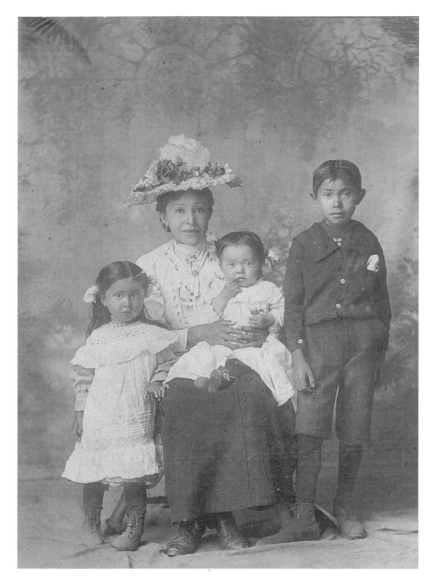

5.11
E. C. BROOKS STUDIO OF NANAIMO
Alice White, her two children, and one boy,
Nanaimo, Vancouver Island, n.d.
Courtesy of the Royal British Columbia
Museum Anthropological Collections
Section #PN 9475

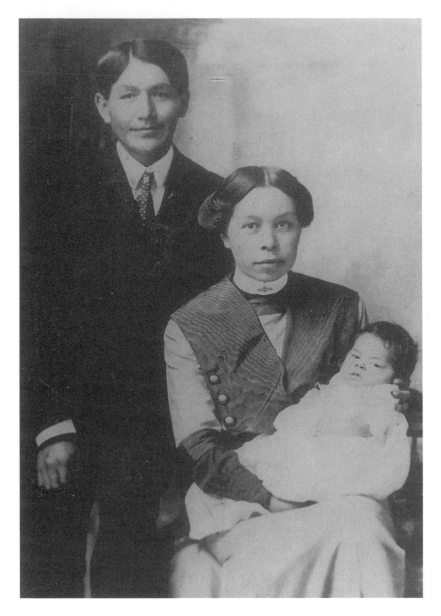

5.12
UNKNOWN PHOTOGRAPHER
William Good, first wife Celestine, and
daughter Hazel, Nanaimo, n.d.
Nanaimo District Museum #12–146

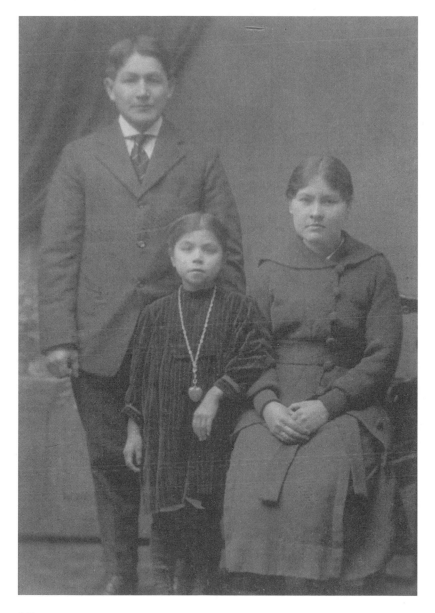

5.13

UNKNOWN PHOTOGRAPHER
William Good, Hazel, and second wife,
Veronica, n.d.
Nanaimo District Museum #12–141

5.14
UNKNOWN PHOTOGRAPHER
William Good, n.d.
Nanaimo District Museum #11–127

time. Collectively, these conventional portraits systematically chart the growth of an individual, marital changes, and a father and daughter's process of aging. Good had acquired external markers of success and status across both Euro-American and Native American culture, and the photographs, all taken in commercial local studios, adhere to photographic conventions reserved for settlers, conventions emphasizing wealth and respectability.

European ideals about family and urban life gathered public authority in the 1880s after the Indian Act—the legislation to control and prohibit the behavior of Indians on reserve and off—took hold. The growing abundance of positive, secular representations of Native families produced by Nanaimo

commercial studios between 1890 and 1900 demonstrates that some families, like the Goods, wished to announce their familiarity with the settler's idiom of success, sophistication, and economic stability. These images of prosperity respond to the many negative stereotypes of Native American life and culture in the print media and public discourse.

The general impression offered by photographs found within nineteenth-century archival collections is that Native Americans of the Northwest Coast were subjected to a repressive scientific inquisition that included cameras wielded by amateurs and professional photographers working on behalf of national and commercial interests. With the exception of the portraits of individual religious converts and celebrated chiefs, honorific or positive representations of everyday women, men, and children were conspicuously absent from the repertoire of photographs produced and marketed commercially prior to 1890. By 1890, Nanaimo Coast Salish individuals and families sought out commercial portraiture in unprecedented numbers, and this endeavor signified, in part, the upward economic and social mobility of some, as afforded by their emergent roles in the industrialization of resources such as fish and lumber. Economic destitution, rather than the incapacity to appreciate the technology of the camera, may have prevented access to the camera by certain individuals and families who were less likely to possess the disposable income for manufactured goods like the studio portrait.

As early as 1854 one Northwest Coast carver, who traditionally conveyed cultural meaning through two- and three-dimensional design and sculpture, expressed aesthetic and documented interest in photography. The camera's capacity for realism also seems to have been influential when a photographic portrait was substituted for the customary goat-hair effigies or rag figures that symbolically stood in for a deceased ancestor at naming ceremonies held at the Coast Salish reserve of Quamichan in the early twentieth century. The use of photography apparently was not exclusively secular or private, as the example of the use at Quamichan demonstrated. If ritual and ceremony demanded, the photograph, although realistic, was infused with spiritual and public import, a unique rationale that distinguished the indigenous encounters with photography during the settlement era.

Conclusion

Finally a contemporary photograph (unattributed, and not reproduced here for permissions reasons), taken between 1930 and 1950, resoundingly corroborates that photographic representation may challenge the stereotypes originating in the colonial era. According to acquisition records, the photograph was retrieved from houses abandoned in the 1960s at Friendly Cove in Mowachaht (a tribal group of the northern Nuu-chah-nulth or Nootkan) territory on the northwestern coast of Vancouver Island. This was where the Spanish explorers of the *Santiago* made contact with northern Nuu-chah-nulth in 1774, followed by prolonged interactions with James Cook and his crew in 1778. With the Spanish military outpost sustained between 1789 and 1795, the presence of this international cohort of explorers, military personnel, and traders reminds us that villagers from this region were long familiar with the relentless pressures of a global marketplace.[1] In this photo, a young woman stands on a dock in a maritime community. She wears a modern knee-length plaid skirt, with a kerchief knotted nattily around her throat, distinctive earrings dangling from her ears, and a belt of interlocking metal links painstakingly aligned with the twist of her kerchief. Her hair is neatly clipped and styled. Most notably, she grasps a Brownie camera in her right hand in an assured manner that declares the camera as her own. She might reside on the periphery of the British commonwealth, but her stylish comportment defies any assumption that she is sheltered. She looks alert to the world and ready to participate in it.

The Brownie, a portable camera introduced in 1900 and priced for those of moderate economic means, had improved on the Kodak, the portable camera first marketed to consumers by the Eastman Company in 1889. According to regional historians, George Eastman of the Kodak Eastman Company had frequented various maritime communities of the Northwest Coast en route to Alaska at the turn of the century. During his visit to the community of Alert Bay, for instance, he "instructed our [*sic*] Indians how to operate cameras."[2] In fact, by 1907, photography had been integrated into the regular curriculum at the government-sponsored industrial school at Alert Bay, and William Halliday, the Department of Indian Affairs regional agent, would confirm, "Several of the young men have cameras and take fairly good pictures."[3] Never missing an opportunity to pontificate on the state of the local Indians, Halliday qualified this complement by adding, "if the evil influence of the potlatch could only be done away with, this band would forge right ahead."[4] Like other federal officials, Halliday believed that Indian youth might abandon potlatch and other "giveaway" ceremonies if they ceded to all things "modern." The modernization of the Indian—a euphemism for a wholesale adoption of Euro-American culture and the rejection of traditional lifeways, indigenous languages, and rituals—formed the heart not only of public sentiment but also of official policy espoused by the agents and bureaucracy of the Department of Indian Affairs in Ottawa. The displacement of traditional culture and lifeways would eventually result in the enfranchisement of Indians as Canadian citizens.[5] Photography, the rhetoric implied, was one of a multitude of industrial skills that would quicken the assimilation of Indian youth.

It comes as no surprise, therefore, that by the date of this photograph, circa 1930 to 1950, that many young people, including girls, were active photographers. Photography, as a skill, had received the stamp of approval within the white man's educational scheme. While skeptics might view this photograph as proof that Indian youth had conformed to the imperative of modernization, an alternative interpretation is possible, perhaps crucial. The photograph fells the historical stereotypes of Native women long sustained among the immigrant population. The young woman in the photograph is not destined for the domestic household in conformity to the codes of femininity inculcated at missionary and industrial schools. She is independent, composed, fashionable, and technologically literate. Her comportment and panache expose a commitment to ideas and trends beyond her community.

Photographed at a point of either departure or arrival, she stands in front of a well-maintained oceangoing vessel that emphasizes, like her pristine outfit, a moderate, rather than impoverished, standard of life. The warmth and receptivity of her face and pose are also telling, as they suggest that a familiar or friendly person stands on the other side of the lens. Did

another member of the family also possess a camera? Signifying the potential mobility of a young woman, she returns to—or leaves—her immediate community, family, and village. With Brownie in hand, she will document a personal impression of the world. Obviously, the innovation and cost of the Brownie benefited young women like this who, along with others in their families or communities, had previously lacked control over photographic self-representation. With the appearance of the more reasonably priced Brownie, the access to cameras—and all that access implied—was no longer confined to educated Euro-American men.

In many ways the surge in photographic activity stimulated by the arrival of commercial merchant photographers such as Frederick Dally, Stephen Spencer, Hannah Maynard, and Richard Maynard at the mid–nineteenth century had cultivated an early receptivity for photography in the region. Their entrepreneurial ambition and aesthetic innovations stimulated an emergent market for portraiture as demanded by certain clientele, primarily settlers, who sought representations of their changing status in the new British colonies. These photographers further catered to the impulse for national promotion by recording the process of modernization so revered by the nation builders. Accordingly, as seen in other colonial settings, the success of northwestern settlement was nurtured by widely circulated photographs depicting "civilization" as represented by churches, mercantile facilities, courthouses, bridges, roads, roadhouses, docks, railways, wharves, and so forth. In addition, early commercial photographers documented the manifestations of industrial entrepreneurialism, including canneries and sawmills along the Northwest Coast, and placer and large-scale mining on the tributaries of the mainland Fraser River. Portraits of prominent or celebrated personages of the governing elite completed this prosettlement vista.

While the earliest photographs produced a limited account of the colonial frontier and, if taken literally, attributed the responsibility for progressive development to a small circle of ethnically homogenous "pioneers," growth was dependent on a continuing influx of immigrants. The call to expand the colony's European population led to the circulation of images beyond regional and national boundaries. Photographs, in essence, distributed knowledge of the North American colonial frontier to the rest of the British Empire, bringing the images of the Northwest Coast and its indigenous inhabitants from the periphery to the forefront of imperial vision. Indians, in particular, fascinated international audiences.

With a subdued, rather than resistant, Indian preferable for settlement, the state initiated the demographic study of the mortality, growth, labor, or underproductivity of the Indian population. Bureaucratic interest in the Indian was largely motivated by frequent eruptions of violence between Indians, miners, and settlers who fought over the rights to resources and terri-

tory. The Indian's heightened susceptibility to introduced epidemic diseases such as tuberculosis, smallpox, influenza, and sexually transmitted infections also made them the target of social discrimination. Settlers were unnerved by the presence of Indians within the urban limits, despite the fact that the trade, provisions, and labor they provided were indispensable to the maintenance and growth of the towns and the comfort of the newcomers. Demographic data collected by the Department of Indian Affairs tours of investigation on Coast Salish, Nuu-chah-nulth, Kwakwaka'wakw, Tsimshian, and Haida villages and reserves was analyzed by a cadre of local civil servants, including surveyors, census takers, militia men, school administrators, teachers, medical professionals, missionaries, and the local and provincial police. Between 1871 and 1881, commercial photographers, commissioned by the regional superintendent of the DIA, supplied photographs to supplement regular government reports about Northwest Coast Indians.[6] The photographs, with the aid of editorial captions and commentary, reinforced the negative attitudes that Native Americans were intellectually or culturally "underdeveloped" in comparison to the Euro-American Christian settler who was normative in disposition, economically productive, moral in character, and superior in intellect.

The image of the "good," compliant Indian was necessarily incorporated into immigrant promotional brochures, guidebooks, and official government records that traveled overseas. By late century, the sustained political scrutiny of the indigenous peoples in the Northwest began to attract scholarly attention. Whereas prosettlement photographs had created a window for prospective British immigrants and entrepreneurs, the photographs and demographic scrutiny of Northwest Coast Indians brought anthropologists, museum specialists, and tourists to the region.

After 1880, the gaze of consecutive waves of newcomers—missionaries, tourists, anthropologists, museum collectors—lingered on the Indian and the newcomers, like the civil servants, generated a combination of written and visual representations of "Indian life" and "Indian bodies." While anthropologists were well intentioned and less directly concerned with the local and imperial politics of territorial expansion, they, like their predecessors, also contributed to the commodification of knowledge about Indian life. Following the earlier ethnographic amateurs and explorers, they became the new "authorities" on Northwest Coast Indians.

Throughout the nineteenth century, the evolutionary framework of anthropology, which placed the European at the apex and the Aboriginal at the bottom, had dominated popular and official perceptions of Northwest Coast Indians. These older views were eroded by the research conducted by Franz Boas, who increasingly espoused theories of cultural relativity. Boas's method of "ethnographic immersions," which he had tested among the northern-dwelling Inuit people in 1882, re-evaluated evolutionary anthro-

pology and therefore the views held by his colleagues at the Washington School of Anthropology and, most notably, by the immediate supervisor of his Northwest Coast research, Horatio Hale.[7] After his ventures in Baffinland, Boas diversified his methods of study to include material culture, language, and daily life. The benefits of longer terms of residency among the people and a close examination of religion, language, and cultural traditions made him appreciate the sophistication of indigenous habits, ways, and customs.[8] With insights gained from this new approach, Boas began to question the established theoretical limits of his discipline:

> I often ask myself what advantages our "good society" possesses over that of the "savages" and find, the more I see of their customs, that we have no right to look down upon them. Where amongst our people could you find such hospitality as here? Where are people so willing, without the least complaint, to perform every task asked of them? We have no right to blame them for their forms and superstitions, which may seem ridiculous to us. We "highly educated" people are much worse, relatively speaking.[9]

Boas applied his methodological innovations among British Columbia's Kwakwaka'wakw, employing local informants like George Hunt of Fort Rupert and Annie Spencer of Alert Bay, to "present the culture as it appears to the Indian himself."[10] The purpose of the local informant was to overcome the anthropologist's outsider status and to achieve the desired rapport with his subjects.[11] He endeavored to describe customs and beliefs in the language of the people and thereby eliminate or avoid "the distortions contained in the descriptions given by the casual visitor or student."[12] With this comment, Boas directly referred to those amateur ethnographers, travelers, and explorers before him who had produced what he thought were biased or corrupt views about northwest coastal Indian life.

Nonetheless, the conduct of anthropologists during this era of apparently improved scholarly respect for Indian remains open to criticism. Anthropologists, Boas included, were swept up by the salvage paradigm, removing house poles, unearthing grave remains (skulls were a desired collectible for those pursuing anthropometric anthropology), and retrieving other artifacts in response to requests from urban, mostly eastern-based museums.[13] While the motives for this collecting frenzy stemmed from a scientific concern for the preservation of the vanishing cultures of the Indian, anthropologists believed, like those before them, in the manifest destiny of assimilation. While the innovations in anthropological method and the rising professionalization of the discipline and its study of Indians, as embodied by Boas's commitment to indigenous languages, renewed scholarly respect for the unique culture of the northwest coastal peoples, political

policies, and public sentiment were not enlightened by this discursive shift. Boas's methodologies, which strove toward a more informed and inclusive view of the subject and culture, distinguished the anthropologist from the uninformed, but anthropology's interest in the indigenous people of the region accelerated rather than deflected the collecting mania.

Boas's use of photography was a significant tool toward greater accuracy in representing Indian existence. Recruiting commercial photographers who had traveled on the earlier tours of inspection with the superintendent of the DIA, Boas sought and hired local photographers who were familiar with the landscape and its people. He used photography in three distinct ways: first, photography in an "object-orientated" manner, to record individual examples of artifacts and architecture "disappearing" in the face of acculturation.[14] Second, photographs of these artifacts and indigenous architecture became an interactive device to elicit information from informants about the family and clan history of this material culture and their practical use within social rituals.[15] Third, the head and profile photographs of individual Kwakwaka'wakw sitters were taken as part of a larger, ongoing anthropometric archive Boas was assembling.[16] Anthropometry, a practice used by nineteenth-century physical anthropologists, was still an acceptable systematic means of measuring and observing different races, their physical comportment, and skeletal shape.[17] The conviction that character could be detected, decoded, or "read" by visual signs emitted by the structure of flesh and bone was affirmed by the combination of anthropometry and photography, as the resulting photographs aided in the visualization of differences between variants of the human stock. Boas's use of anthropometrics in combination with photography, between 1888 and 1902, was part of the four large research projects he conducted on North American Indians, including research for the British Association for the Advancement of Science, for the Chicago World Columbia Exposition, for the Jesup North Pacific Expedition, and the Huntington California Expedition, which "collectively yielded measurements on around 15,000 Amerindians and 2,000 Siberians," but the anthropometric data, including the photographs, were never thoroughly analyzed.[18] Although measurements and observations on the Northwest data were published late in the century, Boas, to his credit, seemed more interested in concentrating his attention on newer methods in order to rectify uninformed views or popular apprehensions about the "savagery" of Indians. Overall he advocated greater scientific accuracy and context in recording practices and research.

While Native Americans were commonly paid to sit and model by Euro-American researchers like Boas, eventually they did seek out and acquire photographs for their own use. Even as consumers of photographs of themselves produced by outsiders, they participated in the interpretation of the photographic artifact and must have exerted a degree of influence over

the manner in which the photograph was taken. Until the 1890s, however, the photographic narratives about quotidian life on the colonial frontier objectified them. Before then, Native American people were unable to effectively counter the popular visual stereotypes of Indians as self-destructive, violent, lazy, drunk, and so on. Nonetheless, many of the photographs produced under the auspices of anthropological research at the turn of the century have since proved politically and historically useful to contemporary indigenous researchers and artists.[19] Artists and educators are returning to the many historical photographs representing Indians and Indian life in order to speak back to the violations of settlement—to counter, as one contemporary Yuchi/Creek photographer asserted, the "absence of [the indigenous] presence."[20] In this way, photographic (mis)representations serve as entry points to redress the shameful treatment of Native Americans throughout history.

On the Northwest Coast of the nineteenth century, the greater economic prosperity created by Native Americans' entry into the wage and industrial economy eased their access to the camera. Wealthier individuals and families began to frequent commercial studios as clients, publicly forging a modern identity for themselves. Whereas late-century photographs challenged the restrictive and negative representations of Indians commonly exchanged among settlers and reproduced in the illustrated print media, the circulation of these portraits was largely confined to immediate family and kin. Settlers were not privy to these views.

Photographs of the modern self coincided with the appearance of other, more spiritually endowed, roles for photography. Photographs were used by the Coast Salish and Nuu-chah-nulth in ceremonial commemorations of ancestral affiliations and were part of the bereavement over lost children and other kin. These unique, culturally specific uses of the photograph reaffirmed the versatility of Native Americans to incorporate Euro-American technology. The photograph of the young modern woman at Alert Bay is therefore no minor triumph. The portrait, progressively and positively interpreted, retaliates against the ever renewable postcard commodification of Indian life, which, despite official imperatives for modernization and assimilation, continued to find a market. Although Native Americans had modernized, racism was so entrenched that the nostalgic image trumped other representations truer to the daily political realities of a people who, by late century, were full participants in the coastal industrial economy as cannery or hopfield workers, loggers, fishers, urban dwellers, and political activists. The realism of the photograph of the young woman, proudly flaunting a fashionable modernity, interjects a defiant vision of indigenous existence consistently denied by the outsiders.

NOTES

INTRODUCTION

1. Andrew Birrell, *Into the Silent Land: Survey Photography in the Canadian West, 1858–1900* (Ottawa: Public Archives of Canada, 1975). The following surveys conducted in the Canadian West used photography: North American Boundary Commission, 1858–1862; North American Boundary Commission, 1872–1975; Geographical Survey of Canada, 1871; Canadian Pacific Railway Survey, 1871–1879;

Geological Survey of Canada, 1875–1900; Dominion Lands Survey and International Boundary Commission, 1886–1900.

2. Roland Barthes, "The Photographic Message," *Image—Music—Text,* ed. and trans. Stephen Heath (New York: Hill and Wang, 1977), 82.

3. I vary use of the terms *Indian, indigenous, aboriginal,* and *Native American.* Those of European and American ancestry who eventually settled in the British North American colonies on the Northwest Coast are identified as *Euro-Americans.* The outsider naming of indigenous peoples in North America as Indians was symptomatic of colonization. Ignorant of the linguistic diversity and various dialects of the people encountered, explorers and traders often corrupted indigenous languages through phonetic translation. *Indian* was the most common term used from colonial times to describe the many culturally and politically distinct peoples in the Dominion of Canada falling under the federal legislation of the Indian Act of 1871. *Indian* also included Métis and the northern Inuit people. In contemporary Canada, *aboriginal* has gradually replaced the term Indian, as has *indigenous. Aboriginal* and *indigenous* intentionally imply the political association with global decolonization movements. The use of *aboriginal* formally replaced *Indian* with section 35 of the 1982 Canadian Constitution. Seen as more inclusive, *aboriginal* may be adopted by those who, in the past, have been outside the Indian communities of the reservation system: thus *aboriginal* is applicable to non-status Indians or those who lost rights under the Indian Act. In the 1982 Canadian Constitution aboriginal rights were guaranteed to three groups: Indians, Inuit, and Metis. In 1975, the term *First Nations* was adopted in Canada when the National Indian Brotherhood changed its name to the Assembly of First Nations. Outsider naming was also integral to the process of Christian conversion, whereby missionaries assigned Christianized names after baptism or similar rites of religious passage and asked Native American converts to discard traditional names. David Pentland, "North American Languages of Canada, 1534–1900," *Facsimile,* no. 10 (November 1993): 5–7; Paul Chartrand, "'Terms of Division': Problems of 'Outside-Naming' for Aboriginal People in Canada," *Journal of Indigenous Studies* 2.2 (1991): 1–8.

4. For a survey of United States Indian policy, see S. Lyman Tyler, *A History of Indian Policy* (Washington, D.C.: Department of the Interior, Bureau of Indian Affairs, 1973); William Sturtevant, ed., *Handbook of North American Indians,* vol. 4: *History of Indian-White Relations* (Washington: Smithsonian Institution Press, 1988), 29–80; and Vine Deloria, ed., *American Indian Policy in the Twentieth Century* (Norman: University of Oklahoma Press, 1985). For Canada, see John Leslie and Ron Maguire, eds., *The Historical Development of the Indian Act,* 2d ed. (Ottawa: Research Branch Indian and Northern Affairs, 1978); John L. Tobias, "Protection, Civilization, Assimilation: An Outline History of Canada's Indian Policy," *Western Canadian Journal of Anthropology* 61.2 (1976): 13–30; and *Canada, Indian Acts and Amendments, 1868–1950* (Ottawa: Indian and Northern Affairs, 1985).

5. Robert Davison, "Turning a Blind Eye: The Historians' Use of Photographs," *BC Studies* 52 (winter 1981–1982): 16–35.

6. British Association for the Advancement of Science (BAAS), *Handbook of the Dominion of Canada* (Montreal: Dawson Brothers Publishers, 1884), 333.

7. The *Victoria Gazette* was the first newspaper in the colony of Vancouver Island. Victoria's *Daily British Colonist* (also known as the *Daily Colonist*), a second newspaper founded in June 1858, was edited by Amor De Cosmos, a Nova Scotia journalist. The *Daily Times (Victoria)* appeared on June 9, 1884, and offered a more sweeping roundup, with reports from Nanaimo, Chilliwack, New Westminister, Kamloops, and other small towns in the province of British Columbia. The *Cariboo Sentinel* covered the mining activities in the interior mainland of British Columbia.

8. Peter Wollheim, "Photography and Narrative," in *The Zone of Conventional Practices and Other Real Stories,* ed. Cheryl Simon (Montreal: Optica, 1989), 59.

9. David Green, "Veins of Resemblance: Photography and Eugenics," in *Photography/Politics Two,* ed. Patricia Holland, Jo Spence, and Simon Watney (London: Comedia Publishing, 1986), 10. Roland Barthes, *Camera Lucida: Reflections on Photography,* trans. Richard Howard (New York: Hill and Wang, 1981), 5.

10. W. J. T. Mitchell, *Picture Theory: Essays on Verbal and Visual Representation* (Chicago: University of Chicago Press, 1994), 291.

11. R. C. P. Baylee, "Vancouver and Queen Charlotte's Island," *Colonial Church Chronicle* (May 1854), 409–417; Alexander Caulfield Anderson, *Handbook and Map to the Gold Region of Fraser and Thompson Rivers* (San Francisco: J. J. Lecount, 1858); John Keast Lord, *At Home in the Wilderness: What to Do There and How to Do It: A Handbook for Emigrants and Travellers* (London: Harwicke and Bogue, 1876); Alexander Rattray, *Vancouver Island and BC Land* (Toronto: Smith Elder and Co. Canadiana House, 1862); James Arthur Lees, *BC 1887; A Ramble* (London: Longman, Green and Co., 1892); H. J. Boam, ed., *BC: Its History, People, Commerce, Industries, and Resources* (London: Sells, 1912); Richard Mayne, *Four Years in British Columbia and Vancouver Island: An Account of Their Forests, Rivers, Coasts, Gold Fields, and Resources for Colonisation* (London: John Murray, Albemarle Street, 1862; reprint, New York: S. R. Publishers, 1969); Edmund Hope Verney, *The Vancouver Island Letters of Edmund Hope Verney, 1862–1865,* ed. Allan Pritchard (Vancouver: University of British Columbia Press, 1992).

12. Benedict Anderson, *Imagined Communities: Reflections on the Origin and Spread of Nationalism* (London: Verso, 1991).

13. Jim Burant, "The Visual World in the Victorian Age," *Archivaria* (winter 1984–85): 110–121.

14. A comprehensive compilation of photographers active in this region may be found in David Mattison, *Camera Workers: The British Columbia Photographers Directory, 1858–1900* (Victoria: Camera Workers Press, 1985).

15. Clair Weissman Wilks, *The Magic Box: The Eccentric Genius of Hannah Maynard* (Toronto: Exile Editions, 1980); David Mattison, "The Multiple Self of Hannah Maynard," *Vanguard* (October 1980): 14–19; David Mattison, "Richard Maynard, Photographer of Victoria, BC," *History of Photography* (April–June 1985): 109–129.

16. British Columbia, *Papers Connected with the Indian Land Question: 1850–1875* (Victoria: Government Printing Office, 1875).

17. Carolyn Marr, "Photographers and Their Subjects on the Southern Northwest Coast: Motivation and Response" *Arctic Anthropology* 27.2 (1990): 15.

18. James Urry, "Notes and Queries on Anthropology and the Development of Field Methods in British Anthropology, 1870–1920," *Royal Anthropological Institute* (1973): 45.

19. BAAS, *Notes and Queries on Anthropology, or a Guide to Anthropological Research for the Use of Travellers and Others*, ed. John George Garson and Charles Hercules Read (London: Anthropological Institute, 1899), viii.

20. Ibid., vii.

21. These thematic headings are from the index. Ibid., xi–xii.

22. Ibid., vii, 7, B2, 146.

23. Ibid., 147.

24. Urry, "Notes and Queries on Anthropology and Development of Field Methods," 50, citing a report authored by W. H. R. Rivers for the Carnegie Institution.

25. Ibid., 51.

26. Benjamin Leeson, "Photographing Brother 'Lo,'" *Camera Craft* (October 1914), 489–490.

27. Letter from Charles Willoughby to Hannah Maynard, n.d., British Columbia Archives (BCA), add. mss. 1077, vol. 20, file 7.

28. Leeson, "Photographing Brother 'Lo,'" 492.

29. Mary Louise Pratt, *Imperial Eyes: Travel Writing and Transculturation* (New York: Routledge, 1992), 4.

30. Mitchell, *Picture Theory*, 288.

31. A. C. Haddon, "Section no. LXXVII—On Photography," *Notes and Queries on Anthropology* (1899), 236. See also Carolyn Marr, "Taken Pictures: Interpreting Native American Photographs of the Southern Northwest Coast," *Pacific Northwest Quarterly* 80.2 (April 1989): 53.

32. See James R. Ryan, *Picturing Empire: Photography and the Visualization of the British Empire* (Chicago: University of Chicago Press, 1997); Elizabeth Edwards, ed., *Photography and Anthropology: 1860–1920* (London: Royal Anthropological Institute, 1992).

33. Alan Sekula, "Photography between Labour and Capital," in *Mining Photographs and Other Pictures: A Selection from the Negative Archives of Shedden Studio, Glace Bay, Cape Breton,* intro. Robert Wilkie (Halifax: Press of the Nova Scotia College of Art and Design, 1983), 193.

34. Green, "Veins of Resemblance," 10.

35. Barthes, "The Photographic Message," in *Image—Music—Text,* trans. Stephen Heath (New York: Hill and Wang, 1977), 25–26.

36. Margaret Whitehead, "'A Useful Christian Woman': First Nations' Women and Protestant Missionary Work in British Columbia," *Atlantis* 18 (1994): 142–166.

37. Valerie Moghadam, "Revolution, Islamist Reaction, and Women in Afghanistan," in *Women and Revolution in Africa, Asia and the New World,* ed. Mary Ann Tetreault (Columbia: University of South Carolina Press, 1994), 212.

38. Leila Ahmed, *Gender, Women, and Islam: Historical Roots of a Modern Debate* (New Haven, Conn.: Yale University Press, 1992), 151.

39. Barthes, "The Photographic Message," 19, 27.

40. John Berger, *About Looking* (New York: Vintage, 1991), 56.

41. See, for instance, Jane Alison, ed., *Native Nations: Journeys in American Photography* (London: Barbican Art Gallery, 1998); and Theresa Harlan, "Adjusting the Focus for an Indigenous Presence," in *Over Exposed: Essays on Contemporary Photography,* ed. Carol Squiers (New York: New Press, 1999); see also essays in Tim Johnson, ed., *Spirit Capture: Photographs from the National Museum of the American Indian* (Washington: Smithsonian Institution Press in association with the National Museum of the American Indian, 1998), and Rayna Green, "Repatriating Images: Indians and Photography," in *Benedicte Wrensted: An Idaho Photographer in Focus,* ed. Joanna Cohan Scherer (Boise: Idaho State University Press, 1993), 150–160.

CHAPTER I

1. Iris Higbie Wilson, introduction to José Mariaño Moziño, *Noticias de Nutka: An Account of Nootka Sound in 1792,* ed. Iris Higbie Wilson (Toronto: McClelland and Stewart, 1970), xxviii; Moziño, *Noticias de Nutka,* 66.

2. Michael E. Thurman, "Juan Bodega y Quadra and the Spanish Retreat from Nootka, 1790–1794," *Reflections of Western Historians,* ed. John Alexander Carroll (Tucson: University of Arizona Press, 1969), 51.

3. *John Ledyard's Journal of Captain Cook's Last Voyage,* ed. James Kenneth Munford (Corvallis: Oregon State University Press, 1963).

4. Moziño, *Noticias de Nutka,* 65.

5. Thurman, "Juan Bodega y Quadra," 49; Moziño, *Noticias de Nutka,* 67. The peak of the maritime trade occurred between 1792 and 1812. Between 1825 and 1830 the Hudson's Bay Company established permanent fur trading posts along the Northwest Coast. Robin Fisher, *Contact and Conflict: Indian-European Relations 1774–1890* (Vancouver: University of British Columbia Press, 1986).

6. John Meares, *Voyages Made in the Years 1788 and 1789 from China to the North-West Coast of America* (1791; Amsterdam: Bibliotheca Australiana #22, 1967), 115.

7. Moziño, *Noticias de Nutka,* 70.

8. Iris Higbie Wilson, "Spanish Scientists in the Pacific Northwest, 1790–1792," in Carroll, *Reflections of Western Historians,* 37.

9. Quadra and Vancouver carried out the anticipated provisions of the treaty at Nootka Sound in 1792. The final abandonment by Spain took place on March 23, 1795. Moziño, *Noticias de Nootka,* 90, n. 9.

10. Higbie Wilson, *Noticias de Nutka,* xxxii.

11. Moziño, *Noticias de Nutka,* 9, n. 20.

12. Conde de Revilla Gigedo, the viceroy of New Spain between 1789 and 1794, was committed to scientific exploration and investigation and enlisted Moziño and others from the Royal Scientific Expedition of New Spain to accompany Quadra on his expedition to Nootka Sound. Higbie Wilson, *Noticias de Nutka,* xliv; "Spanish Scientists," 34.

13. Moziño, *Noticias de Nutka,* 83. See Higbie Wilson, "Spanish Scientists," 39.

14. Higbie Wilson, *Noticias de Nutka,* xlvii.

15. Moziño, *Noticias de Nutka,* appendixes A and B, 99–123.

16. Ibid., 5–9.

17. Ibid., 13, 14.

18. Ibid., 17–19.

19. Ibid., 20–22.

20. Ibid., 42.

21. *Tais* was defined by Moziño as a high-ranked principal chief, such as Chief Maquinna. Rankings were based on ownership of property. Ibid.

22. Barry Gough, "The Character of the British Columbia Frontier," in *Readings in Canadian History: Pre-confederation,* ed. R. Douglas Francis and Donald Smith (Toronto: Holt, Rinehart and Winston, 1990), 494.

23. R. T. Williams, *The British Columbia Directory, 1882–83* (Victoria: R. T. Williams Publishers, 1882), 9; E. O. S. Scholefield, preface, *Minutes of the Council of Vancouver Island: August 30, 1851–February 6, 1861* (Victoria: Archives of British Columbia, 1918), 13. Also, see the comprehensive map of North West Company and HBC posts in the Cordillera, 1805–1846, showing routes and years of operation, in Cole Harris, *The Resettlement of British Columbia: Essays on Colonialism and Geographic Change* (Vancouver: University of British Columbia Press, 1997), 37. For a discussion of the forts, see Richard Mackie, *Trading beyond the Mountains: The British Fur Trade on the Pacific, 1793–1843* (Vancouver: University of British Columbia Press, 1996).

24. Richard White, *"It's Your Misfortune and None of My Own": A New History of the American West* (Norman: University of Oklahoma Press, 1991), 77.

25. Derek Pethick, *James Douglas: Servant of Two Empires* (Vancouver: Mitchell, 1969), 146.

26. Charles Wilson, *Mapping the Frontier: Charles Wilson's Diary of the Survey of the 49th Parallel, 1858–1862, while secretary of the British Boundary Commission,* ed. George F. G. Stanley (Toronto: Macmillan, 1970), 41, nn. 23 and 24.

27. In 1845, the HBC maintained a salmon-curing plant and sheep farm on the San Juan Islands. On June 15, 1859, a dispute erupted between a U.S. representative and the HBC. W. S. Harney, the commander of the Oregon District, sent troops to the island and James Douglas, in response, dispatched a British warship. While joint occupation eventually was agreed upon, in the post–Civil War era the islands were awarded to the United States by Emperor William I of Germany through a process of arbitration. Wilson, *Mapping the Frontier,* 66, n. 47.

28. Gough, "The Character of the British Columbia Frontier," 494.

29. Pethick, *James Douglas,* 66; Frederick William Howay and E. O. S. Scholefield, *British Columbia from the Earliest Times to the Present,* vol. 1 (Vancouver: S. J. Clark Publishing, 1914), 676–680.

30. The Wakefield system was advocated by Lord Earl Grey and other colonial officials who espoused a theoretical, rather than practical, approach to the promotion of settlement in the empire's colonies. Richard Mackie, "The Colonization of Vancouver Island, 1849–1858," *BC Studies,* no. 96 (winter 1992–1993): 3–40.

31. Ibid., 20; Jean Barman, *The West beyond the West: A History of British Columbia* (Toronto: University of Toronto Press, 1991), 57.

32. Pethick, *James Douglas;* Dorothy Blakey Smith, *James Douglas: Father of British Columbia* (Toronto: Oxford University Press, 1971).

33. On African American immigration to Vancouver Island during this era, see Crawford Killian, *Go Do Some Great Thing: The Black Pioneers of British Columbia*

(Vancouver: Douglas and McIntyre, 1978); James Pilton, "Negro Settlement in British Columbia, 1858–1871" (M.A. thesis, University of British Columbia, 1952); and James Walker, *A History of Blacks in Canada* (Ottawa: Minister of State for Multiculturalism, 1980).

34. Dorothy Blakey Smith, *The Reminiscences of Doctor John Sebastian Helmcken* (Vancouver: University of British Columbia Press, 1975), 335–336.

35. Pethick, *James Douglas*, 94.

36. British Association for the Advancement of Science, *Handbook for the Dominion of Canada* (Montreal: Dawson Brothers Publishing, 1884), 335.

37. James Douglas, speech, March 19, 1862, "Minutes of the Council of the Colony of Vancouver Island," in *Journals of the Colonial Legislatures of the Colonies of Vancouver Island and British Columbia 1851–1871*, ed. James E. Hendrickson (Victoria: Provincial Archives of British Columbia, 1980), 76–77.

38. In the colonial period of 1843 to 1866 government was centralized in Victoria. The majority of early residents who came under the purview of the first governor of the colony, Richard Blanshard (1849–1851), were the laborers, servants, clerks, and officers associated with the HBC. Blanshard's assignment was to form a Legislative Council made up of appointed councillors and to summon a representative House of Assembly. The Legislative Council was chosen by the governor, as were judges, justices, and other officers who were to be "be men of good life, well affected to our Government, of good estates and abilities suitable to their employments." Blanshard appointed James Douglas, John Tod, and James Cooper as legislative councillors, with Douglas as administrator. By April 1850, Blanshard still had not fulfilled the call for a House of Assembly, intended to consist of freeholders selected to represent the various districts. In a dispatch to Earl Grey, the British secretary of state for the colonies, he offered reasons for the delay: "No settlers have at present arrived . . . for a Council chosen at present must be composed entirely of the officers of the Hudson's Bay Company, few, if any, of whom possess the qualification of landed property which is required to vote for members of the Assembly, and they would moreover be completely under the control of their superior Officers." In 1851, James Douglas replaced Blanshard as Governor holding this appointment until 1863 when Douglas was succeeded by A. E. Kennedy. Scholefield, *Minutes of the Council of Vancouver Island August 30, 1851–February 6, 1861*, 8–9.

39. The HBC was described as a semimilitaristic, class-bound labor hierarchy with laborers and voyagers as the lowly rank, followed by clerks with the status of noncommissioned officers; above them, chief traders and the chief factors, and "commissioned gentlemen" who sat on the councils of the various departments; at the top of the pyramid was Governor George Simpson, who controlled the northern department of Rupert's Land and above him, the governor and London committee. Dorothy Blakey Smith, *James Douglas*, 15.

40. Commercial activity between San Francisco and Victoria, especially by proBritish individual merchants like James and Thomas Lowe, is discussed in J. M. S. Careless, "The Lowe Brothers, 1852–1870: A Study in Business Relations on the North Pacific Coast," in *British Columbia: Historical Readings*, ed. W. Peter Ward and Robert A. J. McDonald (Vancouver: Douglas and McIntyre, 1981), 290. Also see J. M. S. Careless, "The Business Community in the Early Development of Victoria,

British Columbia," in Francis and Smith, *Readings in Canadian History*, Edward Mallandaine, *First Victoria Directory* (Victoria: privately printed, March 1860), 85.

41. In his guidebook, Richard Mayne listed four routes to Vancouver Island. The most common was via steamer to Aspinwall, overland across the Isthmus of Panama, and north by steamer to San Francisco and Victoria. Mayne, *Four Years in British Columbia*, 356.

42. For a discussion of the Canadianization of British Columbia, see Margaret Ormsby, "Canada and the New British Columbia," in *British Columbia: Patterns in Economic, Political, and Cultural Development,* ed. Dickson M. Falconer (Victoria: Camosun College, 1982), 34–47.

43. Robin Fisher, *Contact and Conflict: Indian-European Relations in British Columbia, 1774–1890* (Vancouver: University of British Columbia Press, 1992); Keith Carlson, "Sto:lō-Xwelitem Relations during the Fur and Salmon Trade Era," *You Are Asked to Witness: The Sto:lō* (Chilliwack, BC: Sto:lō Heritage Trust, 1997), 41–52; Wilson Duff, *The Upper Stalo Indians of the Fraser River of BC* (Victoria: British Columbia Provincial Museum, 1952), 41.

44. The first publicized gold discovery was attributed to Haida chief Albert Edenshaw, and his wife, who presented Chief Factor John Work at Fort Simpson with an ore sample found at Mitchell Inlet in Gold Harbor on Queen Charlotte Islands in 1850. Kathleen E. Dalzell, *The Queen Charlotte Islands, 1774–1966,* vol. 1 (Madeira Park, BC: Harbour, 1993), 59–60. In 1851, a nugget was found at Moresby Island in the Queen Charlotte Islands by a Haida woman, and a subsequent discovery in 1856, also attributed to Indians, occurred on the Nicomen River, a tributary of the Thompson River. T. A. Rickard, "Indian Participation in the Gold Discoveries," *British Columbia Historical Quarterly* 2 (1938): 9. See Mayne, *Four Years in British Columbia*, 43.

45. Matthew Macfie, *Vancouver Island and British Columbia: Their History Resources and Prospects* (London: Longman, Green, Longman, Roberts, and Green, 1865; Toronto: Coles Publishing Company, 1972), 64.

46. James Douglas, cited in Rickard, "Indian Participation," 11.

47. Dalzell, *The Queen Charlottes Islands,* 61.

48. Rickard, "Indian Participation," 11.

49. Ibid., 8.

50. Wilson, *Mapping the Frontier,* 26.

51. James Douglas, "Correspondence Relative to the Discovery of Gold in the Fraser's River District," cited in Rickard, "Indian Participation," 10.

52. *Daily Colonist,* August 14, 1862; Robert Brown, "Journal of the Vancouver Island Exploration Expedition, 1864," in *Robert Brown and the Vancouver Island Exploring Expedition,* ed. John Hayman (Vancouver: University of British Columbia Press, 1991), 140, n. 20.

53. Hayman, *Robert Brown,* 44.

54. The appointment of chief inspector Chartres Brew by the British colonial secretary to the British Columbia Constabulary—the first regional police force—occurred in 1858. Constables were recruited from the British Engineer Corps. Colonial Secretary Sir James Lytton to James Douglas, cited in Lynne Stonier-Newman,

Policing a Pioneer Province (Victoria: Harbour, 1991), 10. Coastal policing was conducted by ships of the British Royal Navy.

55. Edward Mallandaine, ed., prefatory remarks, *Mallandaine's Victoria Directory* (Victoria: privately printed, 1869), 13.

56. Ibid., 13.

57. "Papers Relating to the Commission appointed to enquire into the state and condition of the Indians of the North-West Coast of British Columbia," *British Columbia Sessional Papers* (Victoria: Wolfenden, 1888), 415–462L.

58. For an overview of political organizations such as the Nisga'a Land Committee, the Indian Rights Association, Allied Indian Tribes, and the Native Indian Brotherhood of British Columbia, see Paul Tennant, *Aboriginal Peoples and Politics: The Indian Land Question in British Columbia, 1849–1989* (Vancouver: University of British Columbia Press, 1990).

59. For a view of anti-Orientalism among industrial workers in Canada, see Patricia Roy, *White Man's Province: British Columbia Politicians and Chinese and Japanese Immigrants, 1858–1914* (Vancouver: University of British Columbia Press, 1989); the U.S. Pacific Northwest, see Jules Alexander Karlin, "The Anti-Chinese Outbreak in Tacoma, 1885," *Pacific Historical Quarterly* 24 (August 1954): 271–283.

60. Canada, Royal Commission on Chinese Immigration, *Report of the Royal Commission on Chinese Immigration* (Ottawa: printed by order of the commission, 1885), 95.

61. Gary Y. Okihiro, *Margins and Mainstreams: Asians in American History and Culture* (Seattle: University of Washington Press, 1996), 29.

62. *Report of the Royal Commission on Chinese Immigration*, 87.

63. Wilson, *Mapping the Frontier*, 32.

64. *The British Columbian,* November 11, 1865, cited in Frederick William Howay and E. O. S. Scholefield, *British Columbia: From the Earliest Times to the Present,* vol. 2 (Vancouver: S. J. Clark Publishers, 1914), 193.

65. "The Chinese Menace: Additional Evidence by Practical Men of the Danger of Chinese," *Daily Times (Victoria),* November 20, 1899; "Evidence Piling Up: Miners of Long Experience Testify before Arbitrators at Nanaimo," *Daily Times (Victoria),* November 22, 1899.

66. Mayne, *Four Years in British Columbia,* 352.

67. In *Sojourners in the North* (Prince George: Caitlin Press, 1996), 20–21, Lily Chow notes that anti-Chinese sentiment appears within the pages of Victoria's *Daily Colonist* by 1870. In 1872, two motions, the first establishing a $50 per annum head tax for Chinese and the second prohibiting Chinese labor on public works, were made in the provincial Legislative Assembly by John Robson, the representative from Nanaimo. These motions provide a barometer of race-based animosity at the time. In *White Man's Province*, Patricia Roy observes initial tolerance toward the Chinese in Victoria in 1858 but notes rising intolerance on the mainland, and particularly in the mining fields of the Cariboo. Roy cites a vitriolic attack on Chinese laborers published in the 1867 Barkerville *Cariboo Sentinel.*

68. I. W. Powell, Superintendent of Indian Affairs, *Report* no. 30, October 18, 1877 (Ottawa: DIA Annual Reports, 1877–1878), 36.

69. BAAS, *Handbook for the Dominion of Canada,* 333.

70. Waddington's comments are cited by Margaret Ormsby in *British Columbia: A History* (Toronto: Macmillan, 1958), 17. These sentiments are also repeated in Macfie, *Vancouver Island and British Columbia,* 68.

71. Franz Boas, "Letter-Diary to Parents (1886)," in *The Ethnography of Franz Boas,* ed. Ronald P. Rohner (Chicago: University of Chicago Press, 1969), 22.

72. See Sylvia Van Kirk, "The Role of Native Women in Canadian Fur Trade Society of Western Canada, 1670–1830," *Frontiers* 7.3 (1984): 9–13.

73. Wilson Duff, *The Indian History of British Columbia: The Impact of the White Man* (Victoria: Royal British Columbia Museum, 1992), 61.

74. Douglas is quoted in Peter A. Cumming and Neil H. Mickenberg, eds., *Native Rights in Canada* (Toronto: Indian-Eskimo Association of Canada in association with General Publishing, 1972), 176; also cited by Walt Taylor in "Aboriginal and Ecological Conspiracy: The Life-Sustaining Turning Point in History," *BC Historical News* 20.4 (fall 1987): 3.

75. The fourteen tribes who negotiated treaties with Douglas at this time included the Teechamistsa (between Esquimalt and Point Albert), Kosampsom (Esquimalt Peninsula and Colquitz Valley), Swengwhung (Victoria Peninsula, south of Colquitz), Chilcowitch (Point Gonzales), Whyomilth (northwest of Esquimalt Harbour), Che-ko-nein (Point Gonzales to Cedar Hill), Ka-ky-aakan (Metchosin), Chewhaytsum (Sooke), Sooke (northwest of Sooke Inlet), South Saanich (in south Saanich), North Saanich (in north Saanich), Queackar (Fort Rupert), Quakeolth (Fort Rupert), and the Saalequun (Nanaimo). British Columbia, *BC Papers connected with the Indian Land Question: 1850–1875* (Victoria: R. Wolfenden Government Printers, 1875), 5–11.

76. Duff, *The Upper Stalo Indian,* 41.

77. William A. G. Young, letter to R. C. Moody, dated June 18, 1862, *BC Papers,* 24.

78. Pethick, *James Douglas,* 78.

79. Ibid., 78.

80. Resources were an integral part of debate in the 1888 Provincial Commission published as "Papers Relating to the Commission appointed to enquire into the state and condition of the Indians of the North-West Coast of British Columbia," British Columbia, *Sessional Papers* (Victoria: R. Wolfenden, 1888), passim.

81. Philip Henry Nind, letter to the Colonial Secretary, July 17, 1865, *BC Papers,* 29–30.

82. The letter referred to the survey recommendations made for reserves of Indians at Kamloops and Shuswap. Letter from Joseph Trutch, October 10, 1865, *BC Papers,* 31.

83. James Lenihan, *First Annual Report,* November 7, 1875 (Ottawa: DIA Annual Reports, 1868–1925), 53.

84. E. Brian Titley, *A Narrow Vision: Duncan Campbell Scott and the Administration of Indian Affairs in Canada* (Vancouver: University of British Columbia Press, 1986), 135–136. Titley describes the federal and provincial squabbles over land claims in British Columbia.

CHAPTER 2

1. The most valued resources of the region were fur, timber, gold, silver, copper, iron, coal, and ranch lands. Newton II. Chittenden, *Travels in British Columbia* (1882; Vancouver: Gordon Soules Books, 1984), 15–18.

2. Andrew Birrell, "Survey Photography in British Columbia, 1858–1900," *BC Studies*, no. 52 (winter 1981–1982), 39–60; J. F. Henry, *Early Maritime Artists of the Pacific Northwest Coast, 1741–1841* (Vancouver: Douglas and McIntyre, 1984); Joan Schwartz and Lily Koltun, "A Visual Cliché: Five Views of Yale," *BC Studies*, no. 52 (winter 1981–82): 114–116.

3. William H. Goetzmann, "From the Northwest Passage to the 'Great Reconnaissance,'" in *Major Problems in the History of the American West*, ed. Clyde Milner II, Anne M. Butler, and David Rich Lewis (Boston: Houghton Mifflin, 1997), 136.

4. James Patrick Regan, "Hudson's Bay Company Lands and Colonial Surveyors on Vancouver Island, 1842–1858," *BC Historical News* (n.d.), 14.

5. Doreen E. Walker, "Some Early British Columbia Views and Their Photographic Sources," *Beaver*, no. 314 (summer 1983): 44–51. Walker discusses the cross-fertilization of photography and painting, in particular how landscape artists, such as Lucius R. O'Brien, used photography taken by Charles Horetzky (Canadian Pacific Railway Survey), by George Dawson (Geological Survey, 1875; Queen Charlotte Survey, 1878), by Benjamin Baltzly (interior British Columbia Geological Survey, 1871), and by Frederick Dally (Cariboo, 1860s).

6. Benjamin Baltzly, for example, sold his photographically illustrated account of the 1871 Geological Survey of Canada expedition to British Columbia to the *Montreal Gazette*, which published it in installments over the summer of 1872. Andrew Birrell, *Benjamin Baltzly, Photographs and Journal of an Expedition through British Columbia: 1871* (Toronto: Coach House Press, 1978), 23.

7. Andrew Birrell, *Into the Silent Land* (Ottawa: Public Archives of Canada, 1975); David Mattison, "Richard Maynard: Photographer of BC," *History of Photography* 9 (April–June 1985): 109–129; David Mattison, "In Visioning the City: Urban History Techniques through Historical Photographs," *Urban History Review* (June 1984): 43–52; Joan Swartz, "Images of Early British Columbia Landscape Photography: 1858–1888" (M.A. thesis, University of British Columbia, 1977); Ralph Greenhill, *Early Photography in Canada* (Toronto: Oxford University Press, 1965); Birrell, "Survey Photography," 39–60; Andrew Birrell, "Frederick Dally: Photo Chronicler of BC A Century Ago," *Canadian Photography* (February 1977): 14–19; and Andrew Birrell, "Classic Survey Photos of the Early West," *Canadian Geographic Journal* 91.4 (1975): 12–19.

8. The earliest extant photographs of Native Americans taken in the region were by Lt. Richard Roche in the late 1850s, prior to 1860, when Roche left. David Mattison and Daniel Savard, "The North-West Pacific Coast Photographic Voyages 1866–1881," *History of Photography* 16.3 (1992): 271.

9. Frances M. Woodward, "The Influence of the Royal Engineers on the Development of British Columbia," *BC Studies*, no. 24 (winter 1974–1975): 3–51; Mayne, *Four Years in British Columbia*, 51.

10. Jane Sinclair and Richard H. Engeman, "Professional Surveyor, Amateur Photographer: John F. Pratt on the Chilkat River, 1894," *Pacific Northwest Quarterly* 82 (April 1991): 51.

11. Woodward, "Influence of the Royal Engineers," 9.

12. Mayne, *Four Years in British Columbia*. Mayne exemplifies how individual members of the Corps personally profited from their official survey experiences. Another civil servant, geologist J. K. Lord, published two guides: John Keast Lord, *The Naturalist in Vancouver Island and British Columbia* (London: R. Bentley, 1866); and *At Home in the Wilderness: What to Do There and How to Do It. A Handbook for Travellers and Emigrants* (London: Hardwicke and Bogue, 1876).

13. Birrell, "Survey Photography," 43–44.

14. Ibid., 44–46.

15. The wet plate collodion process, invented and patented by Frederick Archer in 1850, was used until 1885 when it was innovated by the dry plate collodion process.

16. James Ryan, *Picturing Empire: Photography and the Visualization of the British Empire* (Chicago: University of Chicago Press, 1997), 145.

17. Henry Shaw, "Notes on Photography," professional papers of the Corps of the Royal Engineers, paper 17, new series, VIX (1860), cited in Birrell, "Survey Photography," 43.

18. Birrell, "Survey Photography," 40.

19. Carolyn Marr, "Taken Pictures: Interpreting Native American Photographs of the Southern Northwest Coast," *Pacific Northwest Quarterly* 80.2 (April 1989): 53.

20. Birrell, "Survey Photography," 46.

21. George Dawson, *To the Charlottes: George Dawson's 1878 Survey of the Queen Charlotte Islands,* ed. Douglas Cole and Bradley Lockner (Vancouver: University of British Columbia Press, 1993): 5. On Dawson, see Margaret Blackman, "Of 'Peculiar Carvings and Architectural Devices': Photographic Ethnohistory and the Haida Indians," in *Anthropology and Photography: 1860–1920,* ed. Elizabeth Edwards (New Haven: Yale University Press, 1992), 137–142; and Douglas Cole and Bradley Lockner, eds. *The Journals of George M. Dawson: British Columbia, 1875–1878* (Vancouver: University of British Columbia Press, 1989).

22. Dawson, *To the Charlottes,* 196, n. 420; Avrith Gale, "Science at the Margins: The British Association and the Foundations of Canadian Anthropology, 1884–1910," (Ph.D. diss., University of Pennsylvania, 1986), 224.

23. Dawson, *To the Charlottes,* 7.

24. Cited in Gale, "Science at the Margins," 226.

25. Leslie White, *The Ethnography and Ethnology of Franz Boas* (Austin: Bulletin of the Texas Memorial Museum at the University of Texas, 1963), 9–11.

26. Dawson, *To the Charlottes,* 7.

27. Ibid., 70. For another interpretation of this incident, see Margaret Blackman, "'Copying People': Northwest Coast Native Response to Early Photography," *BC Studies,* no. 52 (winter 1981–82): 92.

28. Cited by Keith Bell in "Professional Photographers in Western Canada: Constructing the Great Lone Land," in Dan Ring, Keith Bell and Sheila Petty, *Plain Truth* (Saskatoon: Mendel Art Gallery, 1998), 33.

29. Joseph Howe, secretary of state for the provinces, and Selwyn, director of the survey, cited in Birrell, *Benjamin Baltzly,* 11. David Mattison, review of Andrew Birrell's *Benjamin Baltzly, Photocommunique* 1 (July–August 1979): 12.

30. Mattison, review of *Benjamin Baltzly,* 11.

31. A. R. C. Selwyn in correspondence with Sanford Fleming, chief engineer of the Geological Survey (March 30, 1872), cited in Birrell, *Benjamin Baltzly,* 19. Edward Cavelle observed that the Geological Survey "refused to continue using professional photographers, ostensibly due to the inconvenience of wet plate photography in the field." Edward Cavelle, review of Birrell's *Benjamin Baltzly, Photocommunique* 1 (July–August 1979): 14.

32. Birrell, *Benjamin Baltzly,* 18.

33. Birrell, "Survey Photography," 53–60.

34. Cavelle, review of *Benjamin Baltzly,* 14. Mattison also confirms the commercial interests of Baltzly on the survey. Mattison, review of *Benjamin Baltzly,* 12.

35. Birrell, *Benjamin Baltzly,* 17.

36. Martha Sandweiss, "Undecisive Moments: The Narrative Tradition in Western Photography," in *Photography in Nineteenth-Century America,* ed. Martha Sandweiss (Fort Worth, Tex.: Amon Carter Museum and Harry Abrams, 1991), 100.

37. Specific improvements, such as the 1863 Alexandra Bridge, the first rod and iron suspension bridge spanning the Fraser River, were popular subjects for the camera. Beth Hill, *Sappers: The Royal Engineers in British Columbia* (Ganges, B.C.: Horsdal and Schubart, 1987), 116–117.

38. Patrick A. Dunac, "Promoting the Dominion: Records and the Canadian Immigration Campaign, 1872–1915," *Archivaria* 19 (winter 1984–85): 79.

39. David Mattison, *Camera Workers: The British Columbia Directory, 1858–1900* (Victoria: Camera Workers Press, 1985), vii.

40. Selwyn to Baltzly, February 28, 1873, cited in Birrell, *Benjamin Baltzly,* 18.

41. Dunae, "Promoting the Dominion," 74.

42. Ibid., 75.

43. Ibid., 79.

44. Ibid., 81.

45. Agent General for British Columbia Gilbert Malcolm Sproat to the Provincial Secretary, April 5, 1873; also Sproat to John Ash, May 1, 1873, cited in Dunae, "Promoting the Dominion," 81.

46. Baltzly cited in Birrell, *Benjamin Baltzly,* 114.

47. Lieutenant Edmund Verney, commander of the gunboat HMS *Grappler,* was stationed on Vancouver Island from 1862 to 1865. The photograph is described in a letter to his father Sir Harry Verney at Claydon House in Buckinghamshire, England. Allan Pritchard, ed., *Vancouver Island Letters of Edmund Hope Verney* (Vancouver: University of British Columbia Press, 1996), 3. The authorship of the photograph is debated. Pritchard suggests that the photograph may have been taken by Richard Maynard. Greenhill, Birrell, and Schwartz suggest it was produced by George Fardon, who reproduced a panorama of Victoria in the *Illustrated London News,* January 14, 1863. Ralph Greenhill and Andrew Birrell, *Canadian Photography 1839–1920* (Toronto: Coach House Press, 1979), 87; Joan Schwartz, "G. R. Fardon, Photographer of Early Vancouver," *Afterimage* (December 1978): 5. Fardon's views

of Vancouver Island were presented at the London International Exhibition in 1862. A panorama of Victoria was included in the display and later reproduced in the 1863 *Illustrated London News.*

48. Joan Schwartz, "The Photograph as Historical Record: Early British Columbia," *Journal of American Culture* 4.1 (spring 1981): 76.

49. Pritchard, *Vancouver Island Letters,* 84–85.

50. Mayne, *Four Years in British Columbia,* 44. Population estimates of miners who traveled north from California to the Fraser River mines in 1858 ranged from 20,000 to 30,000. Margaret Ormsby, "Canada and the New British Columbia," in *British Columbia: Patterns in Economic, Political, and Cultural Development,* ed. Dickson M. Falconer (Victoria: Camosun College, 1982), 34, n. 1.

51. Barman, *The West beyond the West,* 87–88. Preemption, proclaimed in 1860, allowed each British subject or those swearing allegiance to the crown the first right to purchase 160 acres, outside of town lots or land reserved for Indian use.

52. Sandweiss, "Undecisive Moments," 100.

53. (Seattle) *Pacific Weekly Tribune,* May 29, 1878.

54. Albert Maynard, in conversation with Isabel Bescoby, June 16, 1931, described his travels with his father to Barkerville in July 1868. In Richard Maynard's last will and testament all buildings and contents inclusive of stock, fixtures, and debts associated with the business of his Victoria property, lot #157, were bequeathed to Albert Maynard, BCA, add. mss. GR #1954; R. E Gosnell, *A History of British Columbia* (Victoria: Hill Binding Co., 1906), 400–401.

55. Sandweiss, "Undecisive Moments," 106; David Mattison, "The World's Panorama Company," *History of Photography* 8 (January 1984): 47–48.

56. Frederick Dally, letter to his sister, Emma, November 1870, BCA, add. mss. #2443, file 2.

57. Dally, correspondence; see the letters of recommendation from William Cleaver, April 9, 1862, and from the Vicar of Wellingborough, 1862, BCA, add. mss. #2443.

58. Dally, indenture of rental agreement, March 28, 1864, BCA, add. mss. #2443.

59. Dally, *Daily Colonist,* June 26, 1866, BCA, add. mss. #2443.

60. Mattison and Savard, "Photographic Voyages," 274.

61. Dally, *Memoranda of a trip round Vancouver Island and Nootka Island on board HMS Scout, Capt. Price a.d. 1866 for the purpose of visiting the Indian tribes by his excellency Sir. A. E. Kennedy the Governor, BCA,* add. mss. #2443, file 9.

62. Blackman, "Studio Indians," 83.

63. Blackman, "Studio Indians," 71, describes Dally's studio advertisement as published in the *Daily Colonist,* September 6, 1870.

64. On August 8, 1867, Barkerville's *Cariboo Sentinel* announced the arrival of Governor Seymour, accompanied by civil and domestic servants.

65. *Cariboo Sentinel,* August 12, 1867.

66. Frederick Dally, *A Journey to Williams Creek Cariboo,* June 21, 1868, BCA, add. mss. #2443.

67. *Cariboo Sentinel,* August 12, 1867.

68. Frederick Dally, *An Account of the Burning of the Town of Barkerville in Cariboo British Columbia on the 16th of September 1868, BCA*, add. mss. #2443.

69. Dally, letter to his sister Emma (November 1870) posted from 1117 Vine Street, Philadelphia, Pennsylvania, BCA, add. mss. #2443, file 3.

70. *Daily Colonist*, September 6, 1870.

71. Before copyright laws it was commonplace that a buyer would substitute his or her studio imprint on the negatives purchased from another photographer. This situation makes it difficult to trace the career of an individual photographer on the basis of an imprint alone. The images marketed by a commercial studio were rarely the product of a single photographer. Dally, note dated September 27, 1870, BCA, add. mss. #2443; *Daily Colonist*, September 28 and September 29, 1870; Blackman, "Studio Indians," 71.

72. Frederick Dally, *Correspondence from the Anthropological Institute of Great Britain and Ireland*, March 17, 1880, BCA, add. mss. #2443.

73. Dally's correspondence includes a letter dated July 19, 1878, from the Anglican Church Missionary Society rejecting his request to be formally engaged by them but inquiring about a loan of some of his northwest photographs to be made into engravings. Also in this file is a thank-you note dated January 11, 1883, from a representative of Queen Victoria to Dally for the "beautiful and interesting album of British Columbia photographs." BCA, add. mss. #2443. file 2.

74. Obituary, *Daily Colonist*, August 16, 1911. In the 1881 census, Stephen Spencer resided in the Yates Street Ward, was fifty-two years old, and unmarried. His occupation was listed as photographer. Born in New London, Connecticut, in 1829, he died at age eighty-two, leaving a wife, Annie Spencer (née Hunt), and five sons.

75. G. R. Fardon, who arrived in Victoria from San Francisco in 1858, was the only other daguerreotypist in competition with Stephen Spencer before 1862. Swartz, "G. R. Fardon," 5. Hannah Maynard and Frederick Dally both opened studios around 1862. Mattison, *Camera Workers*, D-1; M-5.

76. Between 1863 and 1871, Spencer disappeared from the public records, but he resurfaced in the interior mining town of Barkerville after 1871. Dawson, *To the Charlottes*, 202, n. 471. Mattison, *Camera Workers*, S-8.

77. *Victoria Gazette*, July 23, 1859, cited in Mattison, *Camera Workers*, n.p.

78. Joan Swartz, "G. R. Fardon," 5.

79. *Daily Colonist*, January 14, 1862, cited in Mattison, *Camera Workers*, n.p.

80. Ibid.

81. Mattison, *Camera Workers*, S-8.

82. *Daily Colonist*, July 7, 1875, 3.

83. J. B. Kerr, *Biographical Dictionary of Well-Known British Columbians* (Vancouver: Kerr and Begg, 1891), 180.

84. *Guide to the Province of BC* (Victoria, B.C.: T. N. Hibben and Co., 1877–1878), 43.

85. Disputes over the use of the fishing grounds erupted between the cannery owners, Huson and Spencer, and the local Nimpkish fishers. The Nimpkish brought these grievances to George Blenkinsop, the regional Indian agent, who mediated between the two parties. George Blenkinsop to I. W. Powell, "Report filed

September 23rd, 1881," in "General Report on Indian Affairs in British Columbia, 1880–1881," *Annual Report of the DIA for the Year Ending December 31, 1881* (Ottawa: DIA Annual Reports, 1868–1925), 167–171.

86. Edward Mallandaine, *Mallandaine British Columbia Directory* (Victoria: E. Mallandaine and R. T. Williams Publishers, 1887), 300.

87. Gosnell, *A History of British Columbia*, 764–766; Kerr, *Biographical Dictionary*, 179–180; Mattison, *Camera Workers*, H-5.

88. Mattison and Savard, "Photographic Voyages," 279.

89. Ira Jacknis, "Franz Boas and Photography," *Studies in Visual Communication* 10 (winter 1984): 5. See also Jerome S. Cybulski, "History of Research in Physical Anthropology," in *Handbook of North American Indians*, ed. William Sturtevant, vol. 7 (Washington: Smithsonian Institution Press, 1988), 116.

90. Boas, letter dated December 3, 1894, in *The Ethnography of Franz Boas*, ed. Ronald P. Rohner (Chicago: University of Chicago Press, 1969), 189; Jacknis, "Franz Boas and Photography," 7.

91. The size and shape of the skull, physical characteristics, and features were emphasized in determinations of race-related characteristics; thus photographs and casting were gathered for this purpose. *History of Physical Anthropology: An Encyclopaedia*, ed. Frank Spencer, vol. 1 (New York: Garland Reference Library of Social Science, 1997), 188; Virginia Yans-McLaughlin, "Science, Democracy, and Ethics: Mobilizing Culture and Personality for World War II," in *History of Anthropology*, vol. 4 (Madison: University of Wisconsin Press, 1986), 185.

92. Rohner, *The Ethnography of Franz Boas*, 22.

93. Jacknis, "Franz Boas and Photography," 4.

94. Ibid., 6–7; Rohner, *The Ethnography of Franz Boas*, 162, 189.

95. James Douglas, speech to Legislative Council (January 2, 1863), in *Journals of the Colonial Legislatures of the Colonies of Vancouver Island and British Columbia, 1851–1871*, ed. James E. Hendrickson (Victoria: Provincial Archives of British Columbia; 1980), 104; *The Reminiscences of Doctor John Sebastian Helmcken*, ed. Dorothy Blakey Smith (Vancouver: University of British Columbia Press, 1975), 109, n. 1.

96. Leigh Burpee Robinson, "To British Columbia's Totem Land: Expedition of Dr. Powell in 1873," *Canadian Geographic Journal*, no. 24 (fall 1942): 83.

97. A chronology of this activity may be found in Mattison and Savard, "Photographic Voyages," 269–288. Israel Powell, *Report to Secretary of State for the Provinces*, June 25, 1873, cited in Mattison and Savard, "Photographic Voyages," 270.

98. Of the professional and amateur photographers active in the region between 1858 and 1900, they included thirty-three women, four Japanese men, and one male Chinese photographer. Mattison, *Camera Workers*, n.p. Frank Matsura, a Japanese Canadian, practiced photography in interior British Columbia at late century. JoAnn Roe, *The Real Old West: Images of a Frontier, Photographs by Frank Matsura* (Vancouver: Douglas and McIntyre, 1981).

99. Dally, *Memoranda of a trip round Vancouver Island*, BCA, add. mss. #2443, file 9.

100. The total population of the west coast tribes was estimated at 35,154, and a breakdown of individual tribes was published in the *Report of the Deputy Superin-*

tendent General of Indian Affairs ((Ottawa: DIA Annual Reports, 1868–1925): AHT 3,500; Bella Coola 2,500; Quackewlths [*sic*] 3,500; Fraser River 15,000; Comos 88; Cowichans 3,066; Hydahs [*sic*] 2,500; Tsimpshians [*sic*] 5,000.

101. *Sessional Papers,* no. 6 (Ottawa: Maclean, Rogers, and Co., 1882), 139.

102. That the indigenous populations potentially threatened the expansion of settlement was evident in 1872, when northern Tsimshian expressed their collective dissatisfaction with the encroachment of commercial canneries on their traditional fishing grounds on the Skeena and Nass Rivers. The troubles with the Tsimshian were reported in Victoria's *Daily Colonist* July 10, 1872, and offered as partial motive for the 1872 appointment of Israel Powell as regional superintendent of Indian Affairs. Powell held that position until 1890. Robinson, "To British Columbia's Totem Land," 82–83. Barry Gough, *Gunboat Frontier: British Maritime Authority and Northwest Coast Indians, 1849–1890* (Vancouver: University of British Columbia Press, 1984). On the reception of Powell, see Fisher, *Contact and Conflict,* 180–184.

103. James A. McDonald, "Images of the Nineteenth-Century Economy of the Tsimshian," *The Tsimshian: Images of the Past, Views for the Present,* ed. Margaret Seguin (Vancouver: University of British Columbia Press, 1993), 51.

104. By 1881, British Columbia had been divided into six territorial regions overseen by the following field agents: W. H. Lomas in Cowichan Agency, William Duncan at Metlakatla, Harry Guillod in Westcoast Agency, P. McTiernan in Fraser Agency, Henry P. Cornwall in the Kamloops Agency, and George Blenkinsop in the Kwahkewlth Agency. Canada, *Sessional Papers,* no. 6 (Ottawa: DIA Annual Reports, 1868–1925), 139–171.

105. David McNab, "Herman Merivale and Colonial Office Indian Policy in the Mid–Nineteenth Century," in *As Long as the Sun Shines and Water Flows: A Reader in Canadian Native Studies,* ed. Ian A. L. Getty and Antoine S. Lussier (Vancouver: University of British Columbia Press, 1983), 91.

106. Douglas Leighton, "A Victoria Civil Servant at Work: Lawrence Vankoughnet and the Canadian Indian Department, 1874–1893," in Getty and Lussier, *As Long as the Sun Shines,* 113.

107. Baltzly, journal entry, July 3, 1872, cited in Birrell, *Benjamin Baltzly,* 128.

108. Duncan C. Scott, deputy superintendent general, Department of Indian Affairs, "Indians of Canada," in BAAS, *Handbook for the Dominion of Canada,* 19.

109. Angus McLaren, *Our Own Master Race: Eugenics in Canada, 1885–1945* (Toronto: McClelland and Stewart, 1990), 46–47; Terry Chapman, "The Early Eugenics Movement in Western Canada," *Alberta History* 25.4 (1977): 9–17; Donald Avery, *Dangerous Foreigners: European Immigrant Workers and Labour Radicalism in Canada, 1896–1932* (Toronto: McClelland and Stewart, 1979).

110. The 1873 trip of the HMS *Boxer* spanned May 26 to June 17; the 1874 trip was September 3 to 17.

111. Charles Lillard, introduction to Gilbert Malcolm Sproat, *The Nootka: Scenes and Studies of Savage Life* (Victoria: Sono Nis Press, 1987), x.

112. Chittenden, *Travels,* 40–42.

113. Gus Sivertz, "Still, Starched, and Watching the Birdie," (Victoria) *Times Colonist,* January 5, 1957.

114. "Worked Here for Fifty Years," *Daily Colonist,* September 28, 1912. Hannah's retirement, at age 77, was announced in the *Daily Colonist* on September 29, 1912. Richard retired in 1893 and died of natural causes at age 75 on January 10, 1907.

115. *Daily Colonist,* January 30, 1884. Chittenden was a Civil War veteran, a graduate of Columbia College in New York, and trained in law. Apparently he possessed a "strong love of exploration and an active out door life." *Daily Colonist,* April 8, 1884.

116. *Daily Colonist,* April 8, 1884.

117. Charles Newcombe, "Chittenden and Maynard Exploration of the Queen Charlotte Islands, 1884," transcript of a public lecture, BCA add mss. #1077, box 20, file 8.

118. Burpee, "To British Columbia's Totem Land," 91.

119. Douglas Cole, *Captured Heritage: The Scramble for Northwest Coast Artifacts* (Vancouver: Douglas and McIntyre, 1985), 78–79.

120. Mattison and Savard, "Photographic Voyages," 283. Cole, *Captured Heritage,* 83–84.

121. Boas, journal entry, June 6, 1888, in Rohner, *The Ethnography of Franz Boas* (Chicago: University of Chicago Press, 1969), 88.

122. Newcombe, "Chittenden and Maynard Exploration."

123. Ibid.

124. Boas, family letter, November 25, 1894, in Rohner, *The Ethnography of Franz Boas,* 183–184.

125. Boas, family letter, August 13, 1897, in Rohner, *The Ethnography of Franz Boas,* 223; Ira Jacknis, "Franz Boas and Photography," *Studies in Visual Communication* 10.1 (1984): 2–60; C. C. Willoughby, letter to Hannah Maynard, April 1917, BCA, add. mss. #1066, vol. 45, folder 13.

126. "Biographical notes," *Historical Photographs File,* Vancouver Public Library, n.d., n.p.

127. Benjamin Leeson, "A Quatsino Legend," *Canadian Geographic Journal* 7 (July 1933): 22–39; Leeson, "Photographing Brother 'Lo,'" 489–494.

128. Benjamin Leeson, "A Vanished Race," typed introduction to album entitled "A Souvenir of the Vanishing Race," biographical file, the Leeson Collection of Indian Photographs, Northern British Columbian Coast, City of Vancouver Archives (CVA).

129. "Reminiscences of Early Residents," *North Island Gazette* (August 12, 1971): 8–9, 10–11.

130. Sandweiss, "Undecisive Moments," 99.

CHAPTER 3

1. Robin Fisher, "The Image of the Indian," in *Out of the Background: Readings in Canadian Native History,* ed. Robin Fisher and Kenneth Coates (Toronto: Clark Pitman, 1988), 169; see also Robin K. Wright, "Depiction of Women in Nineteenth-Century Haida Argillite Carving," *American Indian Art Magazine* 11.4 (1986): 36–45; Rayna Green, "The Pocahontas Perplex: The Image of Indian Women in Popular Culture," *Massachusetts Review* 16 (autumn 1975): 678–714; Lilianne Ernestine Krosenbrink-Gelissen, *Sexual Equality as an Aboriginal Right: The*

Native Women's Association of Canada and the Constitutional Process on Aboriginal Matters, 1982–1987 (Saarbrucken: Verlag Breitenbach, 1991), 37; Carol Douglas Sparks, "The Land Incarnate: Navajo Women and the Dialogue of Colonialism, 1821–1870," in *Negotiators of Change: Historical Perspectives on Native American Women,* ed. Nancy Shoemaker (New York: Routledge, 1995), 142.

2. Marjorie Mitchell and Anna Franklin, "When You Don't Know the Language, Listen to the Silence: An Historical Overview of Native Indian Women in BC," in *Not Just Pin Money,* ed. Barbara K. Latham and Roberta J. Pazdro (Victoria: Camosun College, 1984), 17.

3. Lorraine Littlefield, "Women Traders in the Maritime Fur Trade," *Native People Native Lands: Canadian Indians, Inuit and Metis* (Ottawa: Carleton University Press, 1987), 173–185; Sylvia Van Kirk, "'Women in Between': Indian Women in Fur Trade Society in Western Canada," *Canadian Historical Association, Historical Papers* (1977): 31–46.

4. Carol Cooper, "Native Women of the Northern Pacific Coast: A Historical Perspective," *Journal of Canadian Studies* 27.4 (winter 1992–1993): 56; Margaret Blackman, *During My Time: Florence Edenshaw Davidson, A Haida Woman* (Seattle: University of Washington Press, 1992), 43–44.

5. Cooper, "Native Women of the Northern Pacific Coast," 58.

6. Ibid.

7. Jonathan Green, *Journal of a Tour on the Northwest Coast of America in the Year 1829* (New York: Charles Heartmen, 1915), cited in Blackman, *During My Time,* 43.

8. Jean Usher, *William Duncan of Metlakatla: A Victorian Missionary in British Columbia* (Ottawa: National Museums of Canada, 1974).

9. Alan Sekula, "The Body and the Archive," in *The Contest of Meaning: Critical Histories of Photography,* ed. Richard Bolton (Cambridge: MIT Press, 1989): 343–390; John Tagg, *The Burden of Representation: Essays on Photographies and Histories* (London: Macmillan, 1988). In general the honorific photograph celebrated the prestige and status of a sitter, whereas the repressive photograph was commonly used to identify and classify those persons who fell outside the norm.

10. Thomas Crosby, *Among the An-ko-me-nums or Flathead Tribes of Indians of the Pacific Coast by Thomas Crosby! Missionary to the Indians of BC* (Toronto: William Briggs, 1907), 208–223; see also Crosby, *Up and Down the North Pacific Coast by Canoe and Mission Ship* (Toronto: Methodist Mission Rooms, Missionary Society of the Methodist Church, Young People's Forward Movement Department, 1907). See also Crosby, *Reminiscences* (1899), BCA, H/D/R57/C88r.

11. Reverend Charles Montgomery Tate and Caroline Tate (née Knott) journals, letters, articles, and diaries, 1872–1932, BCA, add. mss. #303; and Charles Tate, album, CVA, add. mss. #225. Charles and Caroline Tate, clipping file, B.C. United Church Conference Archive.

12. Daile Kaplan, "Enlightened Women in Darkened Lands—A Lantern Slide Lecture," *Studies in Visual Communication* 10.1 (winter 1984), 61.

13. Caroline Tate, *Clayoquot Diary,* February 24, 1898, 113, BCA, add. mss. #303.

14. Charles Tate, *Cowichan Diary,* December 1, 1899, BCA, add. mss. #303, box 1, file 9.

15. Charles Tate, *Diary,* March 30, 1914, BCA, add. mss. #303, box 1, file 2. The first talk Tate refers to was given at Grandview Trinity Methodist Church in Vancouver, and the second took place in Sardis. Tate, *Diary,* November 8, 1914, BCA, add. mss. #303, box 1, file 2.

16. Charles Tate, letter from Chiliwack, August 30, 1876, *Missionary Notices of the Methodist Church,* 3d ser, no. 11 (January 1877), 181.

17. Thomas Crosby, *Among the An-ko-me-num or Flathead Tribes of Indians of the Pacific Coast,* 208–223; Sallosalton is also discussed in Charles Tate, *Diary,* volume dated 1876–1877, November 15, 16, and 17, BCA, add. mss. #303; see also John H. Wright, "A Tribute to the Indian Evangelist" (1936), photocopied article, NDA.

18. Thomas Crosby, *David Sallosalton: A Young Missionary Hero* (Toronto: Department of Missionary Literature of the Methodist Church, 1906), 8, 4–5, 11, 12.

19. Michael Aird*, Portraits of our Elders* (South Brisbane: Queensland Museum Publication, 1993), 46.

20. Thomas Crosby, letter from Fort Simpson, February 16, 1876, *Missionary Notices of the Methodist Church,* 3d ser., no. 8 (June 1876): 131.

21. Caroline Tate was licensed on June 28, 1898. Robert Clyde Scott, unpublished manuscript, *Circuit Register of the Chilliwack Methodist Church,* BCA, add. mss. #1299, box 2, file 3.

22. Thomas Crosby, letter, *Missionary Notices of the Methodist Church,* 3d ser., no. 3 (June 1875): 55.

23. Mrs. David Alexander, unpublished ms., William Henry Lomas (Cowichan Indian Agent 1877–1881) file #74A512, BCA, add. mss. #C2208; see also Margaret Elizabeth Schutt, "Autobiographical Notes" (typed transcript), BCA, add. mss. #1213.

24. Jean Barman, "Separate and Unequal: Indian and White Girls at All Hallows School, 1884–1920," in *Indian Education in Canada,* vol. 1, ed. Jean Barman, Yvonne Hebert, and Don McCaskill (Vancouver: University of British Columbia Press, 1986): 110–131.

25. The Tates started Coqualeetza as a small day school at Squihala in 1879, and they reorganized in 1885 four miles upriver at Skowkale. In 1887 they received a grant of $400 from the Women's Missionary Society. Women's Missionary Society, untitled pamphlet (Toronto: Women's Missionary Society, 1925); Caroline Tate, *Early Days at Coqualeetza* (Toronto: Women's Missionary Society, n.d.), BCA, add. mss. #303; see also Sadie Thompson, "The Story of Coqualeetza," BCA, add. mss. #N/A T37.

26. E. Palmer Patterson II*, Mission on the Nass* (Waterloo, Ontario: Eulachon, 1982), 144.

27. Henry Schutt, "North Pacific Mission Report, Kincolith, February 1st, 1879," *Church Missionary Intelligencer,* no. 4 (1879): 561.

28. Margaret Elizabeth Schutt, "Autobiographical Notes" (typed transcript), BCA, add. mss. #1213, 1–2. See also Henry Schutt, *Correspondence Out,* letter from Kincolith, Nass River, May 3, 1881, BCA, add. mss. #ECSch 4.

29. Victoria Young or Yonge was also identified in documents as Sudahl or Nishlkumik. Cooper, "Native Women of the Northern Pacific Coast." Crosby also

refers to her "official name as Neas-tle-meague" in Crosby, *Up and Down the North Pacific Coast*, 383.

30. Thomas Crosby, Letter from Fort Simpson, February 16, 1876, *Missionary Notices of the Methodist Church*, 3d ser., no. 8 (June 1876): 131.

31. Reverend William Pollard, letter from Fort Simpson, April 1875, *Missionary Notices of the Methodist Church*, 3d ser., no. 3 (June 1875): 55.

32. James Charles Prevost, "Memorandum by a Naval Officer on the Eligibility of Vancouver's Island as a Missionary Station," *Christian Missionary Society Intelligencer* 7 (1856): 168.

33. Ibid.

34. Jean Usher, *William Duncan of Metlakatla*; Fisher, *Contact and Conflict*, 129–131.

35. In fact, O. C. Hastings, not Richard Maynard, was the official photographer on this expedition. Hastings was officially paid for ten weeks at five dollars per week, for a total of fifty dollars for photographs produced on the 1879 trip, as tabulated in a DIA annual report for 1880. However, Richard Maynard was aboard this tour of the HMS *Rocket* and his embossed imprint appears on the stereocard depicting Shu-dalth and Crosby.

36. Israel Powell, *Report to the Department of Indian Affairs*, August 25, 1879 (Ottawa: DIA Annual Reports, 1868–1925), 112, 119–120 (BCA, NW 970.5 c212r).

37. Reverend Alfred E. Green, letter from the Nass River, September 18, 1977, *Missionary Notices of the Methodist Church*, 3d ser., no. 16 (February 1878): 271; Crosby, *Up and Down the North Pacific Coast*, 383.

38. Baptismal records indicated that Shu-dalth's father, identified by the Christian name of James, was dying of consumption, BCA, Methodist Church, Fort Simpson Baptismal Register.

39. Ibid., 385.

40. Powell, *Report to the Department of Indian Affairs*, August 26, 1879 (Ottawa: DIA Annual Reports, 1868–1925), 119–120.

41. Crosby, *David Sallosalton*, 8.

42. Thomas Crosby, "Letter from the Methodist Missionary Society to the Superintendent General of Indian Affairs respecting British Columbia Troubles, with affidavits, declarations, etc.," 1889, BCA, NWP 970.7 M592, ii.

43. Canada, Sessional Papers, no. 8, *Report of the Deputy Superintendent General of Indian Affairs*, February 4, 1875 (Ottawa: DIA Annual Reports, 1868–1925).

44. Joseph Trutch, letter, January 13, 1870, Israel Powell, *Correspondence, Petitions, Accounts, Statements of populations, and Reports relating to Indian land 1861–1877*, BCA, add. mss. #GRO504.

45. Carol Cooper, "Native Women of the Northern Pacific Coast: An Historical Perspective: 1830–1900," *Journal of Canadian Studies* 27.4 (winter 1992–1993), 62; Jo-Anne Fiske, "Colonization and the Decline of Women's Status: The Tsimshian Case," *Feminist Studies* 17 (fall 1993): 509–535.

46. Thomas Crosby, letter from Fort Simpson dated January 20, 1875, *Missionary Notices of the Methodist Church*, 3d ser., no. 2 (April 1875): 37.

47. Crosby, *Up and Down the North Pacific Coast*, 19–22.

48. Ibid., 20.

49. Ibid., 21.

50. Ibid.

51. Thomas Crosby, letter from Fort Simpson dated January 20, 1875, *Missionary Notices of the Methodist Church*, 3d ser., no. 2 (April 1875): 37.

52. Caroline Tate, *Family File, Notebook*, BCA, add. mss. #303, box 1, file 8.

53. Canada, Indian and Northern Affairs, *Indian Acts and Amendments, 1868–1950*, sc 1869, c. 6, sec. 6, p. 7. The section was amended by Bill C-31 in 1985. Kathleen Jamieson, *Indian Women and the Law in Canada: Citizens Minus* (Ottawa: Canadian Advisory Council on the Status of Women and Indian Rights for Indian Women, 1978); see also Shirley Joseph, "Assimilation Tools: Then and Now," *B.C. Studies*, no. 89 (spring 1991): 65–79.

54. Cooper, "Native Women of the Northern Pacific Coast," 63–64.

55. Terry Wotherspoon, *First Nations: Race, Class, and Gender Relations* (Scarborough, Ontario: Nelson Canada, 1993), 31; Jamieson, *Indian Women and the Law in Canada*, 1; Cooper, "Native Women of the Northern Pacific Coast," 47.

56. Vi Keenlyside, *They Also Came* (Duncan, British Columbia: Vidbook Committee of the Duncan United Church, 1987), 7–12.

57. Bishop Edward Cridge, *Memoranda Book*, September 7, 1868, BCA, add. mss. #320 E B CV 87m.

58. Victoria Police Department, *Charge Books* (1873–1900); *Gaol Charge Books* (1874–1882); *Mug Shot Book #1* (July 8, 1897–August 28, 1904), Victoria Police Museum.

59. Margaret Whitehead, "'A Useful Christian Woman': First Nations' Women and Protestant Missionary Work in British Columbia," *Atlantis* 18.1–2 (1993): 159; Clarence Bolt, *Thomas Crosby and the Tsimshian: Small Shoes for Feet Too Large* (Vancouver: University of British Columbia Press, 1992).

60. Canada, *Annual Report of Indian Affairs,* ending March 31, 1934 (Ottawa: Queens Printer, 1934), 10.

61. Douglas Cole and Ira Chaikin, *An Iron Hand upon the People: The Law against the Potlatch on the Northwest Coast* (Vancouver: Douglas and McIntyre, 1990).

62. Ibid.

CHAPTER 4

1. Emigrant guidebooks and travel accounts include R. C. P. Baylee, "Vancouver Island and Queen Charlotte's Island," *Colonial Church Chronicle* (May 1854): 414; Alexander Caulfield Anderson, *Handbook and Map to the Gold Region of Fraser and Thompson Rivers* (San Francisco: J. J. Lecount, 1858); John Keast Lord, *At Home in the Wilderness: What to do there and How to do it: A handbook for emigrants and travellers* (London: Harwicke and Bogue, 1876); Edward Hepple Hall, *Land of Plenty Book for travellers and Settlers British North American* (1879); Alexander Rattray, *Vancouver Island and BC Land* (Toronto: Smith Elder and Co. Canadiana House, 1862); James Arthur Lees, *BC 1887; a Ramble* (London: Longman, Green and Co., 1892); H. J. Boam, ed., *BC: Its History, People, Commerce, Industries, and Resources* (London: Sells, 1912); Matthew Macfie, *Vancouver Island and British Co-*

lumbia: Their History, Resources, and Prospects (London: Longman, Green, Longman, Roberts, and Green, 1865; facs. ed., Toronto: Coles, 1972).

2. *Imbert Orchard Oral History Collection* (interviews with women who resided in coastal villages or in Victoria in the late nineteenth century, conducted and transcribed in the 1960s and 1970s), BCA, acc. 12; *Beyond the Kitchen Door (1900–1930)* (interviews with thirty-eight British Columbia women, conducted by Kathy Chopik, Lynn Bueckert, and Kathryn Thomson in June 1983), BCA, acc. #4088; Josephine Crease, *Diaries, Correspondence, Accounts*, BCA, add. mss. #55 AEC86 C865.9; Caroline Eleanor Fellows, *Correspondence Outward*, BCA, add. mss. 0794 E/D/F 331; Ethel Phebe Freston, *Diary*, April–July 1887, BCA, add. mss. #E/C/F89; Mrs. Helen Marion Dallain (Downey) "What I Remember: The Memories of a Pioneer's Daughter," typed manuscript, BCA, add. mss. #E/E/D16; Agnes Knight, *Journals*, July 10, 1885–October 23, 1887, BCA, add. mss. #F7W15r; Ethel Leather, *Diary*, May 1888–July 1891, BCA, #E/C/D 48; *The Maynard Studio*, BCA Photographic Collection, vols. 1–18, #28299.272.271; Susan Nagle, *Diaries*, BCA, add. mss. #2576; Hannah Maynard papers, BCA, add. mss. #GR1304, file 105/18; Hannah Maynard, Papers, Correspondence, and Diaries, BCA, add. mss. #1077, vol. 47, files 2a–2j; Jane Powell, *Correspondence Inward*, BCA, add. mss. #A/F. P87.p871/A12; Caroline Knott Tate, *Family File, Notebooks,* and *Diaries* (to 1911), BCA, add. mss. #303; Pidcock family papers, *Originals, Diaries, and Reminiscences* (1862–1955), BCA, add. mss. #728; Alice Mary Tomlinson, *Wayside Log* (1879), BCA, add. mss. #2725; Martha Harris, *Papers, Originals* (1834–1905) BCA, add. mss. #2789; Septima Collis, *A Woman's Trip to Alaska: Being an Account of a Voyage through the Inland Seas of the Sitkan Archipelago in 1890* (New York: Cassell, 1890); Sophie Cracroft, *Lady Franklin Visits the Pacific Northwest: Being Extracts from the letters of Miss Sophia Cracroft, Sir. John Franklin's Niece: February to April 1861 to July 1870,* ed. Dorothy Blakey Smith (Victoria: Provincial Archives of British Columbia, 1974); Susan Allison, *A Pioneer Gentlewoman in British Columbia: The Recollections of Susan Allison,* ed. Margaret A. Ormsby (Vancouver: University of British Columbia Press, 1976).

3. Frederick Jackson Turner, *The Frontier in American History* (New York: Dover, 1996).

4. R. E. Gosnell, *A History of British Columbia* (Chicago: Lewis Publishing Co., 1906); Margaret Ormsby, *British Columbia: A History* (Toronto: Macmillan, 1958). For an appraisal of these approaches in local histories, see Elizabeth Furniss, "Pioneers, Progress, and the Myth of the Frontier: The Landscape of Public History in Rural British Columbia," *BC Studies,* no. 115–116 (autumn–winter 1997–1998), 44; and W. Peter Ward, "Class and Race in the Social Structure of British Columbia: 1870–1939," *BC Studies,* no. 45 (spring 1980), 17.

5. Jeremy Adelman and Stephen Aron, "From Borderlands to Borders: Empires, Nation-States, and the People in between in North American History," *American Historical Review* 104.3 (June 1999): 814–841; Patricia Nelson Limerick, *The Legacy of Conquest: The Unbroken Past of the American West* (New York: W. W. Norton, 1987); Williams Robbins, "Laying Siege to Western History: The Emergence of New Paradigms," *Reviews in American History* 19.3 (September 1991): 313–331; William Cronon, "Revisiting the Vanishing Frontier: The Legacy of Frederick Jack-

son Turner," *Western Historical Quarterly* 18 (1987): 156–176; Susan Armitage and Elizabeth Jameson, eds., *The Women's West* (Norman: University of Oklahoma Press, 1987); R. Douglas Francis, "From Wasteland to Utopia: Changing Images of the Canadian West in the Nineteenth Century," *Great Plains Quarterly* 7 (summer 1987): 178–194, David Breen, "The Turner Thesis and the Canadian West: A Closer Look at the Ranching Frontier," *Essays on Western History*, ed. Lewis Thomas (Edmonton: University of Alberta Press, 1976): 147–159.

6. Fisher, *Contact and Conflict;* Barman, *The West beyond the West*; H. B. Hawthorn, C. S. Belshaw, and S. M. Jamieson, *The Indians of British Columbia: A Study of Contemporary Social Adjustment* (Berkeley: University of California Press; Vancouver: University of British Columbia Press, 1958).

7. Adele Perry, *On the Edge of Empire: Gender, Race, and the Making of British Columbia, 1849–1871* (Toronto: University of Toronto Press, 2001); Annalee Golz and Lynne Marks, eds., "Women's History and Gender Studies," special double issue of *BC Studies,* nos. 105–106 (spring–summer 1995), esp. Adele Perry, "'Oh I'm Just Sick of the Faces of Men': Gender Imbalance, Race, Sexuality, and Sociability in Nineteenth-Century British Columbia," 27–43; Ron Bourgeault, "Race, Class, and Gender: Colonial Domination of Indian Women," in *Race, Class, Gender: Bonds and Barriers,* ed. Jesse Vorst (Winnipeg: Society for Socialist Studies, ser. 5, 1989), 103; Peggy Pascoe, *Relations of Rescue: The Search for Female Moral Authority in the American West, 1874–1939* (New York: Oxford University Press, 1990); Theda Perdue, ed., *Sifters: Native American Women's Lives* (New York: Oxford University Press, 2001); Nancy Shoemaker, ed., *Negotiatiors of Change: Historical Perspectives on Native American Women* (New York: Routledge, 1995); Darlis Miller and Joan Jensen, "The Gentle Tamers Revisited: New Approaches to the History of Women in the American West," *Pacific Historical Review,* 18.2 (1980): 173–215; Susan Armitage, "Women and Men in Western History: A Stereotypical Vision," *Western Historical Quarterly* 66.4 (October 1985): 381–387; Anne Butler, *Daughters of Joy, Sisters of Misery: Prostitutes in the American West, 1865–1890* (Chicago: University of Illinois Press, 1985); Elizabeth Jameson, "Women as Workers, Women as Civilizers: True Womanhood in the American West," and Susan Armitage, "Through Women's Eyes: A New View of the West," both in *The Women's West,* ed. Armitage and Jameson (Norman: University of Oklahoma Press, 1987), 145–164, 9–18.

8. Joan Schwartz, "The Photographic Record of Pre-Confederation British Columbia," *Archivaria* 5 (winter 1977–1978): 17–44; Joan Schwartz, "Images of Early British Columbia: Landscape Photography, 1858–1888" (M.A. thesis, University of British Columbia, 1977).

9. *Seattle Pacific Weekly Tribune,* June 26, 1878.

10. George Fardon, BCA Photographic Collection, 1 vol.

11. Jabez Hughes, "Photography as an Industrial Occupation for Women" (1873), reprinted in *Camera Fiends and Kodak Girls I: 50 Selections By and About Women in Photography, 1840–1930,* ed. Peter R. Palmquist (New York: Midmarch, Arts Press, 1989), 29. On the rising popularity of the portrait, see John Tagg, "Portraits, Power, and Production," *Ten-8* 13 (1984): 20–29; and Naomi Rosenblum, *A History of Women Photographers* (Paris: Abbeville Press, 1994), 73–91.

12. Pethick, *James Douglas.*

13. Sylvia Van Kirk, "'What If Mama Is an Indian?': The Cultural Ambivalence of the Alexander Ross Family," in *The Developing West*, ed. John Foster (Edmonton: University of Alberta Press, 1983), 123–136. Sylvia Van Kirk, *Many Tender Ties: Women in Fur Trade Society, 1670–1870* (Winnipeg: Watson and Dwyer, 1983); Jennifer Brown, *Strangers in Blood: Fur Trade Company Families in Indian Country* (Vancouver: University of British Columbia Press, 1980).

14. Caroline C. Leighton, *Life at Puget Sound with Sketches of Travel in Washington Territory, British Columbia, Oregon and California, 1865–1881* (Boston: Lee and Shepard, Publishers, 1884), 141.

15. Prostitution greatly concerned public officials and promoters. Blackman, *During My Time*, 42; Carol Cooper, "Native Women of the Northern Pacific Coast," *Journal of Canadian Studies* 27.4 (winter 1992–1993), 58; Canada, *Sessional Papers No. 8, Report of the Deputy Superintendent General of Indian Affairs*, February 4, 1875 (Ottawa: Annual DIA Reports, 1868–1925), 66; Macfie, *Vancouver Island and British Columbia*, 471; Robert Brown, "On the Physical Geography of the Queen Charlotte Islands," in *The Ghostland People: A Documentary History of the Queen Charlotte Islands: 1859–1906*, ed. Charles Lillard (Victoria: Sono Nis, 1989), 109.

16. Macfie, *Vancouver Island and British Columbia*.

17. Cracroft, *Lady Franklin Visits the Pacific Northwest*.

18. Cecilia (1834–1856) was the firstborn daughter of Amelia Connolly Douglas (1812–1890). Cecilia married Dr. John Sebastian Helmcken (1824–1920), a Victoria medical practitioner and speaker of the Colonial House of Assembly, on December 27, 1852. On March 9, 1858, Jane Douglas (1839–1909) married Alexander Grant Dallas (1818–1882), who succeeded Sir George Simpson as governor of Rupert's Land in 1862. On May 8, 1862, Agnes Douglas (1841–1928) married Arthur T. Bushby (1835–1875), who was register general for the Supreme Court of British Columbia. In 1878, Martha Douglas (1854–1933) married Dennis R. Harris, a survey official with the Canadian Pacific Railway. In 1861 Alice Douglas (1844–1913) eloped with Charles Good (1832–1920), an Oxford graduate appointed, by the governor, as government clerk in the Colonial Secretary's office. Good also acted, briefly, as the governor's private secretary. The Good marriage was dissolved in 1878. Pethick, *James Douglas*; Charles Wilson, *Mapping the Frontier; Charles Wilson's Diary of the Survey of the 49th Parallel, 1858–1862, While Secretary of the British Boundary Commission* (Seattle: University of Washington Press, 1970), 53, n. 40, 72.

19. Cracroft, *Lady Franklin Visits the Pacific Northwest*, 12–13.

20. Ibid., 22–23.

21. Wilson, *Mapping the Frontier*, 28.

22. Edmund Hope Verney, letter to his father, July 20, 1862, *Vancouver Island Letters of Edmund Hope Verney, 1862–65*, ed. Allan Pritchard (Vancouver: University of British Columbia Press, 1996), 75.

23. Cracroft, *Lady Franklin Visits the Pacific Northwest*, 28. On African American immigration to Vancouver Island and British Columbia, see esp. James Pilton, "Negro Settlement in British Columbia, 1858–1871" (M.A. thesis, University of British Columbia, 1952); and Crawford Kilian, *Go Do Some Great Thing: The Black Pioneers of British Columbia* (Vancouver: Douglas and McIntyre, 1978.)

24. Cracroft, *Lady Franklin Visits the Pacific Northwest*, 3.

25. Suzann Buckley, "British Female Emigration and Imperial Development: Experiments in Canada: 1885–1931," *Hecate* 3.2 (July 1977): 26–40; Barbara Roberts, "'A Work of Empire': Canadian Reformers and British Female Immigration," *A Not Unreasonable Claim*, 185–202; also Barbara Roberts, "Ladies, Women, and the State: Managing Female Immigration, 1880–1920," *Community Organization and the Canadian State*, ed. Roxana Ng, Gillian Walker, and Jacob Muller (Toronto: Garamond, 1990): 108–130.

26. Robert Edward Wynne, *Reaction to the Chinese in the Pacific Northwest and British Columbia, 1850–1910* (New York: Arno, 1978), 117–119; Patricia Roy, "British Columbia's Fear of Asians: 1900–1950," *Histoire Sociale/Social History* 13.25 (May 1980), 161–172; Patricia Roy, *White Man's Province: British Columbia Politicians and Chinese and Japanese Immigrants, 1858–1914* (Vancouver: University of British Columbia Press, 1989).

27. Tamara Adilman, "A Preliminary Sketch of Chinese Women and Work in British Columbia, 1858–1950," in *Not Just Pin Money*, ed. Barbara K. Latham and Roberta J. Pazdro (Victoria: Camosun College, 1984), 55.

28. Anthony Chan, *Gold Mountain: The Chinese in the New World* (Vancouver: New Star, 1983), 81.

29. Testimony of BC Supreme Court Justice Crease, October 30, 1884, in Canada, Royal Commission on Chinese Immigration, *Report of the Royal Commission on Chinese Immigration* (Ottawa: Reprint by Order of the Commission, 1885), 144.

30. Joseph Metcalf, in Canada, Royal Commission on Chinese Immigration, *Report of the Royal Commission on Chinese Immigration* (Nanaimo, August 9, 1884), 83. Victoria Police Department, *Detective Record Book* (November 1900), 151–155.

31. Adilman, "A Preliminary Sketch," 55.

32. Ibid., 58–59; Karen van Dieren, "The Response of the WMS to the Immigration of Asian Women, 1888–1942," in Latham and Pazdro, *Not Just Pin Money*.

33. Public testimony by the Nanaimo Knights of Labour, in Canada, Royal Commission on Chinese Immigration, *Report of the Royal Commission on Chinese Immigration*, 155.

34. Jackie Lay, "The Columbia on the Tynemouth: The Emigration of Single Women and Girls in 1862," in *In Her Own Right*, ed. Barbara Latham and Cathy Kess (Victoria: Camosun College, 1980), 19–41. Edmund Hope Verney, letters, August 7, September 14, and September 20, 1862, *Vancouver Island Letters*, 78–80, 88–91.

35. Lay, "The Columbia on the Tynemouth," 21–23.

36. Edward Mallandaine, *Reminiscences*, BCA add. mss. #470 box 1, 104.

37. Macfie, *Vancouver Island and British Columbia*, 80

38. Ibid., 396.

39. Ibid.

40. Cracroft, *Lady Franklin Visits the Pacific Northwest*, 81.

41. Helen Marion Dallain, "What I Remember: Memories of a Pioneer's Daughter," n.d., BCA, add. mss. #E/E/D16, 9.

42. Ibid., 25.

43. Mrs. Winifred Lugrin Fahey (b. 1884), Imbert Orchard Collection, BCA, acc. 1297, tapes, no. 1, May 18, 1962, transcript 4, pp. 5–6.

44. Eleanor Caroline Fellows, *An Octogenarian's Reminiscences* (Letchwood, England: privately published, 1916); Emily McCorkle Fitzgerald, *An Army Doctor's Wife on the Frontier: Letters from Alaska and the Far West, 1874–78,* ed. Abe Laufe (Pittsburgh, Pa.: University of Pittsburgh Press, 1862).

45. Fellows, *An Octogenarian's Reminiscences,* 95.

46. Ethel Leather, *Diary,* Sooke, Vancouver Island, October 1891, BCA, add. mss. transcript #e/c/L48, 46–47.

47. In *A Pioneer Gentlewoman in British Columbia,* Susan Moir Allison reveals how rural women were, out of necessity, more sympathetic to Native American women. Allison lived alongside families of the Interior Salish Similkameen Indians who occupied the territory between Okanagan Lake and Hope on Mainland British Columbia. Allison, *A Pioneer Gentlewoman,* 27.

48. Ibid., 28.

49. Ibid., 23–24.

50. Macfie, *Vancouver Island and British Columbia,* 397.

51. Editorial, *St. Louis and Canadian Photographer,* September 1885, 284.

52. Nora Lupton, "Notes on the British Columbia Protestant Orphan's Home," in Latham and Kess, *In Her Own Right*; Norah L. Lewis, "Reducing Maternal Mortality in British Columbia: An Educational Process," in Latham and Pazdro, *Not Just Pin Money*; Wilson Duff, *The Indian History of British Columbia* (Victoria: Royal British Columbia Museum, 1969), 38–52; Robert Boyd, "Demographic History, 1774–1874," in *The Handbook of North American Indians,* vol. 7, ed. Wayne Suttles (Washington, D.C.: Smithsonian Institution, 1990), 135–148; Cole Harris with Robert Galois, "A Population Geography of British Columbia in 1881," in Cole Harris, *The Resettlement of British Columbia: Essays on Colonialism and Geographical Change* (Vancouver: University of British Columbia Press, 1997).

53. Agnes Knight, journal entry, Fort Simpson, December 10, 1885, 62–63, BCA, add. mss. #F7W15.

54. *St. Louis Photographer,* February 1884, 62.

55. *St. Louis Photographer,* May 1887, 189. On women's widening commission of the baby photograph, see Josephine Gear, "The Baby's Picture: Woman as Image Maker in Small Town America," *Feminist Studies* 13.2 (summer 1984), 419–442.

56. Editorial, *St. Louis Photographer,* May 1887, 188.

57. Editorial, *St Louis Photographer,* October 1886, 349.

58. Editorial, *St. Louis Photographer,* September 1886, 297.

59. Although Chinese children were included in some of the *Gems,* they were nearly invisible due to their confinement in the margins of the design structure. Their presence does, however, indicate that Chinese parents were valued clients at the Maynard Studio—to overlook them in the annual *Gems* might have otherwise alienated these clients.

60. Description accompanying photograph #63, "A Quatsino Grandma," album A-15 (Leeson album), *West Coast Indians,* circa 1900, CVA. A similarly worded description accompanies photograph #63 in Benjamin Leeson's *Catalogue of the Leeson Collection of Indian Photographs: Northern British Columbian Coast,*

CVA. In 1941, after Leeson had retired, an album entitled "Early British Columbia, A Potlatch to the Tyees" containing the captioned portraits of Kwakwaka'wakw of Quatsino was given to Canada's governor general.

61. Frederick Dally, *Memoranda of a Trip Round Vancouver Island.*

62. John Schouler, "Observations on the Indigenous Tribes of the N.W. Coast of America," in *The Ghostland People: A Documentary History of the Queen Charlotte Islands, 1859–1906,* ed. and intro. Charles Lillard (Victoria: Sono Nis, 1989), 80. Schouler was in Fort Vancouver between April and September 1825.

63. Canada, *Report to the Department of Indian Affairs, 1879* (Ottawa: DIA Annual Reports, 1868–1925), 126.

64. Fellows, *An Octogenarian's Reminiscences,* 95.

65. Formal political organization of Euro-American women began early in Victoria, inspired by Anthony's three lectures in support of the woman suffrage held at the Alhambra Hall between October 23 and 26, 1871. On October 23, her lecture "Power of the Ballot" was attended by seventy-five spectators. *Victoria Daily Standard,* October 24, 1871. On October 24, Anthony's lecture "Answering Objections to Women's Suffrage" was warmly applauded. *Victoria Daily Standard,* October 25, 1871; *Daily Colonist,* October 25, 1871. Her final lecture had free admission and the hall was packed, but according to Anthony only twenty women attended. Michael H. Cramer, "Public and Political: Documents of the Woman's Suffrage Campaign in British Columbia, 1871–1917: The View from Victoria," in Latham and Kess, *In Her Own Right,* 95.

66. Carol Lee Bacchi, "Race, Regeneration, Evolution and Social Purity," *Liberation Deferred? The Ideas of the English-Canadian Suffragists, 1877–1918* (Toronto: University of Toronto Press, 1983), 104–117; Mariana Valverde, *The Age of Light, Soap, and Water: Moral Reform in English Canada, 1885–1925* (Toronto: McClelland and Stewart, 1991); Mariana Valverde, "'When the Mother of the Race Is Free': Race, Reproduction, and Sexuality In First Wave Feminism," in *Gender Conflicts: New Essays In Women's History,* ed. Franca Iacovetta and Mariana Valverde (Toronto: University of Toronto Press, 1992).

CHAPTER 5

1. Cornelius Jaenen, "Amerindian Views of French Culture," *Canadian Historical Review,* 55.3 (September 1974): 261–291; Arthur Ray, "Fur Trade History as an Aspect of Native History," in *One Century Later: Western Canadian Reserve Indians Since Treaty 7,* ed. Ian A. L. Getty and Donald B. Smith (Vancouver: University of British Columbia Press, 1978), 7; Lorraine Littlefield, "Women Traders in the Maritime Fur Trade," in *Native People, Native Lands: Canadian Indians, Inuit, and Metis* (Ottawa: Carleton University Press, 1987). For perspectives on early exploration on the Northwest Coast, see Robin Fisher, "Cook and the Nootka," Christon I. Archer, "The Spanish Reaction to Cook's Third Voyage," and Terence Armstrong, "Cook's Reputation in Russia," all in *Captain James Cook and His Times,* ed. Robin Fisher and Hugh Johnston (Seattle: University of Washington Press, 1979).

2. Archer, "The Spanish Reaction to Cook's Third Voyage," 103.

3. For discussion of the reciprocity involved in the photographic encounter, see Victoria Wyatt, "Interpreting the Balance of Power: A Case Study of Photogra-

pher and Subject in Native Americans," *Exposure* 28.3 (winter 1991–1992): 23–33; David Neel, *Our Chiefs and Elders: Words and Photographs of Native Elders* (Vancouver: University of British Columbia Press, 1992), 12–13; and Carolyn Marr, "Photographers and Their Subject on the Southern Northwest Coast: Motivations and Responses," *Arctic Anthropology* 27.4 (1990): 13–126.

4. Mary John, a Sekani woman of northern British Columbia, eloquently spoke of the historical significance of a photograph in her possession. Bridget Moran and Mary John, *Stoney Creek Woman, Sai'k' uz Ts'eke: The Story of Mary John* (Vancouver: Tillicum Library, 1988), 21.

5. Canada, DIA report, abstracted by W. Spragge, January 11, 1873 (Ottawa: DIA Annual Reports, 1871–1873), 9.

6. A. M. Wastell, *Alert Bay and Vicinity, 1870–1954* (Vancouver: City Archives, 1955), 14, 33 (BCA NW970.5C212r).

7. George Blenkinsop, *Kwawkewlth Agency, 1882–83* (Ottawa: DIA Annual Reports, 1868–1925), 65.

8. Cornelius Jaenen, "Amerindian Views of French Culture," *Canadian Historical Review* 55.3 (September 1974): 261–291.

9. Fellows, *An Octogenarian's Reminiscences*, 95–96.

10. National Gallery of Canada, *Glossary of Photographic Media* (Ottawa: National Gallery, 1994), 4.

11. David Mattison, *Camera Workers: The British Columbia Photographers Directory, 1858–1900* (Victoria: Camera Workers Press, 1985), G-3.

12. Fellows, *Reminiscences,* 95–96.

13. Leeson, "Photographing Brother 'Lo,'" 492.

14. Septima Collis, *A Woman's Trip to Alaska: Being an Account of a Voyage through the Inland Seas of the Sitkan Archipelago in 1890* (New York: Cassell, 1890).

15. Ibid., 99–100.

16. Ibid.

17. James Prevost, "Memorandum by a naval officer on the eligibility of Vancouver's Island as a Missionary Station originally published as an anonymous letter," *CMS Intelligencer* 7 (1856): 167–168.

18. Reginald Pidcock, *Adventures in Vancouver Island, 1862–1868,* BCA, add. mss. #728, v 4b, 38, 39, 52.

19. R. C. P. Baylee, "Vancouver and Queen Charlotte's Islands," *Colonial Church Chronicle* (May 1854): 414.

20. Frederick Dally, captions to photograph #9097, *Photographic Views of British Columbia 1867–1870,* Dally, album #5, BCA catalogue #98509–2, p. 23.

21. W. A. Newcombe, "Chittenden and Maynard Exploration of the Queen Charlotte Islands, 1884," transcript of a public lecture, BCA, add. mss. #1077, box 20, file 8.

22. Eugene Arima and John Dewhirst, "Nootkans of Vancouver Island," *Handbook of North American Indians,* vol. 7, ed. Wayne Suttles (Washington, D.C.: Smithsonian Institution, 1990), 393.

23. Charles Tate, *Diary,* January 1, 1899, to April 9, 1900. BCA, add. mss. #303, vol. 2, file 8.

24. Homer G. Barnett, *The Coast Salish of British Columbia* (Eugene: University of Oregon Press, 1955), 21.

25. H. B. Hawthorn, C. S. Belshaw, and S. M. Jamieson, *The Indians of British Columbia: A Study of Social Adjustment* (Berkeley: University of California Press; Vancouver: University of British Columbia Press, 1958), 37.

26. Charles Tate, Cowichican Indian mission, 1903, BCA, add. mss. #303, box 1, file 9. Charles Tate's photographs of the Quamichan potlatch are in the Rev. C. M. Tate Album, CVA, #IN P 8 (negative 6).

27. For an overview of the enforcement of the federal prohibition against potlatch conducted by regional Indian agents, see Cole and Chaikin, *An Iron Hand upon the People*, 106–137. For a timeline reviewing the various amendments to the Indian Act, see John Tobias, "Protection, Civilization, Assimilation: An Outline History of Canada's Indian Policy," *Sweet Promises: A Reader on Indian-White Relations in Canada*, ed. J. R. Miller (Toronto: University of Toronto Press, 1991), 127–144; see also Brian Titley, *A Narrow Vision: Duncan Campbell Scott and the Administration of Indian Affairs in Canada* (Vancouver: University of British Columbia Press, 1986).

28. Canada, *Federal Department of Indian Affairs Report,* October 1, 1875 (Ottawa: DIA Annual Reports, 1868–1925), 45.

29. Franz Boas, "Fieldwork for the British Association, 1888–1897," in *The Shaping of American Anthropology, 1883–1911: A Franz Boas Reader,* ed. George W. Stocking Jr. (New York: Basic Books, 1974), 105, 106.

30. Wayne Suttles, "Central Coast Salish," *Handbook of North American Indians,* 462–463, 461; and see Barnett, *Coast Salish of British Columbia,* 71, 120.

31. Diamond Jenness, hand-typed, hand-bound manuscript, *Saanich Indians of Vancouver Island,* n.d., 76. Manuscript in author's possession.

32. Captions found on copies of the Tate photographs, Tate Album, CVA, add. mss. #225.

33. Barnett, *Coast Salish of British Columbia,* 134–135.

34. Ibid., 138, 157–159.

35. Jenness, *Saanich Indians,* 67. According to Jenness, Coast Salish mortuary practices varied. In some instances it was common to burn all moveable belongings of the deceased—in the case of a man, his tools, weapons, and even a canoe might be burned. Other variations included the burning of some possessions, the placing of others beside the gravesite, and division of other goods among sons and mourners. The substitution of a photograph for the goat-hair effigy is discussed in Barnett, *Coast Salish of British Columbia,* 226. I also discussed this photograph with treaty research scholars and Chief Jill Harris of the Hul'qumi'num Treaty Group in Duncan, V.I., in November 1995.

36. Jenness, *Saanich Indians,* 80–81.

37. Ibid., 72.

38. Arima and Dewhirst, "Nootkans of Vancouver Island," 393.

39. Gwendolyn Bennett interview, January 31, 1983, tapes N00-T-040, Audio-Visual and Archeology Collection, RBCM, acquisition notes.

40. Mattison, *Camera Workers,* G-3.

41. Alan Thomas, "Photography of the Indian: Concept and Practice on the Northwest Coast," *BC Studies,* no. 52 (winter 1981–82), 65.

42. Margaret Blackman determined the dates of the Maynard photographs based on the changes in the linoleum flooring pattern, which varies between the three locations of the Maynard studio. The pattern in two portraits of Seta-Kanim matches the linoleum of the Maynard studio used from 1865 until the move into a new studio in 1869. "Studio Indians: Cartes de visite of Native People in British Columbia, 1862–1872," *Archivaria* 21 (winter 1985–1986), 85.

43. Kyquot, the home of Northern Nootkans, was eighty miles north of Clayoquot Sound. Arima and Dewhirst, "Nootkans of Vancouver Island," 393.

44. Gilbert Malcolm Sproat, *The Nootka: Scenes and Studies of Savage Life,* ed. and ann. Charles Lillard (Victoria: Sono Nis, 1987), 128–129, 46–47.

45. Canada, *Federal Department of Indian Affairs Report,* October 1, 1875 (Ottawa: DIA Annual Reports, 1868–1925), 52.

46. Suttles, "Central Coast Salish," 456.

47. Ibid.

48. Later outbreaks "marginally affected" the central and southern Coast Salish (except for the Songhees), because the access to smallpox vaccine in populated areas increased. Robert T. Boyd, "Demographic of Disease, 1774–1874," in Suttles, *Handbook of North American Indians,* 37–146.

49. Ibid.

50. Wilson Duff, *The Indian History of British Columbia* (Victoria: Royal British Columbia Museum, 1992), 39.

51. Michael Lesy, *Wisconsin Death Trip* (New York: Random House, 1973), n.p.

52. Bridget Moran and Mary John, *Stoney Creek Woman,* 21.

53. Wyatt, "Interpreting the Balance of Power," 29.

54. P. E. Larss and W. C. Pierce operated the Elite Studio on Commercial Street between 1892 and 1896. Mattison, *Camera Workers,* L-2–L-3. William Burton Finley worked on Commercial Street in Nanaimo between 1899 and 1900. Edward Coley Brooks operated two studios, one on Victoria Crescent and the other on Commercial Street, between 1892 and 1900. He arrived in Nanaimo in 1891 and took over the Diamond City Photograph studio on Commercial Street from the previous owner/operator, John Sampson. Brooks kept the studio until 1898, when he departed for New York, where he committed suicide at age 50 in 1908. Clipping file, NCA.

55. Clipping file on William Good, code 17, box 1, NCA.

CONCLUSION

1. Eugene Arima and John Dewhirst, "Nootkans of Vancouver Island," *Handbook of North American Indians,* vol. 7, ed. Wayne Suttles (Washington, D.C.: Smithsonian Institution, 1990), 407.

2. A. M. Wastell, *Alert Bay and Vicinity, 1870–1954* (Vancouver: City Archives, 1955), 20.

3. William M. Halliday, *Annual Report of the Department of Indian Affairs for the year ended March 31, 1907,* 234–236. This quote comes from a typed manuscript

of the Alert Bay Report, unlabeled and undated manuscript, BCA, add. mss. #M/M/A/1/2. For an overview of Agent Halliday and his aggressive enforcement of the federal prohibition against the potlatch in Alert Bay, especially after 1922, see Gloria Cranmer Webster, "From Colonization to Repatriation," in *Indigena: Contemporary Native Perspectives*, ed. Gerald McMaster and Lee-Ann Martin (Vancouver: Douglas and McIntyre and the Canadian Museum of Civilization, 1992).

4. Halliday, *Annual Report of the Department of Indian Affairs*, 234–236.

5. John Tobias, "Protection, Civilization, Assimilation: An Outline History of Canada's Indian Policy," in *Sweet Promises: A Reader on Indian-White Relations in Canada*, ed. J. R. Miller (Toronto: University of Toronto Press, 1991), 127–144.

6. Bill Russell, "The White Man's Paper Burden: Aspects of Records Keeping in the Department of Indian Affairs, 1860–1914," *Archivaria* 19 (winter 1984–85): 50–72.

7. Douglas Cole, "'The Value of a Person Lies in his Herzensbildung': Franz Boas' Baffin Island Letter-Diary, 1883–1884," in *Observers Observed: Essays on Ethnographic Fieldwork,* ed. George W. Stocking Jr. (Madison: University of Wisconsin Press, 1983), 50.

8. Leslie White, *The Ethnography and Ethnology of Franz Boas* (Austin: Bulletin of the Texas Memorial Museum at the University of Texas, 1963), 16.

9. Boas, quoted by Cole, "Baffin Island Letter-Diary," 33.

10. Judith Berman, "'The Culture as It Appears to the Indian Himself': Boas, George Hunt, and the Methods of Ethnography," in *Volksgeist as Method and Ethic: Essays on Boasian Ethnography and the German Anthropological Tradition,* ed. George Stocking Jr. History of Anthropology, vol. 8 (Madison: University of Wisconsin Press, 1996).

11. Ira Jacknis, "The Ethnographic Object and the Object of Ethnology in the Early Career of Franz Boas," in Stocking, *Volksgeist as Method and Ethic.*

12. White, *The Ethnography and Ethnology of Franz Boas*, 9–11. White lists the dates and places of Boas's ethnographic field trips based upon data from his diaries and correspondence in the American Philosophical Society archive. According to White's calculations, Boas spent a total of twenty-nine-and-a-half months in the field.

13. James Clifford, "The Others: Beyond the 'Salvage' Paradigm," *Third Text* 6 (spring 1989): 73–78; Douglas Cole, *Captured Heritage: The Scramble for Northwest Coast Artifacts* (Vancouver: Douglas and McIntyre, 1985).

14. Ira Jacknis, "Franz Boas and Photography," *Studies in Visual Communication* 10.1 (winter 1984), 2–60.

15. Carolyn Marr, "Taken Pictures: On Interpreting Native American Photographs of the Southern Northwest Coast," *Pacific Northwest Quarterly* 80 (April 1989): 55.

16. Jerome S. Cybulski, "History of Research in Physical Anthropology," in *Handbook of North American Indians,* ed. William Sturtevant, vol. 7 (Washington: Smithsonian Institution Press, 1988), 116–118.

17. Hrdlicka, *Practical Anthropometry* (Philadelphia: Wistar Institute of Anatomy and Biology, 1939), 3–6. Hrdlicka, a curator of physical anthropology at the Smithsonian Institution, lists a number of disciplines using anthropometric

measurement of the human body, including industrial design, regulation of art, military selection, medical, surgical, and dental purposes, detection of bodily defects and their correction, criminal and other identification, purposes of life insurance, eugenics purposes, and scientific investigation.

18. Frank Spencer, ed., *History of Physical Anthropology: An Encyclopaedia,* vol. 1 (New York: Garland Reference Library of Social Science, 1997), 188.

19. See artists and essays in *Partial Recall: Photographs of Native North Americas,* ed. Lucy Lippard (New York: New Press, 1992); and in *Native Nations: Journeys in American Photography,* ed. Jane Alison (London: Barbican Art Gallery, 1998).

20. Theresa Harlan, "Adjusting the Focus for an Indigenous Presence," in *Overexposed: Essays on Contemporary Photography,* ed. Carol Squiers (New York: New Press, 1999), 135. Also see essays by Jolene Rickard, Hulleah Tsinhnahjinnie, and Theresa Harlan in Alison, *Native Nations.*

INDEX